UNIVERSITY OF WESTMINSTER

Failure to return or renew overdue books may result in suspension of
borrowing rights at all University of Westminster libraries.

Due for return on:

- 9 NOV 1995

D1513935

int ref 0524

Information Resource Services **Harrow IRS Centre**
Watford Road Northwick Park Harrow HA1 3TP
Telephone 0171 911 5885

22 0042794 9

THE (f) FOCALGUIDES TO

This book is sold subject to the Standard Conditions of Sale of Net Books and may not be re-sold in the UK below the net price.

The
FOCALGUIDE
to
Exposure

David Lynch

COMMUNICATION LIBRARY, P.C.L.,
18-22, RIDING HOUSE ST., W1P 7PD

FOCAL PRESS
London and New York

© Focal Press Limited 1978

All rights reserved. No part of this publication may be reproduced, stored in a retrieval system, or transmitted in any form or by any means, electronic, mechanical, photocopying, recording or otherwise, without the prior permission of the Copyright owner.

🅱🅻 **British Library Cataloguing in Publication Data**

Lynch, David
 The Focalguide to exposure.
 1. Photography — Exposure — Amateurs' manuals
 I. Title
 770'.282 TR591

 ISBN (excl USA) 0 240 50971 4
 ISBN (USA only) 0 8038 2364 9

BOOK No. G7988891

CLASS No. 440.282

CONTROL No. 0240509714

Printed and bound in Great Britain by A. Wheaton & Co., Ltd., Exeter

Contents

What is Exposure

Perhaps it is simply that I'm blessed with an over-active imagination but mention of the word 'exposure' invariably starts me on a train of thought which leads to beautiful bikini-clad blondes, slowly browning on a Mediterranean beach. This book is about exposure but, unfortunately, the blondes are rather thin on the ground. What we are going to talk about in these pages is photographic exposure. There is in fact a closer tie-up then you might imagine between the two subjects. Given the right circumstances, both a photographic emulsion and a blonde will darken selectively upon exposure to light.

With sunbathing, under-exposure produces little effect, and over-exposure unpleasant results. What is more, the results don't show immediately. Everyone has a different response to the sun, and the sun varies from place to place and from time to time.

You have to learn just how long you can stay in the sun, and all the factors that affect that time — your existing tan, the strength of the sun, sun lotion and so on.

In a similar way, a piece of film has to be exposed to the right amount of light. If you under-expose it, you will get a very pale ('thin') result. Over-expose it, and it will be too dense ('thick'). With transparencies, you have to be very accurate, because all you have is that one piece of film. If it is too dark or too light, you can do nothing about it. If you use negative film, the problem is less critical. The density of a print can be controlled irrespective of the negative density. However, if the film had far too little exposure, there will be practically nothing on it; and with far too much, it will be mostly black. In either case it will be impossible to make a reasonable print. Of course, there are variations between the extremes and a satisfactorily exposed negative. Some will produce reasonable pictures, others poor pictures. The way to really good pictures though, is through really well-exposed negatives.

In a camera, you cannot see what is happening at all. The film is shut away, and the only light which falls on it passes through the lens when the shutter is opened. Even if you could examine the film after it had been exposed you wouldn't see any perceptible change in it.

When light falls on a photographic emulsion, a latent, (invisible) change takes place. It is only when the film is developed that those areas which had been exposed to light become dark.

Of course, the time scale is very different too. The blonde may take a fortnight to darken satisfactorily whereas in similar weather conditions a modern colour-negative film will probably be perfectly exposed in something like 1/250 second. An exposure of 1/60 second is four times as much. In terms of human suntan, for instance, like lying in the sun for two months. 1/1000 second is only one quarter of the time — little more than a long weekend spent sunbathing. So, not only is a very short period of time required to produce a correct exposure, it also has to be an accurately controlled period of time.

You control exposure by varying the length of time that the light falls on the film and the intensity of that light. The first is controlled by shutter speed, and the second by the lens aperture. You adjust the speed and aperture to suit the film and the lighting conditions you are using.

Another factor which is going to affect the exposure of a picture is the subject matter. When you take a picture, you don't point the camera at the sun (or whatever the source of illumination might be), you point it at the *subject*. In other words, you expose the film using light which has been reflected by the subject — second-hand light really. This would cause no problems if all substances reflected light equally and evenly. The trouble is, they don't. Soot, for instance, is soft and black and velvety and of course, reflects a lot less light than sand, which is shiny and light and crystalline. To record all the fine detail in the grains of a pile of soot would require perhaps six or seven times the exposure required to record full detail in a similarly lit pile of sand.

Even that produces its own problems, though. By varying the exposure in this way, the pictures of both the soot and the sand would come out about the same tone — a mid-grey. So, they would not be truly representative of the subject.

These factors must be taken into account when we consider exposure.

With modern cameras, who worries?

'Who needs to worry about exposure?' I can hear you saying the **words already. It's quite understandable; after all, you probably buy**

11

a camera because the advertisements tell you that with that particular model the hard work is done for you, the worries are taken away and you simply look through the viewfinder and let the camera do the thinking. So seems to run the blurb whether you are spending £5 or £500 ($10 or $1000). You buy a 110 pocket camera, for instance, and there it is in black and white: 'No exposure problems, simply dial the weather' or, with the more expensive camera; 'Simply align the needle in the viewfinder ' . . . leaves you free from worry about controls and calculations'.

Is this, then, misleading advertising which should be stamped out as quickly as possible? Or are the manufacturers right and are we the ones to have a bee in our bonnets? The answer, of course, is that to a very large extent the manufacturers are perfectly correct when they make their claims, but *only* insofar as average exposure conditions pertain. The moment things get even slightly unusual is the moment you have to start using your thinking gear again.

Let's take an example. You are standing in a field at midday on a bright, slightly hazy day, with the sun shining over your shoulder. In the foreground there is a lake. A white cottage — covered with virginia creeper — stands in the middle distance with some bushes and a few small trees about it. The whole thing makes a beautiful composition. You set your pocket camera to 'bright or hazy sun' or your fully automatic SLR with electronic shutter to your eye, line up the picture in the viewfinder and 'click' — it is all done. No problems, no calculations, no drama — just a perfect exposure

Now, make one alteration to that scene. Instead of shooting with the sun shining over your shoulder, wait two or three hours until it moves around and positions itself to one side and slightly in front of you. Suddenly, without making any earth-shattering changes visually, you have given the camera an exposure problem which, without your help, it just couldn't handle satisfactorily. Here's why: in the first instance, the whole scene was one of average brightness. The sun was behind the camera illuminating everything fairly evenly. No important areas of the picture were in dark shadow or brilliantly overlit. The camera could cope perfectly. The bright or hazy sun setting on the pocket camera was designed with just such a subject in mind and the meter on the automatic camera could measure any part of that subject and still come up with a right reading.

However, as the sun moved round, it stopped illuminating the cottage and trees and left them in deep shadow. The lake, from being a

limpid pool reflecting the cottage and trees, now sends thousands of tiny brilliant needles of sunlight flashing into the camera lens; the sky becomes brighter; everything else, however, stays much the same. An exposure made on the simple camera using the hazy sun setting is now going to reproduce the cottage (which is the main subject) too dark and the lake too bright – in other words we are going to get what that exposure setting was designed to reproduce – the happy medium. Unfortunately, because the contrast between light and dark is so great, the picture is unlikely to be pleasing. That, though is a problem with the scene rather than with the camera.

On the other hand, however, the automatic camera is going to be well and truly fooled both by the sunshine reflected in the lake and the brightness of the sky. There is now so much more brightness in the scene that the meter will decide a much shorter exposure is called for. The result will be that the cottage (which was under-exposed even when exactly the same exposure was given by the pocket camera) will now be very seriously under-exposed and even the rest of the scene (which remained of average brightness) will not reproduce as brightly as it should. The lake, on the other hand, will probably be only slightly over-exposed.

It's a sad fact – or is it so sad, really – that while the conditions under which pictures are to be taken can change, no camera, at the moment at any rate, can possibly be completely automatic and still give you a good picture every time.

I have talked of an automatic camera, but the effect is the same with any meter built in or separate – if you just point it toward the scene and follow its reading directly.

With simple cameras, of course, the idea is that most of the people who use them will want to take pictures under fairly average conditions anyway. That is why they are so simple. They are meant to be virtually foolproof and in ninety-nine cases out of a hundred they are – purely and simply because they are being used by people who are not trying to be creative photographers, who are not trying to produce imaginative pictures, but are simply wishing to record young Freddie playing in the sunshine with his pedal car. They are, in fact, meant for the average non-photographer.

More complex cameras are produced for a very different type of person (in theory, at least). They are meant for the advanced amateur, the serious worker – even the professional – who knows exactly what he is doing and, more important perhaps, why he is

doing it. He is the sort of person who sees his picture and uses the camera to record it. He may wish to over-expose, under-expose or even double-expose quite deliberately. He is the sort of person who does *not* wish to take average pictures. The camera which will only record what *it* wants to record is no earthly use to him – which is why the fully-automatic camera has never proved a very popular product. It is in control of you rather than the other way round. Fortunately, nowadays, most automatic cameras allow some control – perhaps one or two stops or even total override.

An automatic camera with full over-ride is probably ideal. Where circumstances are fairly average and no obvious exposure problems present themselves, the photographer can concentrate entirely on shooting and let the camera get on with the job of setting the right exposure. When the exposure gets difficult, he can use all his experience.

Note, though; it is still you who has to assess the situation to satisfy yourself that there are really no problems that the camera cannot tackle. You never can relax entirely and leave it all to the camera. Let us just look for a moment at some subjects which requires a little bit of thought by the photographer, some subjects which you could not leave an automatic camera to handle on its own.

Some tricky subjects

Although we've headed this section 'some tricky subjects', remember they are only 'tricky' in terms of exposure. They are not 'terribly difficult' or 'almost impossible'. They simply require a little more thought.

Backlighting. Probably the first subject which springs to mind is similar to one we have already discussed, where the main subject is in deep shadow while the background is brilliantly lit. Typical examples would be a full-length portrait on the beach, backlit trees in a woodland scene or a skyline against the setting sun. In the first two cases, exposures would have to be more generous than an average meter reading would suggest in order to preserve all the detail in the important shadow areas. In the third case, less exposure might be required than an average meter reading would suggest in order to lose detail and make a silhouette of the landscape while still maintaining detail and colour in the sky.

14

Brightly lit snow and beach scenes. Snow, sand and water are highly reflective and can return up to 90% of the light which falls on them. Where there are large expanses of these substances and smaller areas of darker subject matter which you want to record, any meter is going to be fooled into suggesting less exposure than is really required, for the darker part of the subject. Of course, to get a picture of the sculptural qualities of the snow or sand, you follow the meter or give even less exposure.

Night shots. Most ordinary meters will tell you it is impossible to take a picture at night, but equally obviously you know you *can* take pictures at night — the only proviso being that you work out the exposure yourself. The problem is, not too many exposure meters are sensitive enough to do the job for you and, even if you use an especially sensitive meter, the exposure it would suggest would produce a result that looked more-or-less like a daylight picture anyway. Exposure meters are designed to take their readings *from* mid-tones and offer exposures which *reproduce* mid-tones.

Scenes with areas of extreme brilliance and deep shadow. This type of picture is always a problem because no film can reproduce detail in brilliant highlights and deep shadow at the same time. Occasionally, of course, you want to produce a pattern of deeply contrasting light and shade. If so, all well and good, If you want a normal picture, though, you have problems. What you have to do is decide which is more important — highlight or shadow detail — and then expose accordingly. Alternatively, you can opt for an exposure which will reproduce the highlights correctly and then use a reflector or a flash unit to lighten the shadow.

Very high key or very low key shots. Here again, because a meter is designed to read from mid-tones, any readings taken from a bright highlight or a deep shadow will give misleading exposure information and produce a degraded result. The tendency will be to under-expose in the high key shot and over-expose in the low key picture.

The image

Up to now, we've been talking mainly in terms of tone reproduction. However, there is another consideration which is, perhaps, a little less obvious but, as far as negative materials are concerned, is also

extremely important. That is, the way in which exposure affects image sharpness.

For every picture you take there is a correct exposure – and that is the minimum exposure which will ensure that the tone range of the subject reproduces exactly as you want it to. As we have already noted, with colour reversal materials (which give you a colour transparency) there is very little leeway. The difference of one stop more or less than the right exposure can mean the difference between the excellent and the mediocre. With black-and-white materials, however, there is more latitude and a difference of one stop under and up to three stops over may not produce bitter disappointment as far as tone reproduction goes – at least, insofar as average subjects are concerned. In fact, manufacturer's advertisements have suggested a possible range of seven or more stops without trouble.

However, as exposure increases over and above the optimum, not only does tonal reproduction suffer but sharpness begins to deteriorate as well. This is because the photographic emulsion is made up of millions of tiny grains of silver salts which blacken when they are developed according to the amount of light which has struck them. When light strikes a light-sensitive grain, that grain attempts to pass a little bit on to its neighbour. It does this both by reflection and refraction and the result is a slight softening or diffusion of the image.

This effect is least when the minimum amount of light is allowed to strike the emulsion. As more and more light is allowed to hit each grain of silver so more and more light is passed on to the surrounding grains and the more is the deterioration in image sharpness.

Film speed and processing

If we are going to talk about exposure, we also have to talk about processing. Although at first there would seem to be no apparent connection between these two functions, they are directly related. The correct exposure for any film depends on its light sensitivity. That sensitivity is normally expressed as *film speed* or *meter setting*. The type of developer used and the time and method of development employed play an important part in the initial establishment of the film speed. Colour materials, which normally

have to be processed following fairly rigid routines, are likely to raise fewer problems in that respect (although the effective film speed of most materials can be altered by modifying processing times).

Black-and-white materials present rather a different situation. Here, the variety of developers available is quite staggering. Many are perfectly conventional, and, used in the prescribed manner, will produce exactly the result you might expect (or hope for) from a film of the speed which you used. Many more, however, purport to offer such benefits as finer grain, increased film speed or enhanced sharpness. While these may sound very attractive propositions, the first two, at least, usually call for some sacrifice of the films full capabilities.

Shall we go on?

Correct exposure then is important. Knowing the correct exposure enables you to reproduce what is in front of the camera lens exactly as you want to reproduce it. An exposure meter will not always tell you the correct exposure, nor will an automatic camera always give it. An exposure meter will tell you what it thinks is the correct exposure and an automatic camera will give what it thinks is the correct exposure — but they may not always be right. It takes *you* to know whether they are right or not, and to be in a position to know you have to understand something about what actually happens when you release that shutter.

In the following chapters we are going to look at the factors which are involved in the production of a 'perfect' exposure. If there are more than you think, don't worry too much. Just consider the number of accurate exposures you have already produced without knowing that much about them. Then think how many more you will be able to produce with extra knowledge.

The Film

In the previous chapter we looked rather quickly at some of the factors which should influence your choice of exposure. Although all of these factors are important and all are inter-related, some stand out as requiring rather more consideration than the others. The first is choice of film. Until you know something about the materials you can choose — how sensitive they are to light, how well they register fine detail, how they respond to colour — you are in no position to consider taking pictures seriously.

Whenever possible, you should suit the film to the circumstances — select the right film for the right job. By doing this you provide the **best possible opportunity, of producing a first class result.**

If you can, find out more about the specific materials you intend to use by reading any technical information about them (particularly the manufacturer's own, for no one is better placed to provide informative literature than he is). One of the best ways of finding out, though, is by taking *pictures*. That way, what you learn tends to stick!

Black-and-white materials

To the photographer of one hundred years ago, who had to manufacture his own materials immediately prior to exposure, the modern black-and-white film would seem a miracle of convenience and compactness.

It is made up basically of three layers. The middle layer, surprisingly enough, is called the base and this is a foundation layer usually made from cellulose triacetate, a strong plastics material.

One side of the base is coated with an emulsion containing light-sensitive silver halides. This is the side which faces forward in the camera and which is exposed to light when the shutter is released. This layer may in fact, be coated as several thin layers, but we consider it to be a single one.

The other side is coated with a gelatin anti-curl backing, similar in character to the emulsion. This backing, as its name suggests,

Layers in B/W film

Irradiation

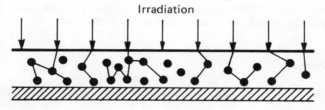

Halation

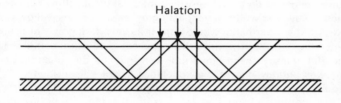

There are three layers in a black and white film: the light sensitive emulsion, the film base, (or support) and a gelatin anti-curl layer which usually incorporates an anti-halation backing.

Irradiation is caused by light being scattered by the silver grains themselves, within the emulsion. It usually occurs where dark and light areas meet and results in poor definition in those areas.

Halation produces a halo effect surrounding bright areas. It is caused by light being reflected back to the emulsion from the rear of the film base. An anti-halation backing on the film will normally prevent the problem. Halation is often aggravated by irradiation; and is considerably increased with over exposure.

counteracts the natural curl of the film inwards towards the emulsion. Without this backing the film would be unmanageable. A dye is added to the backing. This absorbs any light that has passed through the emulsion and base layers; light which might otherwise be reflected back to the emulsion to form a ghost image — usually in the form of a halo round the brightest highlights. So, the backing is often called an anti-halation layer.

The part of the film which interests us most here is the emulsion, for it is the emulsion which records the image and it is the way in which the emulsion is formulated which decides how an image is going to be recorded. A film emulsion has five characteristics: they are colour sensitivity, speed, resolution, contrast and latitude.

Colour sensitivity

An emulsion does not necessarily respond to light of differing colours equally. In the early days of photography, materials were sensitive only to blue light and ultra-violet radiation. A print made from a negative on a blue-sensitive material would show blue skies and blue eyes as white, or very light grey, areas. Greens, yellows and reds, on the other hand, would appear as very dark greys, or blacks, depending on whether or not there was any blue pigment in them. A cheerful country scene could look very gloomy and unnatural and this was entirely due to the imbalance in colour sensitivity.

Around about the turn of the century, progress was made and it was found that by adding certain dyes to the film emulsion during manufacture, colour sensitivity could be extended into the green and towards the yellow. The materials produced by this method, although still insensitive to red, were termed *orthochromatic* (which means correctly sensitive to colour). Such materials are still readily available professionally and are widely used for jobs in which full colour sensitivity is not important.

Finally, fully colour-sensitized emulsions were introduced and these were labelled *panchromatic* — that is, sensitive to all colours — and indeed, these films are sensitive to all the colours that the eye can see. However, the fact that they will record all the colours the eye can see does not mean they will reproduce them in the same shades of brightness that the eye sees them. Blue, for instance, still records as too light a tone; green is still a touch too dark and red, far from

being the black it used to be, now tends to record rather paler than it should. This was particularly so in the case of very fast panchromatic films some years ago where extra speed came from increasing the red sensitivity of the emulsion.

Film speed

Sensitivity is virtually always quoted in relation to white light. Some films are faster than others and require less exposure (or less light) to form an acceptable image. To enable you to identify how fast a film is, film speeds are quoted on the film packaging, usually in terms of ASA/BS or DIN numbers. (The identification *ASA/BS* is gradually being replaced by the prefix ISO (which stands for International Standards Organization). The number however remains the same. ASA/BS 200 and ISO 200, for example, mean exactly the same thing.) A doubling of film speed is indicated by a doubling of the ASA/BS number; adding 3 to the DIN number serves the same purpose. A halving of film speed is indicated by a halving of the ASA/BS number or the subtraction of 3 from the DIN number. Thus, film A with an emulsion speed of ASA/BS 400, 27 DIN is twice as fast as film B which is ASA/BS 200, 24 DIN (film A will need only half the exposure of film D). On the other hand, film C with an emulsion speed of ASA/BS 100, DIN 21 is only half the speed of film B (it will need twice as much exposure).

Typical medium-speed panchromatic films which have reasonably fine grain and well-balanced colour sensitivity are Kodak Plus-X Pan and Ilford FP-4 (ASA/BS 125, 22 DIN); typical fast panchromatic films: Kodak Tri-X Pan or Ilford HP-4 or HP-5 (ASA/BS 400, 27 DIN).

Film speed is decided by the manufacturer and, within limits, he can increase the speed of his emulsion in two ways.

First, he can extend the sensitivity of his emulsion further into the red region of the spectrum. This is effective up to a point, but obviously there soon comes a time when too much red sensitivity will distort the tone range of the picture beyond the bounds of acceptability and yellows, oranges and reds will appear far too light — almost as if the picture had been taken by infra-red radiation. Secondly, he can increase the size of the silver halide grains in the emulsion. While this has the desired effect of increasing the sensitivity of the film, it also has the less welcome effect of producing a

coarse-grained emulsion which cannot be enlarged to any degree before the images of the silver grains themselves become obtrusive. More important, perhaps, is the fact that grain structure itself will mask fine detail in the subject.

Resolving power

This leads us naturally to resolution. The resolving power of a film is its ability to reproduce fine detail. As we have already seen, the faster the film, the larger the silver halide grains and the less capable the film is of resolving really fine detail. However, there are two further problems which stand in the way of high resolution. One we have discussed already. This is called halation, and can be solved to a great extent by the manufacturer, who adds an anti-halation dye to the anti-curl layer. The other is called irradiation and we touched on it briefly in Chapter 1.

Irradiation is the scattering of light within the emulsion layer and it is caused by the individual grains of silver in the emulsion reflecting and refracting the light which falls on them. It is liable to occur whenever there is an abrupt division between light and dark areas and its effect is to cause an apparent softening of the image. Irradiation is accentuated by three factors: the size of the silver halide grains in the emulsion – the larger the grains, the worse the effect; the thickness of the emulsion layer – obviously the greater the quantity of silver halide grains the greater the light spreading potential; and the amount of exposure which is given – the more exposure, the more light there is to spread. Irradiation can aggrevate the effects of halation.

Contrast

Contrast in a film emulsion is the range of grey tones that that emulsion is capable of forming between dense black and clear film. Some materials are inherently contrasty. Lith films, for instance, which tend to be used predominantly for reproducing totally black or white 'line' work, will reproduce only one or two grey tones between densest black and clear gelatin. Lith films are slow and very fine-grained and in general it may be said that the slower the material the

higher the degree of contrast. At the other end of the scale there are **the fast panchromatic films which are low in contrast.** Naturally, between these two extremes, it is possible to find films of almost any contrast you might require — low, low to medium, medium to high and so forth.

For the majority of purposes, the amateur photographer is going to find the low to medium-contrast emulsions the most useful for his purposes — that is, films in the ASA/BS 32 — 400 speed range. These are the films which are most likely to reproduce reasonably faithfully **the tonal ranges of the subjects he is likely to be interested in as well** as having sufficient speed to allow reasonably short exposures.

Latitude

There is another good reason why low-contrast emulsions can be useful. The lower the contrast of the material, the more exposure latitude it will have. This means that although you should make every effort to achieve accurate exposures (and by far the best results will be obtained if you do) it is not a tragedy if you don't succeed. Most medium to high speed films can cheerfully accommodate $\frac{1}{2}$–1 stop under-exposure and 2–3 stops over without a disasterous drop in image quality. Remember, though, the further you get away from the right exposure the greater will be the drop in quality. It is generally considered that although correct exposure depends on a number of factors, for most average subjects the *right* exposure is the one which produces just the minimum of density in the shadow areas of the negative. In other words, the right exposure is the minimum acceptable exposure consistent with the film speed of the material.

Colour films

Taking pictures in colour is not a lot different from taking pictures in black and white — you just have to be more careful. Colour films are more complex — and less forgiving — than black and white. They can be divided into two types: colour-reversal materials, which yield a single original colour transparency; and colour-negative materials, from which colour prints can be produced.

Colour-reversal materials consist of a film base, similar to that of the black and white film, on which is coated a light-sensitive emulsion with three separate image-forming layers. The top layer is sensitive to blue light, the middle layer to green (and blue) and the bottom layer to red (and blue). To prevent blue light affecting the green and red layers, a yellow filter is placed between the blue and the green sensitive layers. When the film is processed, first a black and white negative appears but, as the process continues, this negative image is replaced by a positive, full-colour dye image of the subject.

Because the colour image is made up of three dyes separately or in combination, 100% accuracy in colour reproduction is impossible to achieve. Most reversal materials produce extremely pleasing results. Unless you make a direct comparison with the subject (and this may still prove the film to be surprisingly accurate) you are unlikely to be disappointed. Different materials *do* produce different results, however, and the reds of one material may be brighter than the reds of another, the greens a little duller, perhaps. For this reason, it is worth trying various materials until you find one which suits you individually. You can find surprising differences between different films from the same manufacturer, as well as between those from different companies.

The speed of colour-reversal films ranges from ASA/BS 25 upwards to ASA/BS 500. Unless it is absolutely necessary, though, it is better to avoid using extremely fast materials. These are intended for those situations where, without that extra speed, a picture would be impossible. In general, the colour reproduction from these films is not the best and the slower materials, being inherently more contrasty, give better colour saturation and thus more brilliant results. They are particularly impressive when projected on a large screen.

Latitude

Due to the nature of the process, the latitude of colour slide materials, is generally poor. At best, a half-stop under-exposure and one-stop over is the maximum permissable and even within these limits there tends to be some loss of sparkle and brilliance. Nor can colour materials, in general, offer the same degree of resolution as black and white films — don't forget there are three emulsion layers

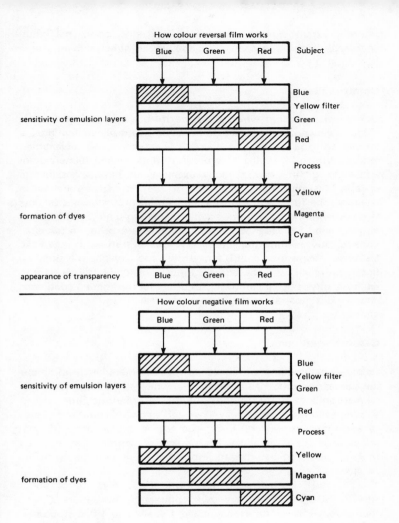

How colour reversal film works

| Subject | Blue | Green | Red |

sensitivity of emulsion layers
- Blue
- Yellow filter
- Green
- Red

Process

formation of dyes
- Yellow
- Magenta
- Cyan

appearance of transparency — Blue | Green | Red

How colour negative film works

| Subject | Blue | Green | Red |

sensitivity of emulsion layers
- Blue
- Yellow filter
- Green
- Red

Process

formation of dyes
- Yellow
- Magenta
- Cyan

In a colour reversal film, exposure produces latent images in the layers sensitive to the different colours. Processing produces dyes which combine visually to form the colours of the original subject.

In a colour negative film, processing produces colours which are complementary to those of the original subject.

in the average colour emulsion — but once again, maximum sharpness is going to come from the slower films.

Colour balance

One special problem which we have to face with colour films is colour balance. Normally, we don't notice that artificial lighting is a lot yellower than is daylight — after a few seconds, our eyes adapt and everything looks just as it did in daylight. Colour films cannot adapt, though; they have to record exactly what they see and for this reason colour-slide films are made in three types; one for use in daylight, one for use in tungsten lighting such as studio spotlights (type A) and one for use in photoflood lighting (type B). If a colour film intended for use in daylight conditions is exposed in tungsten lighting, the resulting transparency will have a strong yellow cast. Likewise, a type A or type B film exposed to daylight will show an unpleasant blue cast. The effect is irreversable and it is important to ensure that you use a film which is correct for the lighting conditions if you want 'normal-looking' transparencies.

Colour negatives

Colour-negative films are similar to reversal materials in structure but processing produces a negative in which the colours are complementary to those of the original subject — greens become magenta, blue becomes a brownish yellow, and so on. It is not always easy to see these colours, however, due to the overall orange-brown appearance of the negative. This is a special dye-mask, put there by the manufacturer, in order to improve the printing quality of the negative.

Most colour negative materials have a speed rating of about ASA/BS 80–100. They are of lower contrast and have more latitude than reversal films of a similar speed. Usually about one stop or so under-exposure and one to two-stops over-exposure is permissable, but again *any* deviation from the correct exposure does lead to a reduction in image quality. ASA/BS 400 colour negative materials give you more versatility in low light, but they do not produce as good images as the lower-speed films.

Because colour correction can be carried out when the prints are being made, colour balance is not such a serious problem with negative materials and only one type of material, which can be used in all types of illumination, is generally available. Professional films — both still and movie, though, are balanced for specific lighting conditions.

Make it work for you

All the top manufacturers produce top-quality products and it doesn't matter too much which one you choose provided it works well in the situation in which *you* work and it gives results that satisfy you. To make sure you get the very best results, it pays you to know the films you use thoroughly.

Apart from the odd occasions when you might wish to use an out-of-the-ordinary material, such as a high-speed recording film or a false-colour infra-red film, you will find that most of your work can be carried out using, at most, two colour films and two black-and-white films. In each case, your choice is likely to be one slowish film, for most general work, so that you can produce the sharpest, most brilliant results with the finest possible grain, and one high speed film for the more difficult shots where lighting is poor, fast action has to be stopped, and, let's face it, getting a picture is more important than getting a high-quality picture. Some photographers, though, standardise on a medium-high speed transparency film — ASA/BS 100–200 — because they prefer the more muted colours, and can accept the increased grain.

So, for a start, try a representative selection of materials. Choose then, the minimum number of films that will cover your circumstances, and get to know them inside out. Use only these films and don't be tempted to try anything new or different. Find out what their capabilities are and what they will do in given circumstances. Try underexposing them and over-exposing them (do this methodically, giving the correct exposure and then up to two stops under and three stops over in half-stop stages); then, at the end of a reasonably exhaustive test period, decide whether or not you are satisfied. The chances are that you will be but, if you are not, choose another film or group of films and go through the same routine again, wherever possible making tests which will allow you to com-

pare the new film with the previous one. This way you will eventually end up with the group of films which are right for you personally.

Your personal film speed

Once you get used to a film, you will know how it reacts in your equipment. We have already discussed the effects of processing on film speed, but there are other reasons for deviating from the figure on the film carton. These depend on your equipment and your preferences. Individual meters and camera controls vary. Added together, the variations (even in top quality equipment) can make up to a whole stop difference either way in your exposures. These differences though, are normally consistent throughout all normal photographing conditions.

Secondly, you may like, say, dense slides because you use a powerful projector and a small screen; or maybe you like thin negatives for quick printing. Your preferences can be a reason to depart from the ideal exposure, and your equipment may not give you that ideal when you think it does.

The answer is to alter your exposure meter setting. There is nothing magical about the figure on the box. It is what the manufacturers feel that the average user should set on his meter to give the best results. When you have tested a type of film in your equipment, you may choose a slightly different figure. That's fine. It is the sensible way to get the right exposures all the time. It is not likely to be very far from the maker's figure, though. Perhaps 50 or 64 for an 80 ASA/BS film.

Exposure Controls in Cameras

There's not much point in discussing exposure in any detail until we've looked at exposure-making equipment and decided what it is capable of. The man with the most expensive and versatile camera available today will be no better off than the man with a Brownie Box camera, if he doesn't know how to use it.

It may seem fairly obvious advice, but if you want to go further towards understanding exposure, the first thing you must do is understand your camera. Learn how to handle it, know what it does and how the exposure controls link up. If your camera has an exposure meter built in find out what type it is and how it operates. Read the instruction manual and practice operating the camera until it becomes second nature. Find out if there are any books available dealing with your particular camera. (The Focal Press publishes two distinct series of camera guides and comprehensive Camera Way books.) If there are, it is a certainty that they will be full of practical information and help — all gained the hard way — by experience. In the absence of specific information, look at general books, such as the Focalguide to Cameras.

Above all, use the camera. Load it with film and take pictures. Black-and-white film isn't expensive and you will learn a lot simply by logging the details of each exposure as you take the picture. You can then examine the negatives later, with a magnifier. It isn't necessary to have the negatives printed but, if you do, it will make it easier for you to analyse your camera technique. (Remember, though that image sharpness and exposure accuracy can only be checked by examining the negatives, errors can be introduced in printing.)

Cameras

It is most likely that the camera you own will fall into one of three categories: cartridge loading, 35 mm viewfinder or 35 mm SLR (single-lens reflex). These are not the only types of camera available,

of course, but they are certainly the most popular and they vary widely in price, image quality and flexibility.

Cartridge-loading cameras must take the prize for simplicity and ease of use and provided they are used strictly within their limitations, they are never likely to produce a really bad picture. The trouble is, for the serious photographer their limitations are severe, the most worrying one being the lack of choice in film stock. **Although many of the more expensive cameras are programmed to take a choice of film speeds, in actual fact, the materials are simply** not available and you are restricted to a small group of colour and black-and-white films mostly hovering around the ASA/BS 50-120 mark. This, of course, makes it impossible to choose a film which will exactly suit any special circumstances under which you are working. While on the subject of film, there is another problem which limits the picture making potential of these cameras and that is the size of the image. The useful image area provided by a 126 camera is no **more than $\frac{2}{3}$ that of a 35 mm camera and a 110 camera provides** negatives or slides which are only $\frac{1}{4}$ the size of their 35 mm counterpart. If any degree of enlargement is required, it does put something of a strain on the resolving power of both the film and the camera lens. Unfortunately, the more you enlarge a picture, the more you **enlarge its faults and even a speck of dust in the wrong place on a** 110 film can blot out a face.

Where cartridge-loading cameras really score, however, is in their simplicity. They are easy to load, easy to carry and easy to handle. The more sophisticated may have alternative lenses built in, and there is at least one zoom lensed SLR. Some have built in exposure meters which work automatically; simply point the camera at the subject and unless a low-light indicator appears in the viewfinder, you can take a picture and know that the exposure will be correct — within reason! Others rely on weather symbols. Provided they are **used intelligently (for average subjects), both systems work well.**

Cartridge-loading cameras are ideal for snapshot and record work but they are never likely to produce a really high-quality image. However, to make the very most of image quality, it will pay to ensure that exposures are as accurate as possible.

Cameras using 35 mm film cassettes range from the really inexpensive (don't buy ten gallons of petrol, buy a camera!) to the 'do you really want a holiday this year?' sort of price. However much (or little) you spend you are almost certainly going to buy better image

quality and greater versatility than you would get from a cartridge-loading camera. For a start, you have a larger image size and a much wider variety of films and film speeds to choose from. In addition, the film is held exactly in place, not by a plastics cartridge, but by the mechanical metal parts of the camera.

So-called 'compact' 35 mm cameras can range from the very simplest types, almost paralleling the cartridge-loading cameras, to sophisticated pieces of equipment offering coupled rangefinders and automatic exposure control. Whereas cartridge loading cameras tend to assume that you know nothing (and want to know nothing) about the basic mechanics of picture-taking, this is certainly not the case with 35 mm cameras. Although some of them also incorporate weather symbols to make exposure setting easier, all of them make use of shutter speeds and f numbers, giving the user a greater degree of control over the actual exposure making. They are light, quiet in operation and, in most cases, very easy to use.

Dominating the 35 mm market are the SLRs, the single-lens reflex cameras. Here, an enormous range of equipment is available, some at quite moderate prices. The big advantage of the SLR is that you can see through the viewfinder right up till the moment of exposure, the exact image you are going to record on your film and this is a tremendous help in composing and focusing the picture with a choice of lenses. The majority of these cameras form the basis of a complete system and a wide range of accessories such as bellows attachments, copying stands and the like are available, in some cases from independent manufacturers, to convert what may be a general-purpose camera into a very specialized instrument.

The majority of SLR cameras incorporate some sort of exposure meter. With a few of the cheaper models, this is simply a small exposure meter fitted at the top of the body of the camera. It is not linked to the camera controls; you simply take a reading (as you would with a separate meter) and transfer the indicated exposure setting to the camera.

Most, however, incorporate 'through the lens metering' (or TTL, for short). In these cameras, the meter is positioned so that readings are taken from the light which is passing through the camera lens. Depending on the method of operation, opening or closing the aperture or altering the shutter speed setting causes a needle visible in the viewfinder to indicate when the correct exposure has been set. This type of meter is a distinct advantage in a camera which permits

interchangeable lenses to be used, for the angle of acceptance of the meter will automatically change with the angle of view of the lens. In addition, filters, bellows attachments, extension tubes and other accessories can be fitted without giving you additional exposure calculation problems. Another advantage is that you can work more quickly because exposure controls can be set, in most cases, while you are still viewing the subject through the viewfinder.

The single-lens reflex camera does have its drawbacks, however. Without exception, all models are bigger (although smaller new models are appearing), heavier and noisier in action than their non-reflex counterparts. Whether these can be said to be serious disadvantages is another matter. If you want a versatile, generally easy-to-use camera which can form the basis of a complete photographic system, then you will, almost certainly, want an SLR.

From looking at cameras fairly generally, we are now going to examine rather more closely the parts of the camera (other than exposure metering equipment) which govern the quality and quantity of image-forming light which falls on the film.

The lens

You don't *need* a lens to form an image, a pinhole in one end of a cardboard box will form a recognisable image on a film held at the other end of the box. The trouble is although the image will be recognisable, it may not be very bright, nor will it be very sharp. The cheapest cameras make use of a single, meniscus lens (often made of plastic) to focus a reasonably bright, reasonably sharp image on to the film. Unfortunately, all lenses, particularly simple ones, show aberrations (or faults) which cause defects in the image. To a certain extent these can be cured by stopping down − covering the outer edge of the lens and making use of the central part only − but this also limits the amount of light which is able to get through and so longer exposures are necessary. A cartridge-loading camera of the least expensive type will have this sort of lens, which is why such cameras can only be used in fairly bright weather conditions.

To produce really sharp, bright, high-quality images, the lens manufacturer has to produce *compound* lenses. While no individual lens can ever be manufactured free from aberrations of one sort or another, lenses can be designed to work together as a single unit so that the aberrations of one cancel out the aberrations of another.

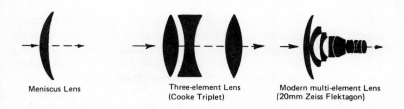

Meniscus Lens

Three-element Lens
(Cooke Triplet)

Modern multi-element Lens
(20mm Zeiss Flektagon)

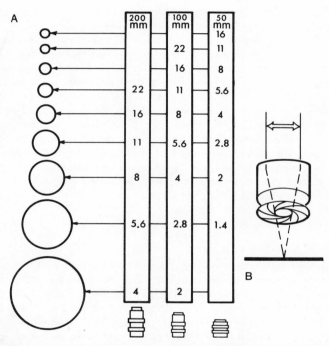

Lenses vary enormously in complexity; while simple cameras frequently use one of the front two designs shown above, a high-quality, precision lens may be computer-designed and contain many individual elements. A, The *f* number is dependent on the focal length of the lens. *f*11 on a 200mm lens and *f*5.6 on a 100mm lens for example, are the same in actual diameter. B, The effective aperture is the diameter of the light beam which actually passes through the diaphragm opening.

F.E.—B

COMMUNICATION LIBRARY, P.C.L., 18-22, RIDING HOUSE ST., W1P 7PD

Usually, the minimum number of elements in a standard compound lens is three. You will find this type of compound lens in the medium priced cartridge-loading cameras and the cheaper compact 35 mm models. Because it has fewer aberrations, this type of lens can be used at wider apertures than the single-element lens.

As you go higher up the scale, lenses tend to become more complex, and a high-quality compound lens can have ten or more separate elements (although a good standard lens is likely to have between four and seven). Much of the design is done by computer and a great deal of precision engineering goes into the production of each lens; consequently, they are fairly expensive items.

In order to improve light transmission and cut down reflections within the lens (which would otherwise degrade the image) the glass to air surfaces are coated with one or more extremely thin layers of magnesium fluoride, or similar substance. This coating produces the characteristic colour of the lens when viewed by reflected light. Although these coatings are extremely hard, they are also extremely thin and care should be taken not to damage them by over-enthusiastic cleaning. Lens elements, too, are often made of very soft glass and should be handled carefully. Keep dust caps in place unless the lens is actually being used, this way the need for cleaning will be kept to a minimum. If you do have to clean your lens, use a soft brush bought specially for the purpose and *kept* for that purpose.

Aperture

If you look at the lenses on two different cameras, say a high quality SLR and an inexpensive compact 35 mm camera, one of the first things you will notice is that the glass area of the lens fitted to the SLR is greater. It is designed to let through a lot more light than the lens of the cheaper camera. Look a little more closely at the inscription on the front of the lens (where it carries the manufacturers name) and on the SLR you might see '1.4/f=50' while on the other '2.8/f=50'. In both these cases the first number refers to the maximum light passing power of the lens and the second refers to the focal length in mm. (Focal length is the distance between a point within the lens, known as the rear nodal point, and the image plane when the lens is focused at infinity. It determines the *size* of the image; the greater the focal length, the larger the image will be).

34

While it is immediately obvious that both lenses have the same focal length, the light-passing abilities are more difficult to compare. The image brightness provided by a lens depends on two things: the diameter of the light beam passing through the lens; and the focal length of the lens.

The diameter of the light beam passing through the lens is controlled by the iris diaphragm — a circular (or nearly circular) hole, usually of variable diameter, positioned between the elements of the lens. If the diameter of this hole is divided into the focal length, the result is the f number. The maximum f-number for the SLR we quoted was 1.4 and for the compact camera was 2.8. You can work out the actual diameters, if you wish, as follows:

$$f_{no} = \frac{\text{diameter of iris}}{\text{focal length}} \qquad \therefore \quad \frac{\text{focal length}}{f_{no}} = \text{diameter of iris}$$

$$\text{diameter of iris of SLR} \quad \frac{50}{1.4} = 35.4\text{mm} \qquad \text{diameter of iris of compact} \quad \frac{50}{2.8} = 17.7\text{mm}$$

The *area* of the hole though, is what actually determines the amount of light passing through it and the *relative* area can be found quite simply by squaring the diameter. So, as 35.4 squared is 1253, and 17.7 squared is 313, we can see that the SLR lens passes four times the light that gets through the "compact" lens. It is, of course, easier to work with the f number: 1.4 squared is 2, and 2.8 squared is 8. Despite this, it might at first seem simpler to use the actual diameter of the iris diaphragm to determine whether one lens will pass more light than another. However, this would only work if all lenses were of the same focal length. The trouble is they are not; lenses can vary in focal length from a few millimetres to thousands of millimetres. So, of course, can the diameters of the iris diaphragms. What does *not* vary, however, is the ratio of these two measurements. All other things being equal, a lens with a focal length of 100 mm and an iris diameter of 50 mm will let through exactly the same amount of light as a lens of 200 mm focal length which has an iris of 100 mm diameter. Both will be $f2$ lenses.

Because you won't always want to work with the lens at its maximum aperture, the iris diaphragm is adjustable and can be closed down until it is quite a tiny hole. To enable you to calculate exposures, the ring on the lens mount which controls it will be marked

with a series of f numbers — on our SLR, these might be: f1.4, 2, 2.8, 4, 5.6, 8, 11, 16 and 22. As the numbers increase, so the size of the **aperture decreases, each larger number indicating a** *halving* **of the** amount of light reaching the film.

As well as controlling the quantity of light passing through the lens, the diaphragm also has some effect on the sharpness of the image. To produce a sharp image, all lenses have to be focused. Any object which is more than about 150 metres (500 ft) away is said by photographers to be at infinity (usually represented by the sign ∝). If a lens is focused on an object at infinity, the distance from the lens to the point at which the image is rendered sharply is the focal length of the lens (for a 35 mm camers, the focal length of the standard lens is about 50 mm). To focus on objects which are *closer* than infinity, the lens has to be moved further away from the image plane. Lenses which need to be focused are marked with a series of distances, or occasionally with symbols, which indicate at what point in front of the lens objects will record sharply.

When you focus an image sharply on the firm, there is an area in front of and behind the image plane in which objects will also be rendered acceptably sharply. This area of sharpness is called the depth of field and it tends to increase as the lens aperture decreases — **thus at** f8 **there will be noticeably more depth of field than at** f4. Depth of field also increases as the lens is focused on objects further away from the camera. The secret of the inexpensive camera which requires no focusing is simply depth of field. The lens which has a very small aperture, about f11 or f16 is pre-focused by the manufacturer to about 14 feet. Depth of field then ensures that everything from about 4 feet from the camera onwards will be recorded sharply. On slightly more complex fixed-focus cameras the minimum distance varies with aperture setting — so on 'bright sun', you can go as close as 1 m (4 ft), whereas on a dull day, 2 m (7 ft) or so may be the limit.

Shutters

The shutter on a camera is rather like a tap — you open it and light flows to the film, you close it and the flow of light ceases. When you make an exposure, you use the aperture and the shutter speed in conjunction with each other to regulate as exactly as possible the

36

amount of light reaching the film.

The simplest shutters will give one exposure time only — usually **about 1/60 second. They consist of a single thin metal blade** covering the lens aperture. When the shutter is released, a spring pushes the blade aside briefly to let light fall on the film. These are the sort of shutters which are fitted to the simplest cartridge-loading cameras. Slightly more sophistication gives you two speeds — cloudy and bright — say 1/40 and 1/80 second.

The more advanced cameras use shutters which are more complicated in construction (and becoming more complicated every day, it seems, as electronic timing and automatic exposure systems are developed). They fall into two basic categories: diaphragm shutters and focal-plane shutters.

Diaphragm shutters are usually fitted between the elements of a lens. They consist of a ring of five interleaving blades, pivoted at their outer edge. When the shutter is released, the blades spring open, rather like a diaphragm, and then close again completing the exposure. The power to open and close these blades is normally provided by a powerful driving spring which must be tensioned before exposure, either by a separate lever or by the action of winding on the film; in such cases a range of shutter speeds is **normally available, from about 1 second to 1/500 second on the most** complex. The required speed must be set before exposure. In some cameras that is done electronically. Although the driving power is still supplied by a spring, the timing is electronic — and often infinitely variable between, say, 5 seconds and 1/650 second, the shutter being opened and closed for precisely the correct period of time and by the automatic exposure-control system.

The diaphragm shutter is compact, reliable, quiet and reasonably efficient. However, because it takes a certain amount of time to physically open and close the blades, exposures shorter than 1/1000 second are not usually possible, and few examples exceed 1/500.

Focal-plane shutters Almost all 35 mm single-lens reflex cameras are now fitted with focal-plane shutters. There are two good reasons for this: first, an SLR lens has to be open all the time to enable an image to be seen through the viewfinder; at the same time the film has to be covered to prevent stray light from fogging it. A focal plane shutter does this perfectly. Secondly, most SLRs are designed to accept inter-changeable lenses. The cost of providing a diaphragm shutter (which is best positioned *between* the elements of a lens)

with every lens would push costs up unnecessarily.

The older type of focal-plane shutter consists of two blinds of fabric or metal. As the shutter is released, the first blind moves across the film, exposing it to light. The second blind follows after an interval (depending on the shutter speed set) covering the film again. With this type of shutter, the shutter-speed depends on the gap between the two blinds, which is variable; and on the time taken for the blinds to traverse the film, which is normally constant. While at slow shutter speeds (longer than about 1/30 second) the film will be exposed in its entirety, at high shutter speeds, it will be exposed piecemeal — a portion at a time.

Most modern designs of focal-plane shutter work on the same principal, but they make use of folding metal blinds which travel vertically down the film. With this type of shutter, the film is usually completely uncovered at speeds as short as 1/100 second.

For maximum efficiency, the focal plane shutter should work as close to the film plane as possible to prevent any light creeping around the edges of the slit during exposure.

While this type of shutter has important advantages (it makes possible extremely high shutter speeds without especially powerful springing, for example) it has its own problems. Electronic-flash synchronisation used to cause difficulty for instance — unless the flash is fired while the film is completely uncovered, only a portion of the image will record. This is because the short duration of the flash 'freezes' the movement of the slit. Another problem is that the acceleration and deceleration of the blinds can give rise to localized areas of under- or over-exposure — particularly at very short exposures. Distortion can also occur when moving objects are photographed. This is because the movement of the shutter causes one part of the image to be recorded before another. Last but not least, focal plane shutters are usually fairly noisy.

Shutter speeds

On modern shutters, the range of speeds has been standardized so that each faster setting will admit just about half as much light as the previous setting. A typical range of shutter speeds would read: 1, $\frac{1}{2}$, $\frac{1}{4}$, $\frac{1}{8}$, 1/15, 1/30, 1/60, 1/125, 1/250, 1/500, 1/1000. However, some cameras will permit longer exposures and some will permit

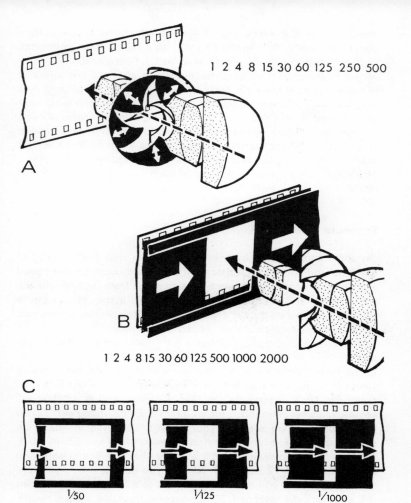

1 2 4 8 15 30 60 125 250 500

1 2 4 8 15 30 60 125 500 1000 2000

1/50 1/125 1/1000

A, A between-lens shutter allows the whole of the picture area to receive exposure instantaneously, top speed is usually in the region of 1/500 second. B, A focal plane shutter, situated immediately in front of the film, exposes the film a portion at a time – top speed can be anything up to 1/2000 second. C, Exposure time of a focal plane shutter is governed not by the time it takes to traverse the film but by the width of the 'slit' between the two blinds.

shorter. In all probability, shutter speeds will not be indicated fractionally on the shutter speed ring, but as a figure, thus setting the shutter speed dial to 60 would give you 1/60 second.

As we mentioned earlier, some electronic shutters are infinitely variable within their range, and exposures of 1/27 of a second or a 1/43 of a second are quite possible, although such speeds would not be indicated on the ring or on the digital viewfinder display. As you change the shutter speed from one setting to the next smaller (1/125 to 1/250 for example) so you reduce the time that the light reaches the film by one half. As the intensity control (lens diaphragm) also halves or doubles at each step, they are simple to relate.

Exposure values

On some cameras and exposure meters, you may find a series of numbers additional to, or instead of, the more usual shutter speed and aperture scale. These numbers may range from 0 to 18 and will link aperture and shutter speed so that when a specific number is set, a specific exposure will always be given irrespective of how you adjust the aperture or shutter speed individually.

That may sound complicated, but it isn't really. Let's look at an example.

In the table below are shown the more commonly-found exposure values together with the aperture – shutter speed combinations they represent. Now, supposing you take a meter reading and the exposure value recommended for your film is EV12. If you set '12' on the exposure value scale of your camera, you will, in effect, be setting an exposure of 1/250th of a second at f/4, 1/25 at f/5.6, 1/60 at f/8 or equivalent. Let's assume that the actual exposure which is set is 1/125 at f/5.6. Now, if you decide you need more depth of field and you move the aperture to f/11, the shutter speed will automatically reset to 1/30 of a second. If you decide you need a faster shutter speed and set 1/500 of a second, the aperture will automatically reset to f/2.8. The series of aperture/shutter speed combinations will only be broken if the exposure value is changed.

Do not confuse exposure values with light values. Light values represent actual light levels, not camera settings. They are, though, related. Light values are the exposure values for 100 ASA/BS film.

EXPOSURES AND EXPOSURE VALUES

Exposure Value		Shutter Speed (Seconds) at Aperture								
	f1.4	f2	f2.8	f4	f5.6	f8	f11	f16	f22	f36
−1	4	8	$\frac{1}{4}$m.	$\frac{1}{2}$m.	1m.	2m.	4m.	8m.	$\frac{1}{4}$h.	$\frac{1}{2}$h.
0	2	4	8	$\frac{1}{4}$m.	$\frac{1}{2}$m.	1m.	2m.	4m.	8m.	$\frac{1}{4}$h.
1	1	2	4	8	$\frac{1}{4}$m.	$\frac{1}{2}$m.	1m.	2m.	4m.	8m.
2	1/2	1	2	4	8	$\frac{1}{4}$m.	$\frac{1}{2}$m.	1m.	2m.	4m.
3	1/4	1/2	1	2	4	8	$\frac{1}{4}$m.	$\frac{1}{2}$m.	1m.	2m.
4	1/8	1/4	1/2	1	2	4	8	$\frac{1}{4}$m.	$\frac{1}{2}$m.	1m.
5	1/15	1/8	1/4	1/2	1	2	4	8	$\frac{1}{4}$m.	$\frac{1}{2}$m.
6	1/30	1/15	1/8	1/4	1/2	1	2	4	8	$\frac{1}{4}$m.
7	1/60	1/30	1/15	1/8	1/4	1/2	1	2	4	8
8	1/125	1/60	1/30	1/15	1/8	1/4	1/2	1	2	4
9	1/250	1/125	1/60	1/30	1/15	1/8	1/4	1/2	1	2
10	1/500	1/250	1/125	1/60	1/30	1/15	1/8	1/4	1/2	1
11		1/500	1/250	1/125	1/60	1/30	1/15	1/8	1/4	1/2
12			1/500	1/250	1/125	1/60	1/30	1/15	1/8	1/4
13				1/500	1/250	1/125	1/60	1/30	1/15	1/8
14					1/500	1/250	1/125	1/60	1/30	1/15
15						1/500	1/250	1/125	1/60	1/30
16							1/500	1/250	1/125	1/60
17								1/500	1/250	1/125
18									1/500	1/250
19										1/500

Subject and Lighting

Every picture has to have a subject. If it hasn't got a subject it doesn't mean anything — it doesn't express an idea, a feeling or an emotion. Pictures are a bit like sentences — they should say something and they should say it clearly; if a sentence hasn't got a subject, then it can't say anything, it can't, in fact, be a sentence. In the same way, if a picture hasn't got a subject, *it* can't say anything. It is important to identify the subject when you take a picture, not just from a pictorial point of view, but because your exposure calculations must be based on it. When you take a picture in black and white, what you are trying to do is record the different intensities of light reflected by the subject. These can range from the brightest highlights, where most of the incident light (the light striking the subject) is reflected back towards the camera, through the bright areas, the mid-tones and the dark areas until you get to the deepest shadows where the eye can just discern the faintest detail.

Contrast in the subject

Not all subjects have a long range of tones. Imagine a softly-lit group of old books sitting on a dusty, dark oak table. The range of tones here would be very short, recording from a medium grey to a dark grey.

Contrast too, would be low, with the difference in brightness between the lightest and the darkest tones being small. This would be an easy subject to record accurately even if exposure was not spot on. The longer the range of tones in the subject and the greater the contrast, the more accurate exposure needs to be. However, a film in a camera can only accomodate a certain range of tones and once the difference in brightness between the lightest and darkest parts of the subject exceed that which the film is capable of recording, then one exposure will not suffice. You can choose between recording the highlights and the mid-tones accurately and losing the shadows or recording the shadows accurately and losing tones in

the highlights. It's rather like having twelve buttons and only ten but-tonholes. Whichever end you start, two will be left over at the other.

Subject contrast can be altered by changing the lighting. The group of dictionaries lit softly — say by fluorescent lamps overhead and windows all round — will provide an entirely different subject from those same dictionaries lit from the rear three-quarter position by one spotlamp. Similarly, imagine your own high street, first on a dull, overcast day and then in brilliant sunshine.

Distance, too, can apparently change things. A landscape, even on a bright, sunny afternoon, can be a fairly low contrast subject with fields, sky and trees in the distance and a heat haze softening everything into broad masses of mid-tone; extremely dark areas and extremely bright areas are usually too small to bother about. Start moving in, however, and the subject matter begins to change from being the landscape, to becoming the copse of trees in the valley. At the same time, areas of brightness and shadow take on a greater significance. As they grow in size, they grow also in impor-tance and clarity. Finally, as you get close enough to make the sub-ject of just an old farmhand sitting on the fence in front of the trees with the sun highlighting his white hair against the blackness of the woods behind him, contrast reaches its maximum.

— and in the image

Imagine, now, you are photographing a car in full sunlight using black-and-white material. The brightest, most sparkling highlights will be the reflections of the sun in the chromium-plated bumpers and the headlamp glasses. These will be so brilliant that you won't see any detail in them. Next will come the bright areas which consist of bright colours strongly lit, or polished areas reflecting white clouds. The mid-tones will be medium colours brightly lit or light colours in semi-shade. Next will come the dark areas, such as the car interior, which are lit solely by reflected light, the brightly lit blacks of the car tyres, and the deep browns and blues. Finally, there are the heaviest shadow areas, inside the wheel arches which are hardly lit at all and show only the faintest detail.

When you photograph the car you are trying to do the impossible. You are trying to record all the tones which are there before you. The trouble is, the brightest highlights on the car may be 10,000 times

brighter than the deepest shadow. You can not see detail in the highlights or shadows when you look at the car and your film has much less tolerance than you have. Even 1000:1 is well beyond its capabilities. The moment the rays of light pass through the camera lens the brilliance of the image starts to deteriorate. Light scatter within the lens, the camera and the emulsion reduces the image contrast considerably. The negative itself will show a reduction in the brightness range due to a certain amount of base fog which is an unavoidable result of the process. At this point, the difference between the maximum density (which is really the brightest highlight) and the most transparent part of the negative (the deepest shadow) will have been reduced to something like 300:1. When the image is finally produced on bromide paper, we are down to the almost incredibly low level of about 60:1 for a really high-quality, highly glazed print.

There is nothing anyone can do about this compression of the tonal range, it is simply due to the limitations of the process. What you must do, however, is fight every inch of the way to ensure that you retain in the final print the maximum range of tones of which the process is capable. The first and most important round of this fight will be won if you can succeed in producing a first-class negative — one which is perfectly exposed and developed. Development should not be a problem. Development is a standardized technique which we can occasionally modify, within limits, to adjust the contrast range of the negative. Exposure, however, is another matter. Exposure is something intangible which makes demands on your experience, your judgement and your skill.

Going back to the motor car, this is a subject which has an extremely long tonal range. To hold as much of this tonal range as possible, you need to use a low contrast film and be extremely accurate with exposure control. Too little exposure and there will be no detail even in the moderately shaded areas — it will not have time to record on the film — too much exposure and the light areas become filled in. **Detail at this end of the tone range will be lost in the clumped** blackness of the silver grains. You start from the knowledge that there will never be any detail in the brilliant highlights, or the **deepest shadows. So you compose the picture with these as accents. Then ensure that the detail which** *can* **be recorded** *is* **recorded.**

Now, look at another, rather different type of subject. A portrait of a

girl with dark blonde hair wearing an orange blouse. The sun is behind a cloud and the background is a dark grey stone wall. Here, there is no massive range of tones, no brilliant highlights which are too glaring to look at, no deep black shadows in which the detail is almost lost in the gloom. In a subject such as this, the range of tones is probably no greater than about 100 : 1. No difficulty in retaining this tone range — in fact any one of a wide range of exposures would probably produce an extremely good result.

Here, you might say that there are only seven buttons to fit into those ten buttonholes. You have four ways of doing it, any one of which would work. There is still only one *correct* exposure, though, and that is the minimum exposure which can be given which will record detail in all the areas of the subject where we want detail to be recorded (fastening the buttons so that the coat hangs as well as possible). This is the exposure which takes maximum advantage of the emulsion speed of the film. Less exposure than this is *under-*exposure and causes shadow detail to be lost; more exposure causes definition to deteriorate, makes printing more difficult than it need be and is simply unnecessary.

Change the lighting

Often, where you have a subject such as the car in bright sunlight — you have to help the materials out a little by reducing the tonal range before taking. One way of doing this is to reflect light into the heavy shadow areas to lighten them a little; another is to use a flash to do the same job. It has to be a weak flash, though, or the picture will look a little odd — as though the car were being illuminated by two suns (more about this technique on page 111).

Using colour in this sort of situation requires rather more care. A typical medium-speed colour reversal film is far more contrasty than the average black-and-white emulsion and will not accommodate such a long range of tones. Where a particularly contrasty subject occurs, with heavy, black shadows and really bright highlights, the only answer is to put some light into the shadows — again using a *white* reflector, blue (daylight balanced) flashbulbs or electronic flash.

The same is true of colour-negative films. When in doubt, it is always

best to err on the side of softness of lighting with colour materials and let the colours themselves provide the brilliance and contrast.

Texture

Lots of things appeal to us because of their texture — the silky richness of a cat's fur; the rough, brittle hardness of a tree-trunk; the slithering smoothness of satin. Think about sunlight glancing across the crisp granularity of snow and then think about the warm, yielding softness of soot.

When you take a picture, you have to use every trick possible to get over to the viewer the reality of the subject. One way to do this is to make sure that the characteristic texture of the subject is retained or even, depending on the picture required, emphasised. Lighting plays a vital part and the controlled, careful use of lighting can enhance texture where you didn't know texture even existed. Have you ever taken a winter shot where the snow recorded as a white anonymous substance which could have been cotton wool, icing sugar or even flour, purely because the characteristic texture was missing? Next time there is snow on the ground take a shot when the sun is to one side and in front of you, when the light is glancing across the surface and, bringing out the crunchy, granular texture — making it *look* like snow. Get the exposure right, though. If in doubt, slight under exposure will produce a better result here than slight over exposure.

To really bring out the texture of a subject you need strongly directional lighting — the best lighting position is between 90 and 180° to the camera axis and at an angle of 45° or lower. Naturally, to make things more interesting, this is just about the most difficult form of lighting to expose correctly, for here you have strongly lit highlights sitting beside deep-black shadows — and a brightness range of perhaps 10,000:1. You simply can't record everything on your negative; in this case you have to make a choice — do you expose for the shadows and let the more brightly lit areas suffer? Do you expose for the highlights, losing all the detail in the shadows? Do you make an unsatisfactory compromise, exposing for the mid-tones and losing detail at the two extremeties? Or, do you modify the contrast range by using a reflector or fill-in flash. This latter course of action is undoubtedly the best, but it doesn't necessarily help you if you are out on a freezing winter's day with no white card or

46

A, A correctly exposed negative should show a full range of tones between the brightest highlight (1) which will appear black in the negative — to the deepest shadow (2) which will be clear film. A very contrasty emulsion would compress this tone range considerably. B, Under exposure and over exposure cause the tonal range to become distorted and while in each case the mid-tones may record adequately, the highlights and shadows will record badly. C, Where a subject contains only a few mid-tones and no extremes of light and shadow, exposure can vary from the optimum without ill effect. For example, a subject containing five tones could fall into either of the two positions shown and, in each case, each would still bear the same relationship to its neighbours, one set differing from the other only in density.

flashgun. Even if you had them, they wouldn't reach very far anyway. Of course, you do have the natural reflective properties of any snow that happens to be around!

Colour

Colour is another characteristic which most things possess and it can vary according to the type of illumination being used. When you use black-and-white films you have to translate colours into terms of grey and as we have already seen, photographic materials don't record things exactly the same way that we think of them. Blue skies, for instance. We see all blues, even pale ones, as medium to dark tones and a midsummer blue sky can look very dark.

The film doesn't see them this way, though. It sees blue as very bright indeed and on a photographic print it will appear a very pale grey. Over-expose slightly and the blue sky will become white on the print. Should you *under*-expose, however, the opposite will happen. Less light from the sky will fall on to the film and it will appear as a darker grey. The trouble is, everything else will be under-exposed, and appear darker. What you really need to do is expose selectively so that although the non-blue areas are exposed correctly, the blue areas receive less exposure. You can do this quite easily by fitting a yellow filter over the camera lens. Because yellow is complementary (or opposite) to blue, a yellow filter acts as a sort of barrier to blue light; the effect in the finished print will be that all the blue areas will appear much darker than they otherwise would (see page 118).

Colour films

With colour materials, exposure is extremely critical if the best possible reproduction is to be achieved. — particularly for transparencies where there is no separate printing stage in which faults can be ironed out. Not only is the exposure critical, it must also fall within a certain range if the colours are to be reproduced as accurately as possible. Normally, average times of exposure will vary between, perhaps, 1/30 second and 1/500 second and only in special circumstances will they fall outside this bracket. However, all colour films have a specified optimum exposure range and beyond the limits of

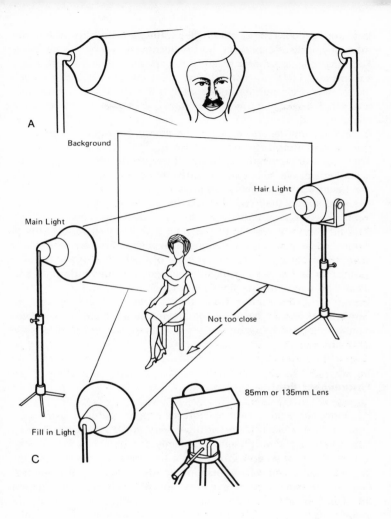

A, In portraiture, two 'main' lights can produce the unpleasant effect of a double nose shadow. B, Typical artificial 'classical' lighting set up for portraiture. Of course, you should set your lights each time to produce the effect you want.

this range colour reproduction will be affected — subtly, at first, but more obviously as exposures start to become very long or very short. For most colour films, a reasonable exposure range is between 1 second and 1/1000 second. If you are making exposures of much longer or shorter duration than that, it is likely that you will be more interested in obtaining a *record* rather than particularly accurate colour reproduction.

Reciprocity law failure, which is the correct term for this effect, is discussed in more detail on page 154.

The source of illumination is also critical where colour reproduction is concerned. We have already stated that colour reversal emulsions are balanced for particular sources of illumination and you must ensure that only that type of illumination is used to light the subject. Special conversion filters can be used over the lens to enable daylight film to be used in tungsten lighting and vice versa but both types involve a significant increase in exposure. For best results you should use the right film for the type of lighting in use (electronic flash units and blue flashbulbs are designed to match daylight and should be used with daylight type films).

Even more peculiar effects will appear if two different types of illumination (such as daylight and tungsten lighting) are used in combination. Part of the picture will look right while the remainder will look either too yellow or too blue.

Fluorescent light

Problems can also arise if a fluorescent light source is used to illuminate the subject. Different tubes vary in the colour of the light they give out and what seems perfectly acceptable to the eye can look really weird when captured on a transparency. No colour films are designed specifically for use in fluorescent lighting and the best course is to make tests to see what sort of results you get. Quite a lot of fluorescent tubes tend to give a greenish image and a pale magenta filter over the camera lens will help counteract this. However, even this may not produce a terribly natural result.

Another problem with fluorescent tubes is that they pulse at the rate of 25 times a second (if you look at one out of the corner of your eye, you may see this). If you use an exposure which is shorter than 1/25 second, you may, with a diaphragm shutter miss some of the

illumination and produce an under-exposed picture. With a focal plane shutter, you can get bands of varying density across the film. Colour casts can also be produced by reflected light. Imagine somebody standing close to the camera and just outside the picture area there is a brightly coloured wall or similar large area. Coloured light from the wall will be reflected on to the subject giving rise to a peculiar, unexplained colour cast. The same thing can happen in portraits, where the model is wearing a strongly coloured blouse or jersey. In this case, the area under the chin will show the colour cast. Where the cause of the cast appears in the picture, the result does not appear too unnatural, though it may not be very pleasant. Where it does not appear in the picture, the effect is most odd.

Exposure Meters . . . and Things

Before we travel too far along our route towards the correct exposure, it might be a good idea to question just how accurate the correct exposure must be.

Looking at films first, we found that the slower the material, the less tolerance it has to over- or under-exposure. A fast panchromatic film is less contrasty and therefore, provided contrast in the scene is not excessive, it is less likely to become blocked up in the highlights due to a stop or two over-exposure. Colour negative films are less demanding than colour reversal films which *must* be accurately exposed (if we want really good results) to within, at most, half a stop either way.

As far as subjects are concerned, contrast is again the deciding factor. Unless the brightness range is reduced by lightening the shadows with a reflector or flash, the more contrasty the subject the more accurate the exposure needs to be. Where there is only a limited range of tones in the subject — as, say, would occur on a misty morning, critically accurate exposure is not essential. (See also page 116).

Equipment is a factor which also has to be taken into consideration. How accurate is your shutter? How accurate is your aperture scale? How accurate is your exposure meter? Do you, in fact, use an exposure meter? If you want your exposures to be really accurate, you have to be sure your equipment is capable of fulfilling the demands you are placing on it. You can't expect an inexpensive camera — such as a cartridge-loading model, with weather symbols instead of shutter speeds or *f*-stops to give you the sort of accuracy you would expect from a top-line SLR. They just cannot be in the same league. If you have any reason to doubt your equipment — and shutters *can* become unreliable and exposure meters *can* go on the blink — then get it tested. Go to a good, specialist, equipment service shop, or perhaps even the manufacturers, have it tested and serviced and then you will know exactly where you stand.

One final point concerns the use that the finished picture is going to be put to. If a picture is required for reproduction in a high-quality

magazine, or if it is being taken for submission to a judging panel (as in the case of an exhibition, perhaps) then quality should be the highest it is possible to achieve. In a case like this, when you are taking the picture, make a series of exposures at half-stop intervals from what you assumed to be 1 stop under- to 1 stop over-exposure. This way, you are as certain as you ever can be of hitting the correct exposure.

At the other end of the scale, however, a photograph may simply be needed to show somebody where one building is in relation to another, or how much litter is left lying around in the High Street after a busy shopping day. In these circumstances, photographic quality is not the most important requirement of the pictures. All that is required is that they do the job they are asked to do, efficiently and without frills. Nevertheless, just because high quality is not of primary importance, that shouldn't be the signal for you to take the easy way out. It should be a mark of your ability that you try to produce the best result *whatever* the requirement.

Exposure tables and weather symbols

Supposing we assume that you haven't got the most expensive and accurate photographic equipment available (perhaps a low priced compact 35 mm camera or an SLR without metering equipment), that you normally use a medium-to-high-speed film, that you take pictures of fairly average subjects and that you *don't* normally demand the highest quality. How, then, do you go about working out your exposures. Obviously, you won't need to worry too much about being pedantically spot on, but you will want to be within striking distance of accuracy to ensure the results you get are reasonably good.

Well, let's start with the exposure table you find packed with the film.

This chart is designed to be used for simple picture-taking in conjunction with the film it was packed with; practically speaking, it will work equally well with any film of the same emulsion speed. In operation, it is perfectly straightforward, giving a list of average subjects and weather conditions and a corresponding list of exposures which suit the conditions mentioned. Provided that the conditions really are average, with no fancy lighting techniques in use, then you

really can't go far wrong; but once you start taking more imaginative pictures then exposure tables tend to become less reliable.

You can buy exposure calculators which range from the very simple (giving little more information than the tables mentioned above) to the very complex (taking into account speed of film, seasons, time-of-day etc.). Although they can be very helpful, they are at best only typical examples of average exposures under standardized conditions.

Weather symbols

Some of the cheaper compact cameras and most of the cartridge loading types use weather symbols instead of shutter speeds and apertures. Using these is simply a matter of looking at your subject and the weather and setting the exposure on the dial. Once again, provided everything is straightforward you are not likely to go far wrong. The symbols in fact, correlate to specific apertures and shutter speeds and the pattern followed is usually:

Bright sun on light sand or snow	— 1/80 sec f22
Bright sun (distinct shadows)	— 1/80 sec f16
Weak, hazy sun (soft shadows)	— 1/80 sec f11
Cloudy bright (no shadows)	— 1/80 sec f8
Cloudy dull or open shade	— 1/40 sec f8

It is worth remembering the actual shutter speeds and apertures (though the relationship of shutter speed to aperture may vary slightly with individual cameras, the actual exposure should be the same) because knowing them can help you work out exposures for situations which are not catered for by the symbols. Knowing the exposure settings enables you to make use of an exposure calculator or a meter in situations which may bear no relation to those indicated by the symbols.

Guesswork and rule-of-thumb

In most cases it just doesn't pay to make guesses about exposure — all too often you end up with a near miss which, if anything, is more disappointing than abject failure. A colour transparency which is 1

stop under-exposed is usually fit only for the waste bin.

There are occasions, however, when you just *have* to make a guess rather than lose a picture completely. Situations do arise when you barely have time even to set the camera controls, let alone start working out the subject conditions listed in a table. A lot depends on the type of film you have loaded in your camera, of course, but there is no reason why, in case the unexpected does occur, you shouldn't have your camera set to a reasonably average exposure, bearing in mind the weather conditions. For instance, assuming you have your camera loaded with colour-negative material (ASA/BS 100), the sun is bright (throwing hard shadows) and it is early summer, then why not take a leaf out of the weather-symbol camera book and set your exposure to 1/60 sec at *f*16. You can then put the camera away and forget about it until it is needed. If you are faced with a surprise situation you can shoot, happy in the knowledge that you are likely to obtain a reasonable picture. For differing conditions, of course you can set different combinations.

As well as setting aperture and shutter speed in this way, set the focusing ring to about 12–15 feet. By doing this you will be sure that everything from about 5 feet to infinity will be reasonably sharp in the picture.

Of course, you don't *have* to use your camera in this way, once it is set. It is simply a matter of convenience. If you have time to check the exposure correctly and set the focus accurately then, of course, you should do this.

Meters can fail, batteries can go flat, and so on. If you have no other aid, follow the old rule of thumb: 1/ASA speed at *f*16 in bright sun, or *f*8 if it is dull. (*f*4 if it is really dull.) That should give you printable negatives in most outdoor shots. Thus with an ASA/BS 25 speed film, set 1/30 (the nearest speed) at *f*16 – or 1/125 at *f*8, 1/500 at *f*4 or any other equivalent combination.

Exposure meters

Although tables, calculators and rule-of-thumb methods are fine where high quality is not the prime consideration, if you have precision equipment which is capable of extreme accuracy, then obviously you want to make the most of it. By far the best method of arriving at the correct exposure is by actually measuring the amount

of light which is being used to make the exposure. To do this you need an exposure meter.

The most commonly used exposure meters fall into two categories. The original photo-electric type in which a photo-generating cell produces a voltage when light falls on it. This type of meter produces its own current and doesn't need a separate battery to operate it. The second type consists of a tiny light-sensitive cell which varies its electrical resistance according to the level of illumination it receives. This type of meter *does* need a battery to power it and is often incorporated into the camera.

The selenium cell meter

This is the original tried-and-trusted type of exposure meter designed to measure the amount of light reflected from the subject. Although it is still sometimes built in to the cheaper types of camera, it is at its best and most useful when it is a separate unit. It consists of a flat cell containing selenium which is sandwiched between two electrically-conductive layers, the top one being transparent. Illumination reaches this cell through a window in the meter housing and causes an electric current to be generated. Although extremely weak, this current will register on a micro-ammeter from which a reading can be taken and transferred to a calculator dial. The exposure can then be read off from this dial.

One problem with the selenium cell exposure meter is that under low levels of illumination it tends to be limited in accuracy owing to the very weak current it produces. This can be off-set to a certain extent by dividing the meter action into high and low readings using a baffle fitted over the meter window. When the bafffle is in position (in reasonably bright lighting conditions) a high-reading scale is used. In poor light, the baffle is moved away and a second 'low-reading' scale with wider divisions is moved into position.

It is worth noting that the angle of acceptance of most exposure meters of this type is about the same, or very slightly wider, than that of a standard lens. While this is not too important when using standard or wide-angle lenses, it can cause problems with long-focus or telephoto lenses owing to their narrower angle of view.

Many selenium cell meters are also designed so that they can be used in another way. Instead of measuring the amount of light

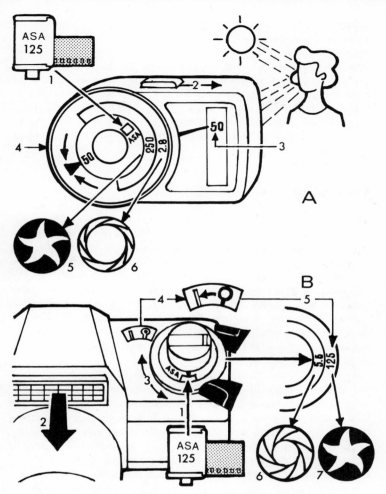

A, Using a separate exposure meter. 1, Set film speed. 2, Switch on meter (not necessary on some meters) and point meter window at subject. 3, Take reading. 4, Transfer reading to metal scale. 5 and 6, Read off exposure time against aperture setting. B, Using a built-in (non TTL) meter. 1, Set film speed. 2, Point meter windows to subject. 3 and 4, Adjust control to align pointers. 5, Read off exposure. 6 and 7, Set aperture and shutter speed.

reflected *from* a scene, by fitting a special opal window over the meter window, they can be used to measure the amount of light falling *on* the scene. A reading taken this way (from the subject position) is called an incident light reading. The opal window serves two purposes: first, it gathers all the light falling on those parts of the subject that face the camera and, second, it blends it into a uniformly bright beam of light which passes to the sensitive photocell. From this point on, the system is the same; a reading is taken from the meter scale and transferred to the calculator to enable the exposure to be read off.

The CdS cell meter

Unlike the selenium cell, the CdS cell (CdS stands for cadmium sulphide) does not produce current; instead it does rather the opposite and when light strikes it, it varies its resistance according to the brightness of the light – the brighter the light the weaker the resistance. Because of this, it needs a battery to power it. The battery used, however, is quite tiny – usually no bigger than a suit button – and it lasts quite a long time. There is often a switch between the battery and the cell to enable the meter to be switched off when not in use.

Although a CdS meter is more expensive than the selenium type, it does have two big advantages –

Firstly, it is up to a hundred times more sensitive to light. Whereas the selenium cell can only be used where there is a reasonable amount of illumination, CdS cells are available which can be used to take readings in moonlight – although in very low light situations they do take rather a long time to react: sometimes minutes!

Secondly, being so sensitive, only a very tiny cell is necessary in order to measure light accurately. Because of this, CdS meters can be built into the camera so that they read the light coming through the camera lens.

They have two problems. The first is the slow response, or 'memory'. A CdS cell can be put out of action for several minutes, or even hours by being exposed to a really bright light. Secondly, it is oversensitive to red light. Thus, meters calibrated for daylight (as they all are) tend to overestimate the level of artificial light. In fact, you may well find that you need to set a film speed about two thirds

slower than normal for tungsten lighting — say 64ASA instead of 100ASA. Once again, it is a matter for trial and test.

Other light-sensitive cells

Although selenium and cadmium sulphide are by far the most commonly-used light-sensitive cells in exposure meters, new types are continually being developed and tested. The ones which you are most likely to meet up with (at least, at the time of writing) are silicon blue cells. These are gradually replacing the cadmium sulphide type, partly because they react much more quickly in poor lighting conditions and partly because their spectral sensitivity is **considerably improved (by the blue filter) so it is closer to that of** the film emulsion. At least one camera is now using Ga As P (gallium arsenide phosphorus) cells. Although, the most common use for this material is in digital read-out systems, it is now also being used in exposure meters. It is more sensitive to light and has better spectral sensitivity than silicon cells without the need for a blue filter.
Both these substances generate current (like selenium). However, they generate far too little to register on a meter. So they are used in conjunction with a tiny IC amplifier. This needs a source of power. So cameras and meters with these cells need batteries.

Separate or built-in?

Exposure meters are available in two forms — either built in to the camera or as individual units. Both types have their own particular advantages and disadvantages.
The individual unit is light, compact and, usually, very robust. Because it does not have to be fitted into the camera, it can be made to a reasonable size — which means that it can use selenium as its light-sensitive cell (although individual CdS meters are available). Now, although selenium lacks the sensitivity that cadimium sulphide has, it does have the advantage that it produces its own electric current — so doing away with the need for a battery. Also, because of its larger size, the calculator portion can be used to provide a lot more information than the simple index and pointer of the typical through-the-lens meter.

For indoor work where several light sources may need to be balanced, the individual meter can come into its own. It is far easier to take readings from the lamp positions or from various parts of the subject with this sort of meter than it is to try to perform the calculations while peering through the viewfinder of the camera. It is also usually very easy to convert a selenium-cell meter to take incident light readings.

Built-in meters fall into two categories. Those which are simply an individual type of meter which has been incorporated into the camera and those which measure the light passing through the lens from a specific part of the subject.

The first type can be useful in a fairly limited way – at least, when you have the camera with you, you can be sure you haven't forgotten the meter – but, generally, they are more clumsy to use because although you use them in the same way that you do an individual meter, instead of a compact easily-handled instrument, you have a whole camera to wave about. The light from the subject is received by a window in the front of the camera, perhaps a large one around the lens barrel or a smaller one somewhere near the viewfinder lens, and the reading is taken through another window on the top of the camera.

Normally, what is termed a 'following needle' is employed to indicate the correct exposure setting. That is, one needle is linked to the film speed and shutter speed scales of the camera (or the meter, if the camera is non-automatic) and this needle will fluctuate according to the amount of light falling on the receptor window. It can also be moved physically by altering the setting of either the aperture or shutter speed scales. A second needle is linked to the aperture scale and this only moves when the photographer moves the aperture scale itself. When the two needles are made to coincide, the correct exposure is indicated.

A more convenient version of this meter shows both needles in the viewfinder, so making for a much speedier operation.

Through-the-lens meters

Through the lens (or TTL, to give it its more common abbreviation) metering is nearly the sole preserve of the single-lens reflex camera. This is primarily because it is only in the SLR that the necessary

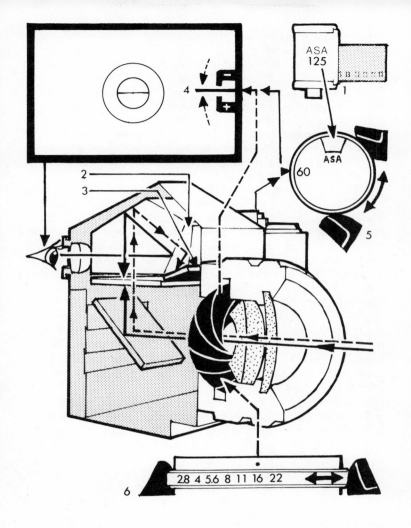

Using a TTL meter. 1, Set film speed. 2, Part of light picked up by pentaprism is deflected by beam splitter and 3, 4, strikes photo resistor. 4, Variations in current from meter battery cause needle to move with light intensity. 5, Adjust shutter speed to bring needle to indicated position for correct exposure. 6, Alternatively, adjust aperture setting for same purpose.

reflective areas (mirror and pentaprism) can be found to enable some of the light passing through the camera lens to be deflected to the light-sensitive cell located in the camera body. The one range-finder camera with TTL metering has to move the light gatherer out of the way, just as an SLR moves its mirror. Because this type of meter has to be as compact as possible (there isn't a great deal of space to spare within the camera) only the smaller types of cell, such as cadmium sulphide, silicon blue, or Ga As P can be used. This, of course, necessitates the use of a battery. To maintain peak efficiency for as long as possible, therefore, a switch is often included to enable the meter to be turned off when it is not in use.

To make camera operation simpler and quicker, the TTL meter is nearly always linked to the exposure controls of the camera. On some cameras, moving the film-speed setting dial, the shutter speed ring or the aperture ring will cause a needle, visible in the viewfinder window, to line up with an index mark when the correct exposure is set. Sometimes more information is available. In many cameras the actual shutter speed and aperture which have been set are shown and there may be index marks indicating one stop under- or one stop over-exposure.

It is becoming more and more common for manufacturers to make use of light-emitting diodes to convey exposure information through the viewfinder. This can vary from the low light warning which appears in the viewfinder of some simple cameras when under-exposure is imminent, to the full digital read-out, giving the aperture and shutter speed set.

With some fully automatic cameras, once the aperture is set, the shutter speed will automatically lengthen or shorten according to the amount of light falling on the meter. With others, it is the aperture which is continuously adjusted to compensate for the shutter speed chosen.

One advantage that TTL meters have over all others is that no matter what lens is in use or what accessory is being used over the lens, because they measure *only* the light passing through the lens, they are always capable of indicating the correct exposure − provided they are used correctly. This, of course, means that no calculations are necessary when bellows, extension tubes or filters are being used.

Through-the-lens meters follow a variety of patterns. Depending on the type of camera you have, the meter may be an 'integrating' type,

Exposure is calculated on a photometer (A and B) by matching the brightness of a spot in the centre of the viewing area to that of a particular area of the subject. (C, A spot meter. D, A photometer.)

which measures the overall light coming from the subject, it may be a 'spot' type, which takes its measurement only from a very small area at the centre of the subject or it may be in between, giving a reading from the whole of the subject, but weighted in favour of the centre or some other area. Each type is satisfactory provided it is used properly, but the latter is most common and probably best for all round use. The spot type, however, can be capable of much more accurate results in skilled hands.

Although spot meters are usually incorporated in SLR cameras, there are also a few individual models available. Compared with the more common type of individual meter which will fit neatly in the palm of the hand, the self-contained spot-meter is large and rather cumbersome resembling, in some cases, a single-lens reflex camera or even a small movie camera. Spot-meters of this type are expensive and not very quick to use.

On the credit side, the CdS spot-meter is capable of producing extremely accurate results provided you are capable of interpreting them correctly. Most models have an extremely narrow angle of acceptance — from around 10° to 1° — and so can be used to measure the light being reflected from very small areas of the subject even when you are a long distance away. The most important function of the spot-meter however, is in measuring the relative brightness of different areas of the scene. Used in this way, it can tell you if the contrast range of a particular subject is going to fall within the range of the material you are using.

For the amateur photographer — even the exceptionally keen one — this type of meter is not a worthwhile proposition. It would rarely be used to measure anything other than usual mid-tone and the conventional reflected-light meter is capable of giving results which are just as accurate, provided it is carefully handled.

Photometers

Up to now we have dealt only with the more common types of exposure meter. There is, however, one more which differs from all the others in that it is complex in design, slow to use, bulky, expensive, delicate but — in the right hands — extremely accurate. That is the photometer.

The photometer works by means of comparison. It looks something

When the weather is dull, you get nice soft lighting, but the exposure can be a problem. With still subjects, choose a reasonably long shutter speed to give you a small enough lens aperture, but beware of movement in the subject or camera – *Curzon Studios*.

With a bright background, your exposure meter may indicate too little exposure. Go in close to your main subject to take your reading. Note how the fast shutter speed has nearly frozen the movement of the water – *Curzon Studios*.

Opposite: A moving subject is often better shown as a blur, than as a static abstract. Here combination of a long shutter speed and panning the camera really combine to show the runner moving – *Colour Library International*.

Clouds and skies produce their own exposure problems. Meter from the sky; and, if anything, under-expose a little to increase the effect. Better still, take a series of shots at different exposures — *David Lynch*.

Evening light can add dramatic colour to your pictures. Exposure is again a major factor in producing the right results – *Curzon Studios*.

COMMUNICATION LIBRARY, P.C.L.,
18-22, RIDING HOUSE ST., W1P 7PD

Even with quite a small lens aperture, you get strong differential focus close up. This sort of picture is difficult to take with a simple camera, but not impossible just with a close-up lens. Screen-focusing cameras, though, make exact composition much easier — *Curzon Studios*.

Opposite: When you have the sun in your picture, be sure that you don't let it over-influence the exposure. Take a reading of the scene without the sun, and use those settings — *Geoff Marion*.

Two flashguns give a simple lighting set-up. The brightest one should be away from the camera, perhaps somewhere above the subject. Then you can soften the shadows with a light on or near the camera, producing about a quarter of the light. A computer gun set for two stops larger aperture than the main light is a simple way of achieving this – *M. O'Neill.*

like a small periscope and the subject is viewed through an eyepiece in which appears a small, bright spot. The brightness of this spot is varied by rotating the outer shell of the meter until the spot matches the subject in brightness. The recommended exposure is then read from the meter housing.

Photometers have extremely narrow angles of view – perhaps 2–3° only. This allows extremely accurate matching of small, key subject areas even from quite a distance. They also have a very wide range of sensitivity which makes them particularly useful where conditions are extreme – very bright or very dark. However, their particular inconveniences tend to make them less useful to the amateur than those types previously discussed.

Using an Exposure Meter

To measure exposure correctly, you must know what you are doing. Used incorrectly, the world's finest and most accurately engineered exposure meter is just as capable of giving the wrong answer as the calculator that was given free with one of last year's magazines. Exposure meters are just like computers, before they will work correctly, they have to be fed the right information. A computer can work things out quickly, but it can't think for itself; neither can an exposure meter. Point it at the subject, feed it the right information and it gives you the right exposure. It can save you time, trouble, worry and money — but it can't think.

Only *you* can do that.

The first step is to set the meter to the speed of the film you are using. We said a little about film speed in the Film chapter. If you have no reason to do otherwise, use the film speed marked on the box.

Reflected light readings

The first thing you have to understand about exposure meters is that they can't see. If you point a meter at a white object, it can't see that it's white. If you point it at a black object, it can't see that it's black. All an exposure meter can do is measure how much light is being reflected from something and then tell you how much exposure you need to give in order to reproduce that something in a certain way.

In case that sounds rather like double-dutch, let's look at it another way. The majority of exposure meters are designed with the average subject in mind, and the average subject is made up of light tones, dark tones and all those in between. If you were to mix up (integrate) all the tones of an ordinary subject, you would end up with a mid grey. An exposure meter is programmed to work on this basis. Whatever you point an exposure meter at, it will always 'assume' that it is a medium tone.

If you point an exposure meter at a *black* object, it will give you the exposure for a medium-tone object which is not very brightly lit. That

74

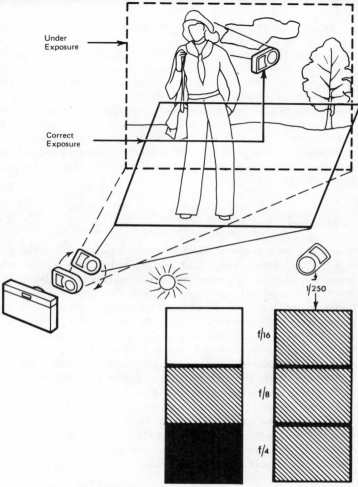

Outdoor pictures, where the sky occupies a large proportion of the picture area, can present exposure problems. To avoid under-exposure, tilt the meter down slightly or go in close to the main subject. Exposure meters are designed to take readings from mid-tones. Take a reading from a light area and the exposure recommended will produce a mid-tone. Take a reading from a dark area and the result will still be a mid-tone. Moral: For correct exposure, always take exposure readings from mid-tones.

75

is, enough to record the black object as a medium-tone; in other words, it will indicate over-exposure. If you point the meter at a *white* object, conversely, the exposure it will indicate will then be one which is too little. Follow it, and the white will be under-exposed and thus record as a medium tone, to all intents and purposes the same as the black one.

Reflected-light exposure meters, then, are ideal when they are used in conjunction with average subjects and you need to bear this in mind whenever you take a meter reading. Should there be any imbalance either to light or dark in the scene you are photographing, then the exposure suggested by the meter will be incorrect for your purposes.

Landscapes

Supposing, for example, you intend to take a picture of a landscape. It has trees, fields, houses and sky. Apart from the area of sky, everything else in your picture is going to average out perfectly as a mid-tone. The problem comes from the sky, probably the least important part of the scene. If you point the meter at the subject in the normal way, the acceptance angle of the meter is going to include a great deal of sky; this will almost certainly be the brightest part of the scene and, as such, it will have a profound effect on the meter reading. The exposure meter is going to 'assume' that there is an extremely brightly-lit area of mid-tone and advise an exposure which is too short to accurately expose the landscape.

In a situation such as this, the answer is to point the meter *down* slightly when you take your reading. Your real subject here is the area of trees, fields and houses, *not* the sky, so when you take a reading, make sure you read from your *real* subject and not from any irrelevant feature which might be included in the scene.

Closer views

Problems of a similar nature can also occur when you are working closer in to your subject. Imagine you are taking two pictures, both lit in the same way — one, of a girl in a medium-grey dress against a white background; the other of a girl in a medium grey dress against

a black background, both full length. In each case, the subject is identical – a girl in a grey dress. Only the backgrounds, (which, for exposure purposes at least, are irrelevant) are different. Normal meter readings of both subjects from the camera position, are going to recommend two different exposures. In the first case, the white background is going to influence the meter to suggest a very short exposure – one which will *under*-expose the girl; in the second, the meter is going to suggest an exposure which is too long – one which will cause the image of the girl to be seriously *over*-exposed.

Again, the answer to the problem is the same. Take the meter reading from the important part of the subject only and exclude incidental parts of the picture. In this situation you would need to go a lot closer to the girl so that the meter picked up only the light which was reflected from her skin and her dress. This would give a much more accurate exposure setting.

Another situation where you have to take your reading close into the subject is when the sun is shining towards you. Here, your subject will be in shadow, and everything else may well be blindingly bright. To get detail in your main subject, take a reading from that alone. The ideal way to get a superb silhouette picture is to take a general reading under these circumstances.

Reading from substitutes

Instead of pointing the exposure meter at the scene itself, you can always take a reading from a mid-grey piece of card. Provided this is illuminated in exactly the same way as the subject, your meter will indicate exactly the same exposure as it would if it were pointed at an average scene itself. The advantage to you is that you don't have to worry about excessively light or dark areas of the subject upsetting the accuracy of your reading. So, your grey card represents exactly the average scene your meter is calibrated to measure. Remember, though, it is important that the lighting of the card *is* the same as that of the subject. Don't let your shadow fall across it, for instance or, if you are working in artificial light make sure that you take your reading with the card at the same distance from the main lamp as the subject is.

There is one slight problem, however, and that is that what *I* think a mid-grey card may not necessarily agree with *your* idea of a mid-

grey card. The 'standard' grey card reflects 18 percent of the light falling on it. Even if you use one of these, before putting this technique into practice make some test exposures. Place the card in front of a typical subject – one without extreme highlights and shadows – take a reading from the card and then make a series of exposures ranging from two stops under to two stops over the indicated correct exposure, at half-stop intervals. When the film is processed, examine the negatives and decide which exposure is correct for your purposes. If you are using transparency material, you can compare the original grey card with its image on the transparency.

If the indicated exposure is correct, then you have no problems. However, if the indicated exposure is, in your opinion, not correct, then you will need to take into account the amount that future readings from the grey card need to be modified. For instance, if you think that the exposure indicated is one stop too much, then for all exposures in future, you will need to give one stop *less* than that indicated by the meter. If you think that the exposure indicated is one stop short, then, in future, give one stop *more* than the meter recommends. Alternatively, it might be more convenient to modify your film speed setting on the exposure meter to take this into account, or even choose a lighter or darker grey card.

Instead of a mid-grey card, of course, which will eventually get bent and dirty, you can always use something more simple and convenient – such as the palm of your hand. This is always in reasonably good condition and always with you (one hopes). In addition, it is also a flesh tone and this can be important where people are included in your pictures, for it will ensure that all flesh tones are accurately recorded. However, do make the same exposure tests suggested for the grey card.

White-card readings

The highlight method of exposure assessment is basically similar to the grey card method, although it does involve a small calculation. Instead of taking a reading from a grey card, you use instead a white card or a clean white handkerchief. The reading you get will be very high so to achieve the correct exposure, you divide by eight (or open up three stops) – for example, if the exposure indicated by the meter is 1/125 second at *f*16 you will actually give 1/125 sec at *f*5.6. To

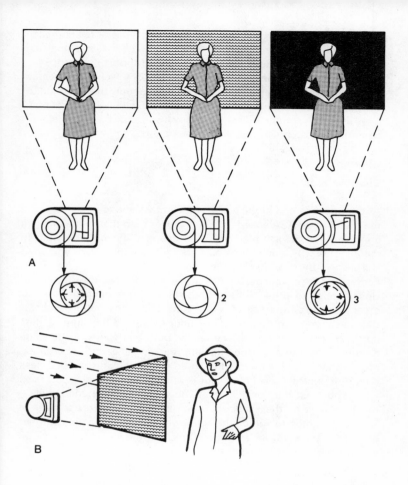

A, How the background can affect exposure: 1, A light background can cause the meter to read high, leading to under-exposure. You need to open up your lens to get accurate exposure. 2, A mid-tone background should not cause problems. 3, A dark background can cause the meter to read low, resulting in over-exposure which you can cure by closing down your lens. The best answer is to go in close and read from a mid-tone or, B, Take readings from 18% grey card.

avoid complications, if you use this method it is easier to set the film speed dial of the meter (or the camera) to 1/8th the actual film speed — in other words, if the actual speed of the film you are using is ASA/BS400, set the meter speed dial to 40, which is the nearest realistic speed setting. The useful thing about this method of calculating exposure is that it ensures that the highlights in your pictures always record to the same density level, and so you can always be certain of recording detail in those areas.

Shadow readings

At the opposite end of the scale, you can take shadow readings. Set the meter to an ASA speed 16 times higher than that of the film you are using and always read from the deepest shadow you wish to record. This way, you will be sure that the shadow detail you want will always be recorded on the film.

For both of these techniques it is important that you take the meter close enough to either white card or shadow area to ensure that no other light or dark areas of the subject affect the meter reading.

Of course, you can do both these things — take a highlight reading *and* a shadow reading and, hopefully, both will give you the same answer. If they don't, if the highlight reading indicates a shorter exposure than the shadow reading, then it means that the brightness range (or contrast) of the subject is greater than the film can cope with. You must then decide what you wish to record adequately — the highlights or the shadows. Alternatively, you can use a fill-in light, or reflector, to lighten the shadows (and so lessen the contrast) or you can work out the average exposure — the half in between — in which case you will lose a little at either end.

Built-in meters

The comments above are aimed primarily at non built-in meters but they apply equally to the built-in variety (provided they are not fully automatic).

Generally, the simple, built-in meter, being less easy to handle than the individual type, encourages one to take reflected light exposure

One way to take an exposure reading at night is to use the highlight method. Read from a handkerchief or piece of white paper and give three stops more exposure than the meter indicates.

readings from the picture taking position. As we have seen already, however, this is not necessarily a good thing, and a meter used in such a way can often provide misleading information. Often, the best method of using this type of meter is to take readings from a grey card (or the back of your hand) or to make highlight or shadow readings. These methods, as well as being simpler and more convenient, are also likely to produce more accurate results. Don't forget to make test exposures first, though.

TTL meters, as we have said before, are intended to be used at eye-level and even if the only information visible in the viewfinder is the needle and index mark, this is normally sufficient to enable you to assess the correct exposure. They fall into three categories: those which take a general reading over the whole of the picture area, those which do the same but which take more notice of the centre of the picture area (the 'centre-weighted' variety) — and variants which choose other parts of the field — and those which measure from a small spot in the centre of the picture area covering between about 2° 3° and 10° or so (the 'spot-meter').

Meters in the first category (apart from the fact that they only measure the light actually coming through the lens) are no different from any other reflected light meter. They suffer from the same disadvantage that should there be any disproportionately bright or dark parts in the picture area, they will bias the meter towards under- or over-exposure. With this type of meter, the only way to ensure that you get the correct exposure is by making sure that there are no such exceptionally light or dark areas showing when you actually use the meter. This may involve pointing the meter down (to cut out the sky), going in close (to measure only the subject) or actually pointing the camera at something completely different from the subject (a grey card, the back of your hand, or a nearby object such as an area of grass or stone which is lit in the same way) to obtain a mid-tone reading.

The second category of meter — the centre-weighted variety — is probably the best all rounder. It is easy to use in that you simply aim to get the subject in the centre of the finder when you take your reading. You don't have to worry too much about odd areas of light and dark around the edges of the finder, provided they are not excessively so or do not occupy too great an area. Once again though, in situations where there *are* excessively bright or dark areas around the subject — as for instance in against-the-light shots — you are

going to have to move in close to take the meter reading or find another area of average brightness to read from.

Some meters are weighted toward the bottom of the frame. With 35 mm cameras, this is normally when the camera is held horizontally. Such meters work well, but you must know what yours is doing. For example, a meter which reads the lower part of the horizontal picture may be unduly influenced by the sky when you hold it for vertical format shots.

Spot meters

The third category of meter — the spot meter — because it measures from a very small area, is normally used to take a reading from an important part of the subject without going in close — a flesh tone, for example. This usually works well, but you have to remember to take your readings from mid-tones and not from light or dark areas of the subject. As, with such a narrow angle, you have no surroundings to compensate for your chosen subject, that subject must be especially close to a mid-tone.

The spot meter was originally devised to measure relative brightness in the picture area — that is, by how much light area exceeds a dark area in terms of brightness. The result tells you whether or not the tonal range of your subject will fit neatly into the tonal range of your film (see page 92).

Fully automatic cameras

The camera which is fully-automatic is marvellous where all the tones in the picture area average out to a mid-tone. You don't have to think about anything except the composition of the picture — you just lift your camera and shoot. Mind you, it is worth looking closely to ensure that there aren't any excessively bright or large dark areas surrounding the subject. And it is a good idea to check whether the shutter speed you are using will stop any movement, or the aperture will give you sufficient depth of field. In other words, fully-automatic cameras can often create as many problems as they apparently solve — you do still have to think.

In a totally automatic camera, this is what happens. When you point

it at the subject to take a picture, the meter measures the light reflected by the subject and then automatically sets either shutter speed or aperture to produce the exposure which it decides is correct. In some cameras, it is the aperture which varies against a set shutter speed; in others, an infinitely variable shutter speed works against a fixed aperture. Sometimes the two are linked, so that when one approaches its limit, the other takes over.

While a camera such as this will produce a high proportion of excellent pictures, it does, unfortunately, rob you of a large degree of creative control. If the camera decides that 1/60 second at f8 is the exposure to give, then it doesn't matter whether you would like more depth of field to ensure that everybody in the picture is sharp, or a faster shutter speed to freeze the jump of the hurdler, 1/60 second at f8 is the exposure combination set and that is the exposure combination you have to use.

One way you can exercise control is by using a fully-automatic camera as though it were an individual meter. If you disagree with the exposure it recommends, point it at the area from which you want to take your reading and then check the setting. If, when you place the camera in the taking position the exposure setting changes, alter the camera settings to change it back. Cameras often have an over-ride dial. If yours doesn't, change the film speed dial until the exposure reads as it should. A higher film speed setting will give less exposure, a lower setting will give more. You can do this without any difficulty if the camera is the type which indicates the exposure in the viewfinder.

Some automatic cameras have manual over-ride. They allow you to set whatever combination of shutter speed and aperture you want. Others simply have an exposure compensation dial.

A compensation dial lets you increase or decrease the exposure that the camera would otherwise give by anything up to two stops. You can thus take account of any special conditions (such as extra bright areas or very dark backgrounds) which would otherwise influence the metering system of the camera to give too much exposure or too little. Normally, the exposure compensation dial is marked in $\frac{1}{2}$ or $\frac{1}{3}$ stop divisions enabling you to be extremely precise. The compensation dial is commonly calibrated in factors: 2X and 4X for giving one and two stops more exposure – useful when the background is much brighter than the subject; $\frac{1}{2}$X and $\frac{1}{4}$X for one and two stops less exposure – for small spotlit subjects, for example.

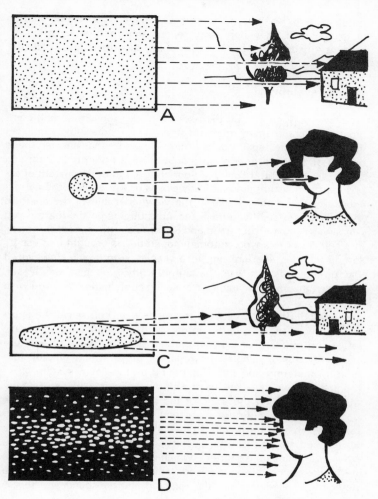

Through the lens meters vary in their sensitivity pattern. A. Some read from the entire screen area. B. Spot meters let you select a small part of the subject to read from. C. Meters may read just part of the scene, for example the bottom. D. Most read all over the scene, with extra attention to the centre. One which can measure light reflected from the shutter blind shows clearly the pattern of sensitivity.

Some cameras don't have a compensation dial as such, but a button or lever which, then depressed, opens the aperture by a certain amount — usually $1-1\frac{1}{2}$ stops. Obviously, this offers less flexibility.

Priority systems

To allow more control by the user over the exposure-setting combination selected, many modern automatic cameras allow you to set either the shutter speed or aperture — called either shutter speed priority or aperture priority. In a shutter speed priority system you simply set the shutter speed of your choice and at the instant of exposure, the aperture automatically closes down to allow the correct exposure. The meter needle in the viewfinder shows the aperture that will be set so, if you have second thoughts on the matter, you can always change your mind and alter the shutter speed. Normally, in a camera of this type, automatic operation is brought into use by setting the lens aperture ring to a special 'auto' mark. However, if you do not wish to use the auto facility, you can simply set, manually, the aperture and shutter speed combination that you wish to use.

Aperture priority cameras work the other way. You select the aperture you wish to use and the correct shutter speed is automatically set at the moment of exposure. There are two types of aperture priority system in single-lens reflexes: those which employ full-aperture metering and those operating a stop-down system.

The first type works by means of a memory circuit. When you set the desired aperture on the scale of the camera, the meter takes the reading with the aperture *open* and then calculates the shutter speed which will be required when the aperture is closed to the desired setting. This shutter speed is displayed in the viewfinder. When you release the shutter — which of course, cuts off the light to the meter as the mirror is raised — the aperture closes down, the meter memory remembers the required shutter speed and this is automatically given.

The second type of aperture priority camera works by means of a photo-cell (always silicon or gallium) close to the film plane. You set the aperture you wish to use, then, when the shutter is released, the mirror rises, the aperture closes down and the cell at the film plane measures the light level. The correct shutter speed is then set, the

cell moves out of the way and the shutter opens and closes.

The Olympus OM-2 uses a combination of the two. The full-aperture (CdS) sensors indicate the expected shutter speed; and give you normal manual exposure full aperture metering. Silicon cells on either side of the lens mount measure (stopped-down) the light reflected from the shutter blind, or (when the shutter is open) from the film. These give stop-down automatic shutter speed control without a memory. In fact, they can alter the exposure in the unlikely event of the light level changing during exposure.

With aperture priority systems, the shutter speed range is infinitely variable. Manual operation can also be employed simply by setting the desired shutter speed and so over-riding the system.

Incident light readings

Some photographers swear that there is only one way to arrive at the correct exposure when using a meter, and that is by taking an incident light reading. In actual fact, the incident light method is closely related to taking a grey card reading. It is often more convenient. Instead of measuring the light reflected from a suitably-toned surface, you measure the light falling on your subject.

Incident light readings can usually only be taken with a hand-held light meter, which has a special attachment for fitting over the meter window. A few built-in meters also have this facility. To take an incident light reading, you place the white (usually shaped) plastics diffuser over the receptor window of the light meter, stand by the subject and point the meter at the *camera*. This sounds an odd way of finding the correct exposure for the subject. In fact, what the meter is doing is collecting exactly the same amount of light that the subject is receiving, diffusing it (and at the same time, cutting it down by a pre-determined amount) and passing it on to the light-sensitive cell.

An advantage of this method of measuring the light is that it is almost certain to produce more uniform exposures. You are not measuring light which has been reflected from different subjects, different colours and different textures, but the light which *falls on* them — in this sytem of measurement the subject plays no part and can have no effect on the meter reading. So your pictures give an accurate record of the subject's tones.

A problem may be that it is not always possible to get close to the subject. However, as long as the illumination is the same from the camera position, merely pointing the meter diametrically away from the subject provides the reading you need. Where the lighting conditions are *not* the same at the camera position, it is a simple matter to take the plastic cover from the meter and revert to the reflected light reading.

Problem subjects

As long as you carry on taking pictures you will find that problem subjects turn up. Not necessarily the highly unusual types, such as firework displays or street lamps at night (which we will deal with later on) but the more everyday subjects which just have a slightly tricky twist.

Most likely to prove troublesome (and probably the most frequently found) is the picture shot into the sun — that is, where the sun is behind the subject. Supposing you are on the beach near the pier. The water is sparking brilliantly, the foam is like crystal and the uprights and crossbars of the pier itself make a powerful criss-cross pattern against the sky, hiding the sun itself. There is a group of children playing under the pier.

There are three ways you can take this picture. The first, is to take a general reading, allowing the brightness of the sky, water and sand to assume full control. The result of an exposure from this reading will probably show the sea, sky and sand beautifully exposed while the pier, its shadow and the children are black silhouettes.

The second method is to take a reading only from the area under the pier. This will result in a much longer exposure which will record the children playing and the detail in the pier itself but will cause the surrounding bright areas to be badly over-exposed. The third is to take a grey card or an incident-light reading. This, producing an average grey reading, is going to be a compromise and, probably, the one unsatisfactory result with the bright areas over-exposed and the dark areas under-exposed.

Where problems do arise, the first thing you must do is isolate your subject — decide exactly which part of the picture is the most important. When you have done that you can then consider how it is to be reproduced. Is it a mid-tone? Should it reproduce as a dark shadow

area? Will a close up reflected-light reading be best or will an incident-light reading give you the exposure you want? If, after asking yourself these questions, you are still in doubt then take a grey card reading. You can then work out the exposure and make one picture at the indicated setting and one moving one stop over or one stop under — whichever you think is the right direction.

What is the Right Exposure

Place two experienced photographers in front of the same scene, give them each a roll of the same film and let them go into action. You will be amazed at how many different ways they find of looking at the same thing. One will immediately look for something to frame his subject; the other will prefer to capture it stark and unromanticized. One will use a telephoto lens to compress the planes of the picture, the other will open everything up with a wide-angle lens. One will concentrate on recording minute detail, the other the broad aspects of the subject. Even from the same viewpoint, their exposures would probably be different. They would have 'seen' the subject in different ways and set about interpreting it differently. Let's see how they could have done this.

The scene is an old stone cottage set on a hill in a bleak moorland. The first photographer looks at it and notices the superb texture of the stonework, the weeds and bushes growing wild in the garden, the dry stone wall around it. In his minds eye he sees a superbly detailed black and white print showing a full range of tones from pure white through soft greys to beautiful rich blacks. He takes a meter reading – perhaps an incident light reading, perhaps a grey-card reading – and sets an exposure which, if he uses his favourite soft-working, fine-grain developer, will give him precisely the negative he needs to produce such a print.

The second photographer looks at the scene. The first things he notices are the stark bleakness of the moor and the lonely desolation of the windswept cottage. He immediately sees in his imagination a hard, grainy print, showing this dark, sombre cottage in sharp relief – a silhouette, almost, against the sky. He takes his meter reading – a straight reflected light reading from the camera viewpoint which allows the brightness of the sky to dominate. Not content with this, he decides to under-expose by half a stop and overdevelop in a vigorous-working developer to obtain maximum contrast and graininess to produce just the effect he wants on the finished print.

Can two be right?

At this point, we could ask ourselves, which photographer gave the 'correct' exposure. To all intents and purposes the first chap did – at least, according to theory. His would be the negative which displayed a full range of tones, his would be the negative which just showed detail in the deepest shadows and his would be the negative which produced the finest detail and the highest definition. In other words as perfect a negative as it is possible to get.

What about the second photographer, though. He broke all the rules. He deliberately destroyed shadow detail, ruined the gradation of the negative and showed no interest whatsoever in sharpness and fine definition. But he did get exactly the picture *he* wanted, and that is what correct exposure is all about – getting what you want. There's no point at all in following the rules rigidly all the time if you don't achieve the results you want. You can't say 'but I know that's the wrong exposure' if it gives you the picture you are after.

The rules are there, but they are there to help you. You must understand the rules and then know how to interpret them to achieve what you want. Rules are made with particular circumstances in mind, but if they are not your circumstances, then they are not your rules.

Choose your objective

So, the first thing you have to do is formulate an objective. Do as the two photographers in our example did and see in your own mind's eye the sort of result you want to achieve. You can't do this every time, of course. There are some pictures which simply won't wait while you consider what sort of effect you want. Occasionally, a picture appears in front of your camera – out of the blue as it were – and you just have to shoot and hope for the best. Stop to think and the shot has vanished.

However, on most occasions you *do* have time to think and it is worthwhile pausing for a few moments before you press the button, and weighing up exactly what ideas you want to put over in your picture. Much depends on the material in your camera, of course. Is it a case of the material fitting the subject or the subject being *made* to fit the material? What processing methods are you going to em-

ploy? What is the end product to be: a print or a transparency? If you can answer these questions correctly, you are well on the way to selecting the correct exposure.

The material in your camera

How often do you come across a subject which is a 'natural' for any material other than the one in your camera at the moment? It seems to happen perpetually but unless you are prepared (or wealthy enough) to carry three or four cameras around with you, all loaded with a different material, there isn't a lot you can do. Usually, you load up with the type of film which is likely to serve you best in the foreseeable circumstances and that more or less settles it. You can, of course, make a note of the frame you have reached on that particular cassette — assuming you are using 35 mm — re-wind and re-load the camera with the material you need. However, do that sort of thing with any frequency and you find you need a filing system for past-used films; and they never do seem to find their way back into the camera. If they do, too often it is as 'fresh' films and you lose two sets of pictures.

The important thing is to know exactly what you are able to do with the materials you have available.

Reversal materials must be correctly exposed — there is no significant leeway, you either give the correct exposure or produce a poor picture. However, it *is* possible to rate some reversal materials (but not the Kodachromes) at higher or lower speed ratings and modify the processing. Ektachrome 200, for instance, which is officially rated at ASA 200, can be pushed as far as ASA 800, although there is some loss of quality when you do this. Obviously, too, it is better to decide what speed rating to use before you start exposing a film, otherwise you have to cut it and run the risk of cutting through what might be an important exposure. Push processing is discussed more fully on page 185.

If you have a material in the camera which does not suit the colour balance of the lighting you are using, then, except in special circumstances such as for firework pictures or pictures of floodlighting, you should use the correct conversion filter over the lens and increase the exposure accordingly. There is more about filters on page 118 and in the *Focalguide to Filters*.

When you have a transparency, you can (in theory, at least) have colour prints or black-and-white prints made from it. To produce successful colour prints, the contrast of the original transparency should be fairly low. Surprisingly enough, it seems to be a lot more difficult to produce high-quality black-and-white prints. The rule, wherever possible, with transparency materials, would seem to be make a well-exposed transparency and stick with it. Make derivatives from it only if you have to.

Colour negative materials give you a little more leeway. Slight underexposure and moderate overexposure will still produce you a **printable negative, but there is no easy way you can increase the** speed of the film (using the film manufacturers chemicals) without causing colour reproduction to go haywire. The negative to aim for is always the perfectly exposed one.

Where you score with colour negative materials is in the versatility of the medium – when you have a high quality colour negative you can have high-quality colour prints, colour transparencies or black-and-white prints made from it. What is more, you also have the ability to control the finished result during the printing procedure using filters, masks or simple shading techniques.

Black-and-white materials will virtually let you get away with murder. Slight under-exposure and severe over-exposure will still produce printable negatives although quality does deteriorate the further you move from the optimum; but, as we said a short while ago, is high quality what you are looking for?

As for processing, there are hundreds of different developers on the market, some which reduce film speed in return for producing less clumping of the silver grains, some which produce greater apparent sharpness and some which offer to increase film speed at the expense of increased graininess. Furthermore, you can experiment with them at your leisure and yet still be fairly certain of the results you are likely to achieve.

Once again, you have a negative process, and the great advantage of a negative process is that there is a printing stage which gives you all the opportunity you need to use creativity to the full. At this point you can make use of all the wizardry you can muster to make a superb print from a superb negative, the very best of a bad job or a work of abstract art from a most humdrum negative. You can even, if you are prepared for the unexpected, make colour prints of a sort from a black-and-white negative.

A reason for accurate exposure

There is one very good reason for producing a perfectly-exposed picture every time. Once you have a good-quality master, you can play about with duplicates for as long as you like afterwards to your hearts content.

As far as negative materials are concerned, at any rate, you have ample opportunity for experiment after the processing stage. Provided you have a perfect negative, you can make any number of intermediate negatives, positives or combinations of both in any degree of over- or under-exposure and showing a variety of colour biases. And you always have a perfect negative to go back to. You can have as many failures as you like *after* you've produced the perfect original, but while you have that master negative, you haven't failed at all.

It's not quite so easy to do the same thing with colour transparencies, but to my mind, it is even more important to produce the perfect master. Once again, there is always afterwards, you can always try making prints and duplicate transparencies. Much depends on how you feel about darkroom work.

How precise are your requirements?

Accurate exposure depends on what you want to produce. The more correct you want your colours to be, the brighter you require your black-and-white prints to look, the sharper you want your reproduction — then the less latitude you have with exposure. Don't forget too, there is a lot of difference between a mood picture, designed to show the soft mistyness of a September morning, and a record shot of a group of rare stamps. One is meant to convey an impression, the other to record something exactly as it is. Take into account, if you can, the viewing conditions under which your pictures will be examined — a transparency viewed through a high-powered projector on a brilliant screen in a darkened room is somewhat different to one which is going to be looked at through a hand viewer reflecting the light of a table lamp. The 'correct' exposure for the latter could be $\frac{1}{2}$ to 1 stop greater (to produce a thinner transparency) than that required for the former.

Factors like these help to decide how accurate your exposure needs

to be. A point worth bearing in mind, though is that a picture which is exposed correctly will look right when it is examined by the most critical audience under perfect viewing conditions – and that is more than one can hope for from a badly exposed shot.

Also worth bearing in mind is the fact that if you produce transparencies for reproduction, they *must* be perfectly exposed. They will be examined critically by art editors and blockmakers alike on a viewing screen illuminated by 5000K colour-matching tubes. Remember, it is difficult enough to reproduce well from a good transparency – don't give them the headache of a bad one. They may not look forward to hearing from you in the future!

Image Sharpness and Exposure

One of the most interesting features of photography is that no single aspect of it can be looked at in isolation. One factor will always affect another factor. Take image sharpness for example, and the way in which it influences your choice of exposure settings. Most photographers think first of focusing when image sharpness is mentioned. Immediately following on that first thought, however, comes a whole list of reasons for unsharp pictures — subject movement, camera movement, dirty lens, insufficient depth of field, over-exposure, irradiation, over-development, condensation on film or lens.

In this chapter, we are going to examine some of the ways in which our choice of exposure settings will be influenced by considerations of image sharpness. The relevant factors are, of course, drawn from the list above. They are: depth-of-field, subject movement and camera movement, but even here we will find situations where these factors overlap and cause you to, perhaps, think twice before you finally settle on a specific exposure setting. Let's take a look at the first of these factors.

Depth of field

Theoretically, when you focus a lens on a particular point, only objects in the same plane as that point will be reproduced sharply on the film. Fortunately for photographers (and camera manufacturers) things don't work out quite so simply in practice and there is always an area in front of and behind the plane of sharp focus which will be recorded tolerably sharply. This area is called the depth of field (some people refer to it as *depth of focus*, but this is a term used to define the area in front of and behind the *film plane* in which an image can be recorded tolerably sharply).

You will notice, that I use the word *tolerably* to qualify the degree of sharpness; there is a good reason for this. Supposing you take a photograph — say a fairly close-up portrait of one of those bikini-clad blondes from Chapter One and you focus, sensibly enough, on her

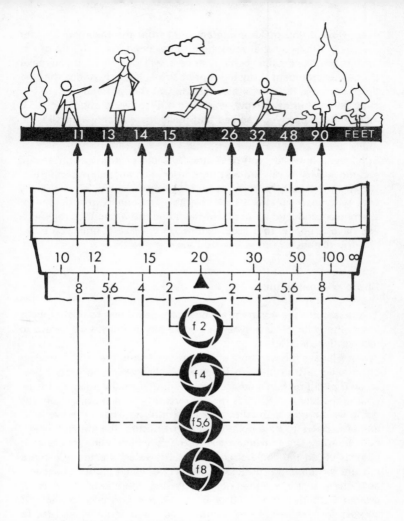

The effect of aperture on depth of field. Here, the camera lens is focused on a subject 20 feet away. At f2 only subjects within the range 15–26 feet from the camera will be in sharp focus. At f8, however, subjects from 11 feet to 90 feet from the camera will be reproduced reasonably sharply. For all practical purposes, the more you stop down the more you increase depth of field.

97

eyes. Now if you make a contact print from the resulting 35 mm negative, it is likely that the whole of her head, from the tip of her nose to the blonde curls behind her ears, will look sharp. If you make a small enlargement – say to en-print size – you may notice that the tip of her nose isn't quite as sharp as you thought and nor are the curls behind her ears. Now, enlarge the negative to about 12 × 15 inches. Suddenly, you can see that really there is only a small area, extending from just in front of to just behind her eyes, which looks *really* sharp.

Supposing, however, you now stand the big enlargment on a shelf and move back about ten feet from it – notice anything? The further you move back, the sharper everything begins to look again. This is why we *must* use the word 'tolerably' to qualify the degree of sharpness produced by depth of field, and the amount of tolerance you have depends, to a great extent, on the size of print you make and the distance from which you view it.

Circle of confusion

The reason for the apparent change from sharpness to unsharpness lies in the ability – or maybe we should say inability – of the eye to resolve fine detail.

When a lens is focused on a point source of light, the image produced is never a true point, it is always a disc which no matter how small it might be has a measurable diameter. As the lens is refocused and the plane of focus is moved forwards or backwards from the point, so the size of the disc increases until, at last, to the eye it no longer appears to be a point. When that occurs, the image will appear blurred. The maximum size of circle which still appears as a point is called the circle of confusion. The value chosen by camera makers for the depth-of-field scales is one which produces acceptably sharp pictures under normal viewing conditions. A figure of around 0.25 mm (on a 10 × 8 in print) is normally chosen. Of course, for the same size picture, you need more sharpness (a smaller circle) on smaller negatives and less on larger ones. For that reason, with the standard lens, manufacturers take, say, 1/1000 of the focal length as the circle of confusion.

If you intend to produce big enlargements, or enlarge just part of your negative, you may find the chosen circle of confusion too large.

So you will see the picture as unsharp well within the 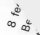 suggested by the depth-of-field scale. In that case, yo... exacting standards. The simplest rule-of-thumb is to ... calibrations for the next larger aperture. That is, if yo... at *f*8, choose the scale markings for *f*5.6.
Once you have chosen your criteria, the amount c... produced in a picture depends on three things: the focal ... the lens; the aperture used; and the camera-to-subject distance.

Focal length of lens

The shorter the focal length of the lens, the greater the depth of field. Look at a really wide-angle lens photograph and you will notice that practically everything in the picture is sharp — in fact some ultra-wide-angle lenses (such as 'fish-eyes') are not capable of being focused. Once they are firmly positioned on the camera, they record everything which is in front of them reasonably sharply. A long focal length lens, or a telephoto lens, is a different matter, and using one of the longer lenses the field of sharp focus will be very shallow.

Aperture

The more you stop down the lens, the greater is the depth of field. An aperture of *f*11 produces deeper areas of sharpness in front of and behind the subject than, say *f*8. In turn *f*8 produces greater depth of field than *f*5.6 and so on. The depth of field is directly related to the *f*-number, for a given focal length lens, focused on a given distance. In fact, however, there is an optimum aperture for any lens and although stopping down further than this will produce more depth of field, the general effect will be a reduction in overall sharpness rather than an increase.

Camera to subject distance

Generally the farther from the lens is the point focused on, the greater will be the depth of field. When you focus on an object which is perhaps, 18 inches away, the depth of field may only stretch an inch or two in front of the point focused on and a few inches behind it. When you focus on a point, say, 10 feet away, objects as close as

t and as far as 15 feet may well be reasonably sharp.

ause the zone of sharp focus stretches beyond the point of focus,
ere comes a time when (although the lens is not focused on in-
finity) the depth of field stretches just to infinity. This distance (from
the camera to the point focused on) is called the hyperfocal distance.
Obviously, focusing on a point farther from the camera than the
hyperfocal distance will cause a *reduction* in depth of field rather
than an increase.

Taking all of these factors into account, then, it is obvious that if you
use a wide-angle lens, a small aperture, and focus on the hyperfocal
distance, you are going to produce the maximum depth of field
possible. If you use a long focal-length lens, a large aperture and
focus on a point close to the camera, you are going to get very
shallow depth of field. Of course, you will suit the technique used to
the type of picture required.

However, as we said at the beginning of this section, the depth of
field you require affects your choice of exposure setting because, to
a great extent, it will dictate the lens aperture needed; the greater
the depth of field you require, the smaller the aperture you must use;
the less depth of field you need, the wider the aperture you will use.
It is still too early to settle on a final exposure setting though, we
have two more factors yet to consider.

Subject movement

There are two ways of dealing with movement in the subject area:
either you can use a shutter speed which is short enough to stop it
dead, giving you a crisp, sharp image; or, you can introduce a certain
amount of blurring, the degree of which depends on just how slow or
fast was the shutter speed you decided to use. Depending on how it
appears in the picture, blurring can indicate speed, fantasy or just
poor technique.

Normally, you know in advance when you are going to be faced with
subject movement – you don't go to a speedway meeting entirely
unprepared for action and a football match will usually provide some
excitement, even if it is only some spectators hammering each other
into the ground. You can, therefore, decide in advance how you want
to record the action. Do you want to freeze the movement –
providing a superlative record, fit for a technical manual on style or

A, Movement across the camera axis calls for the highest shutter speeds, for maximum stability, stand with feet apart and elbows tucked in. B, You can control which part of your picture is blurred by panning (swinging the camera to follow the moving object). C, When movement is at a 'dead point', quite a slow shutter speed will freeze action; as the movement speeds up, so a higher shutter speed is needed (slight blurring often suggests speed).

sporting technique perhaps but not necessarily suggesting great speed? Do you want the image to form a blur – suggesting lots of speed but not necessarily endowed with a great deal of clarity? Or, do you want the best of both worlds, having the important, or major parts of the image sharp while the less important, or minor parts of the image are allowed to blur into a mist of movement? Let's have a look at the three techniques.

Freezing movement.

Provided you have a fast enough (short enough might be a better term) shutter speed, you can stop any movement (assuming your own reactions are quick enough, of course). However, most cameras with between-lens shutters are limited to a minimum of 1/500 second and the majority of focal plane shutters only go as far as 1/1000 second – which may sound pretty fast until you realise that anything less than 25 feet away and going faster than 30 mph, across the field of view is *still* going to be blurred, even at that shutter speed. To freeze movement in the picture, therefore, you have to arrange: that it is not too fast; if it *is* moving quickly, the main direction of movement is not *across* the camera, but towards or away from it; or, if it is moving quickly *across* the camera, it is far enough away to be stopped by your fastest shutter speed.

Of these three choices, the third is probably the least useful because the image will probably be too small to serve as a useful record anyway, the second is the one most likely to provide the *impression* of speed allied with reasonable sharpness and the first, if it occurs, is not likely to have caused you any problems in the first place.

Just in case the thought crossed your mind, there is no point in moving farther back and then enlarging. The movement blur depends on the speed that the image crosses the film, multiplied by the magnification in printing or projecting. So, enlarging, or using a **longer focus lens has exactly the same effect as going closer does.**

Introducing blur.

Even a very tiny amount of blurring in a photograph can suggest movement and, from a pictorial point of view, this will look far more interesting, or even exciting, than a frozen-image picture. How much blurring you introduce is very much a matter of personal taste but unless you want a picture showing very little detail in the subject, then the degree of unsharpness should be kept reasonably small. A lot will depend, of course, on the parts of the image which are actually moving. For instance, the whole of a car moving across the

field of view of the camera might be very slightly blurred. On the other hand, a person walking in the same direction may be shown with extremely blurred legs but a very sharp body.

One way of achieving the impression of speed or action in a picture occurs when the movement is back-and-forth (such as a child on a swing) or up-and-down (such as a pole-vaulter). Here, there is a 'dead point' when the movement reaches its climax in one direction immediately prior to starting its journey in the other. If the picture is taken when the movement reaches this dead point, the action can be stopped (or, at least, almost stopped) with quite a long shutter speed and yet the impression of movement will come across quite strongly.

SHUTTER SPEEDS NEEDED TO FREEZE MOTION

Subject	Approx. Speed MPH	Camera-to-subject distance	Motion at right angles to camera	Motion at 45° to camera	Motion toward or away from camera
Swimmer Rowing boat	2–3	25ft	1/125	1/60	1/30
		50ft	1/60	1/30	1/15
		100ft	1/30	1/15	1/8
Sailing boat Horse walking	3–9	25ft	1/250	1/125	1/60
		50ft	1/125	1/60	1/30
		100ft	1/60	1/30	1/15
Cyclist Runner Horse trotting	8–15	25ft	1/500	1/250	1/125
		50ft	1/250	1/125	1/60
		100ft	1/125	1/60	1/30
Athletics Horse racing Motor boat Driving Football	15–30	25ft	1/1000	1/500	1/250
		50ft	1/500	1/250	1/125
		100ft	1/250	1/125	1/60
Motor car Motor cycle Train	over 30	25ft	1/1250	1/1000	1/500
		50ft	1/1000	1/500	1/250
		100ft	1/500	1/250	1/125

Another method is panning the camera. Panning is a technique which allows you to use a relatively slow shutter speed and yet still stop fast movement. It can only be used when subject movement is *across* the camera field of view and is most successful when the subject shows no other movement. For instance, a motor cyclist could be rendered extremely sharply — even if he was moving at, say, **120 mph, because he is moving as a single unit; a runner, on the** other hand, whose legs and arms are moving up and down as well as backwards and forwards would reproduce as a reasonably sharp body with very blurred limbs.

Panning consists of locating the subject in the viewfinder well before it reaches you and then following it with the camera and releasing the shutter as (or fractionally before) it speeds across in front of you. Then — and this is important — you must follow through, smoothly and easily *as though nothing had happened* — almost as if you hadn't managed to take the picture. Panning is not particularly difficult, but it is a knack and to carry it out successfully requires a lot of practice. However, you can learn the technique without wasting film simply by swinging your camera to follow the action through the viewfinder at any sports meetings you attend. Soon, you will be able to keep the moving subject steady in the field of view. When you feel ready, you can then start taking pictures.

The marvellous thing about panned pictures is the tremendous feeling of speed they convey. The reason for this is that you are moving the camera with the subject. When the shutter is released it is almost as if the film sees a stationary subject against a rapidly moving background, for this is what it records — a sharp image of your subject against a background which is simply a blur of speed.

These, then, are the three methods of recording moving subjects on your film. The first technique may demand the highest shutter speed you have available — and it still may not stop the action completely. The second two are more accommodating and allow you to use quite slow shutter speeds — the deciding factor being your own personal opinion of how the movement of your subject can best be recorded.

Now you can choose your shutter speed. But — it must combine with your lens aperture to give the correct exposure. Juggling the two is the most important technicality in picture taking.

Movement of the camera

The two topics previously discussed — depth of field and subject movement — are factors which can be harnessed by you in order to produce a better picture. The same is not normally true of involuntary camera movement. Usually, this is a problem which you have to face and overcome before you can produce even an *acceptable* picture.

The slower the shutter speed, the greater the risk of camera movement. Most people can hold a camera steady at speeds of 1/60 second and less, but using slower speeds than this invites problems. If you would like to find *your* threshold of steadiness, try taking a series of pictures of a subject with reasonably strong outlines, or with some fine detail (a newspaper, perhaps). Make sure the subject cannot move and use a film which will resolve reasonably fine detail. Then, hand-holding the camera, take a series of pictures using shutter speeds of from, say, 1/8 second down to 1/250 second (be fair to yourself and repeat the procedure just to ensure that you didn't hiccup at 1/30 second). If you now process these pictures and either view them through a strong magnifying glass or project them onto a screen (if you used a negative film, check the negatives, not the prints), you will have some idea of your own capabilities. If you find that exposures longer than 1/30 second all show movement, then you know that if you want sharp pictures, you must *never* hand-hold the camera for exposure longer than 1/60 second. You must always use a tripod, or find some other means of support for the camera.

Summing up

To sum up, then, before you take any photograph, you have to consider those three points: depth of field, subject movement and camera movement. The first has a direct bearing on the aperture to be used, the other two affect the shutter speed. However, the last one — camera movement — is one you can plan for in advance. You know from the moment you see the results of your tests just how long an exposure you can safely use without additional support for the camera.

We are left then, with depth of field and subject movement. Many of

the photographs you take will require only one of these to be taken into account. In bright sun, you can choose a suitable compromise that gives you all-over sharp pictures of a normal subject; and not worry much about either. However, there will be those very awkward occasions when you want a small aperture to provide great depth of field and a fast shutter speed to stop action. Provided the light is good, of course, there still won't be any problems with a reasonably fast film. However, there will be times when something has to be sacrificed — and then you have to make the decision as to which type of unsharpness is to be preferred: unsharpness due to movement or unsharpness due to an out-of-focus image. At that point, unfortunately, only you can decide and the less important just has to give way to the more important.

Perhaps there ought to be a Focalguide to snap decision-making!

Typical Exposure Situations

Most of the pictures we take are outdoor scenes — pictures of land-scapes, people and animals. We tend to think that, perhaps because we take so many of them, they are easy, always turn out well and re-quire no special effort. Is this really true? Think back over the last year and ask yourself how many disappointments you had in this particular easy field. Because we take so many outdoor pictures, it may be that our failures in photography tend to get forgotten and only our successes remembered.

Even if we don't have many failures, how many of us can point to even a 50% success rate — and by success I mean pictures with which we are *totally* satisfied?

In this chapter, we are going to look at the 'easy' pictures and see if there are any ways in which we can tighten up and improve our technique — particularly with reference to the exposure aspect. It's surprising how often a little more forethought, planning and, perhaps, knowledge can be used to good effect to turn an average photograph into a superb picture. The first thing we are going to look at is the weather, because this dictates very much the pictures we can take and how we must go about taking them

What is good weather?

If you are on holiday with your camera there won't be any doubt in your mind at all that good weather is the sunniest, brightest and warmest that can come along — and if it can be even sunnier, brighter and warmer than that, so much the better. Circumstances alter cases, and what is good weather to one photographer may well be simply an upsetting nuisance to another. However, in most situ-ations, some sunshine is usually welcome. That doesn't mean that photographically-speaking it is always the ideal light source. It does mean bright, sparkling pictures, brilliant colours and fast shutter speeds coupled with lots of depth of field; but sunshine can also mean heavy, filled in shadows and burned-out highlights. It can

mean squinting eyes and wrinkled features. It can mean backgrounds which are, irritatingly, as sharp as the subject itself. In other words, bright sunshine can bring its own problems. However, if you can learn to deal with these problems and make sunshine work for you every time, then perhaps you will find yourself a lot nearer the 100% success rate this year than you were last year.

Pictures of people

Most of us enjoy taking pictures of people — our wives, husbands, girl friends and, with luck, maybe even other people's girl friends. Most of us also (as we said earlier) like bright sunshine. However, bright sunshine and pictures of people don't necessarily go together, especially when you start going in close. The trouble with strong sunshine is that it produces strong contrasts — particularly if there are few clouds about to act as natural reflectors. And, as you go close to a person, particularly if he or she is over 25, you will see just how merciless the direct rays of the sun can be, underlining every speck, line and wrinkle with a hard, black shadow.

If you use a slow film, this problem will be accentuated because slow films are inherently contrasty. We've all seen colour slides in which the subject doesn't seem to have eyes, only two big, black holes — this does nothing for the picture and can do very little for the ego of the person whose portrait it is supposed to be. Now, you might say, why not give a little more exposure and get some detail into those black shadows — but, what then is going to happen to the brighter areas? will you be happy to have detailed shadows but all the other areas looking as though they faded with the washing?

No, the real answer to the problem is either to avoid the shadows occuring in the first place or to try to soften lighting contrast before you take the picture.

Choose the shade

To avoid the shadows occuring, find an area of open shade where there is plenty of light but no direct sun, in the shadow of a tree or a wall, or under the pier on the beach, perhaps.

A, To reduce contrast in a strong back-or-side lit scene, add light to the shadow areas with a reflector or fill-in flash. B, Where the background is fuzzy or obtrusive, choose a wide aperture to minimise depth of field and make the subject stand out more clearly.

This is the ideal light for portraits and will produce soft, luminous skin tones with none of the brittleness normally associated with outdoor portraits. Be on your guard, though, if you are using colour film. One of the problems which can arise when you are taking portraits in this sort of lighting is that of colour casts. If you choose to place your model in the shade provided by a beautiful blue-painted stone wall, you may find that he or she gets a touch of the blues — courtesy of the light reflected from the wall. On the other side of the coin, a cream or golden coloured wall can give a pleasant touch of warmth to your picture. The sky itself may cause problems. When it is a clear blue with no white clouds, all the shaded areas take on a blue cast. A sky light (1A) filter can help to cure this problem and will require no increase in exposure. If you live in a place where the sky is strongly blue, you may need a stronger pink or amber filter. One labelled R3, 03 or CC 20 R is probably about right. Make some tests with gelatin filters before you buy a glass one. In the shade, you must be extremely careful when you take a meter reading. Be sure when you take reflected light readings, that the brightly-lit background is not allowed to influence the meter. The subject is the important thing, so go in close and take your reading from an area approximating to a mid-grey.

Adding light

What about softening contrast, then? How can you do this when you are taking pictures in brilliant sunshine? Easy. You add light to the shadows.
There are two fairly simple methods — with a reflector, or with flash. Using a reflector is very easy, but it *must* be a white one if you are using colour materials (a silver one is also permissable but it should have a roughened texture otherwise it will produce bright specular reflections, rather in the same way as a mirror would). You can see the effect your reflector has by moving it slowly towards your subject, occasionally turning it completely away and then swinging it back.
Don't fall into the trap of 'over-kill' — that is, don't allow the light from the reflector to dominate. This has a most peculiar effect, destroying the naturalness of the picture. The ideal balance will be achieved when you can still just see the shadows thrown by the sun;

the contrast of the film will enhance the effect so that a pleasing result is obtained.

Using a reflector properly — that is, from the camera position, to lighten the shadows cast by the sun — will make no difference to your exposure. Take a reading in the normal way, with or without the reflector in position.

Fill-in flash

We will be dealing with flash and talking about calculating flash exposure in detail later on in this book (page 177 to be precise). However, it is worthwhile mentioning it at this point because it provides a convenient and easy method of lightening and softening the harsh shadows in strongly sunlit pictures.

There are two points you have to remember. First, when you use flash with colour materials, you must use blue flashbulbs or flashcubes, magicubes or electronic flash (which are all colour balanced for use with daylight colour films). Second, you must ensure you don't over-use it. The trouble is, unlike using a reflector, you can't see the effect of fill-in flash until your pictures are processed. If you use too much flash it will overpower the sunlight and become the main light source — which looks most unnatural. For best results, the flash should *under*-expose by about two stops — that is, if the calculated flash exposure requires an aperture of f5.6, then your daylight exposure should be f11. If necessary, you can cut down the intensity of the flash by covering it with a thin cotton handkerchief (reducing by about 1 stop), or two layers of tissue ($\frac{1}{2}$ stop).

Fill-in flash and to a lesser extent, a reflector provide very good ways of lowering the contrast which is a normal feature of pictures taken against the light. Once again, however, you have to be extremely careful not to overdo it. Against the light shots have a particular magic of their own, whether they are almost silhouettes surrounded by a brilliant corona of light or fully-exposed pictures bearing a beautiful, silvery-gold halo. Too much fill-in flash and the magic is gone. If you are in any doubt, a good precept is always to double up. Make one exposure at the setting you think is correct and one exposure at the setting you think *might* be correct. This way you can be reasonably certain of getting a good result.

Children and animals

In almost all cases, children and domestic animals have two great similarities (which is why we have grouped them together here). They are both affectionate and they both enjoy playing. If you intend to take pictures of either — or even more difficult, both, you can be sure of two things: you are going to produce some extremely **rewarding pictures; and you are letting yourself in for some hard** work.

Part of the hard work will simply consist of playing with them, because if you are going to get involved in any way, they will not allow you to sit on the sidelines taking the odd picture as and when you feel like it. The other part will be getting your exposure settings **right, because these pictures are going to call for massive depth of field combined with the shortest shutter speed** you can find.

If you can, choose a bright day and a fast film so that you will be able to give the shortest exposures possible at the smallest apertures — this will help take care of the movement and will give the depth of field you require. Take an exposure reading and set the shutter speed and aperture, then forget about them. Don't make any alteration to your setting unless the sun goes behind a cloud, or the weather changes drastically — then either open up a stop or take another reading depending on how confident you feel. It isn't often that the light is going to change more than one stop in brightness and you will find that you need all your concentration for the actual picture-taking — look away an instant and you will find you've lost a picture.

One good tip — particularly if you're photographing children — is to chose (or suggest) a game which is going to restrict their playing area or, at least, slow them down a little. This allows you to select your shooting position and pre-focus, enabling you to devote as much of your attention as possible to the business of taking pictures. Depth of field should then take care of any minor movement away from the point of focus. Make a point, though, of never missing a picture just because you want to check your focus or your shutter speed — the picture you miss will always be the unrepeatable one.

A word about backgrounds

Just a minor point (although forgetting about it can spoil what might otherwise be a superb picture) concerns depth of field again. When

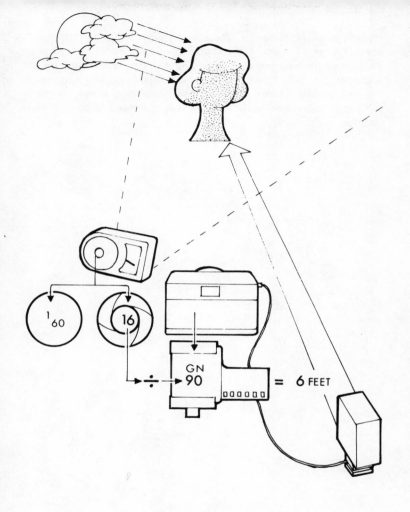

Fill-in flash. Read exposure required for daylight at suitable shutter speed for flash. Divide aperture into guide number to obtain required flash distance. Use extension flash cable if required.

COMMUNICATION LIBRARY, P.C.L., 18-22, RIDING HOUSE ST., W1P 7PD

you are taking pictures in bright or sunny weather the tendency is to use a fairly small aperture. If you do and your subject is fairly close to the camera, make a point of looking hard at the background, for the extra depth of field may bring into sharp focus unwanted objects in the background. We've all heard the hoary one about telegraph poles growing out of heads — make sure it doesn't happen in your pictures.

More Imaginative Pictures

Although this chapter is headed 'More Imaginative Pictures', don't be fooled into thinking that you can type-cast pictures into the ordinary and the extra-ordinary before you take them. Our heading is one of convenience, to separate the type of subject you might take 100 times a year from the subject you may only see once or twice. Whether a picture is imaginatively handled or not depends on you. Given the brief to take a photograph of a pretty, country cottage, 9 out of 10 photographers might do just that — produce a picture of a pretty, country cottage. The tenth, however, might go farther — he might think a little, look around, maybe see the cottage as a reflection in the polished panel of a car standing nearby and that will be his picture. Any subject, no matter how hackneyed, can be improved by using a little imagination. What we are asking you to do here is use your imagination *first*. Find unusual pictures and then record them. Of course, that is still no good if you get the exposure wrong — and exposure can be a problem.

Pictures in the rain

It takes a lot of enthusiasm to go out in the pouring rain and start taking pictures, particularly at night. If you can manage to drag yourself out of your favourite armchair and away from the 'telly', however, it is possible to produce some quite spectacular results especially if you are using colour materials.

The sort of pictures that spring to mind immediately are the ones showing busy streets with lots of brightly-lit shop windows, neon signs and car lights reflected on the rain-soaked road; girls with colourful umbrellas, crystal-clear droplets on car enamels and lots of flamboyant rainwear. Don't just be content with the obvious, though, look for the detail, as well. Notice the bedraggled dog waiting for the gap in the traffic; look for the contrasting personalities in the crowd huddling in the shop doorway (a long focal length lens is useful); watch the droplets of rain forming on the

clothes line in your own back garden. Country towns and villages can provide a wealth of material when it rains, some of them seeming to change their personality completely – particularly if they have an open-air market. Watch how everybody will either disappear completely or become even more feverishly involved in their shopping when the downpour starts.

From a slightly more technical standpoint, the things you have to watch for are: *The rain itself* – try to keep your camera as dry as possible and, if you can, prevent raindrops actually hitting the lens. They won't damage it, of course, but they will play havoc with definition. A good umbrella is a useful accessory and somebody to hold it is another. *Material* – use a reasonably fast film. This will enable you to use moderately-high shutter speeds and fairly small apertures. When it's raining, people don't hang around to be photographed and *you* certainly won't want to keep focusing and refocusing. *Exposure* – you will almost certainly be tempted to disbelieve your meter and under-expose by a stop or two, but, don't foget, it *does* get darker when it rains. Remember to take your reading from a mid-tone and there is no reason why you should't produce a correctly-exposed picture. One point in your favour here is that because contrast is often low in this type of scene and a fast material has a fairly low contrast, anyway, you do have some leeway as regards exposure – it is not hyper-critical.

Mist and fog

Mist and fog, although they can look similar, are, in fact, two different things. Mist is simply particles of water suspended in the atmosphere; fog, on the other hand, consists of particles of water plus dirt and dust. For obvious reasons, you are more likely to find fog in urban areas, where there is always some dust in the air.

Photographs taken in mist or fog can often be extremely beautiful, having a rather ethereal quality all their own – one immediately thinks of the delicate woodland scene with sunbeams filtering through the trees. In fact, this type of picture will nearly always produce an attractive result, particularly if the camera is pointed towards the sun. This is partly because the effect of the mist is to suppress detail, and partly because the objects in the picture are thrown into semi-silhouette due to the position of the sun. The pic-

ture, therefore, will consist of varying planes of soft, delicate tone. Colours will be more subtle and minor detail eliminated. If possible, it is a good idea to have a tree or a bush fairly close to the camera. This will reproduce clearly and distinctly, adding depth and dramatic quality to the picture. If it is in shadow, it will also add a more solitary, perhaps sombre note to the scene.

Because mist transmits reddish light and reflects bluish light, a yellow, orange or red filter coupled with a black and white film will tend to cut through it to a certain extent (but coloured filters absorb light and so more exposure will be required if you use one when taking a picture; more details are given on the next page).

If you really want mist to disappear as completely as possible, you must use infra-red film and an infra-red filter over the lens. These techniques are discussed on page 198. Fog is a different matter. Because it contains so much dirt and foreign material, filters and special films do not penetrate it to the same extent. Content yourself with taking pictures which emphasise the dramatic or pictorial possibilities of the subject – car headlights and brightly lit shop windows provide good opportunities for pictures.

Exposure in mist and fog is very much a hit and miss affair. Really, what you are trying to record is an impression rather than a detailed photograph and none of the recognised methods of exposure assessment are geared to help you do that. In addition, the effect of the mist will be heightened due to the high sensitivity of the film to blue light (the mist tends to reflect the blue light). By far the best advice is to take a reflected-light reading from a mid-grey tone in the usual way and then make one picture using the recommended exposure and two more pictures, one at one stop more and one at one stop less than this. Often, a slight over-exposure will add to the 'etherial' effect, but suppressing details in the misty distance. Under-exposure is more likely to produce a heavy, dull-looking picture.

Haze

One type of atmospheric effect which can be a problem on hot sunny days is the bluish haze which you frequently find obscuring distant scenes. Unlike mist, this does not contain water droplets. Again, with black and white films a yellow, or even red, filter will usually cut through this. With colour films, however, the only thing

117

you can do is use a 'haze' filter. This will not actually penetrate the haze, but it will reduce its bluishness, making it less objectionable in the picture. (A haze filter can be left in position permanently, if you wish. It requires no increase in exposure but it does eliminate the bluishness of pictures taken in the shade and also helps to protect the camera lens.)

Using filters

The use of filters in photography could take a whole book to itself (as a matter of fact, it has; The Focalguide to Filters by Clyde Reynolds will tell you practically all you will need to know about the subject). In this section we cover the important points.

The basic use of all filters (except special effects screens, such as star filters or diffraction screens, which are not really filters at all) is to stop (or absorb) one type of light and pass (or transmit) another. For example, a filter which is deep yellow in colour will absorb blue light. It transmits red light and green light (which add up to yellow). Filters are generally used in black and white photography to do just this — to modify the way in which certain colours are recorded by the film. The classic example is the use of a yellow filter to darken a blue sky. Because all films are over-sensitive to blue light, blue skies tend to reproduce as a very pale grey or even white in the finished print. If a medium yellow filter is placed over the camera lens, it will stop some blue light from reaching the film and the sky will be reproduced on the print as a deeper, more natural looking grey. Of course, it will have the opposite effect on yellows, yellow-greens and reds which will reproduce rather paler than normal.

The filters most commonly used in colour photography are the Skylight (haze) filter (which we discussed earlier in this chapter and 'conversion filters'.

Filter factors

Unfortunately, so the saying goes, 'there is no such thing in this world as a free lunch' and the price you have to pay for modifying the colour sensitivity of the film is a loss in effective film speed. Films, as a rule, have their speed rating assessed for light which is of

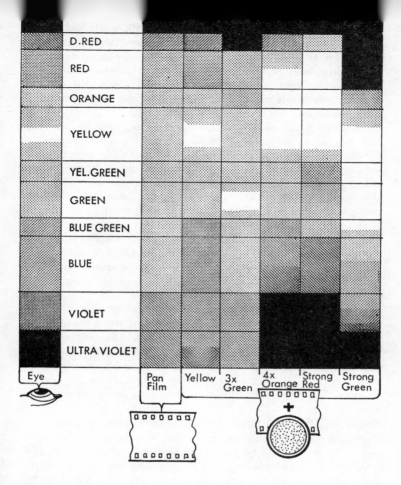

Filter effects. The density of the image produced on panchromatic films by light of various colours varies with the colour of any filter placed over the camera lens. The chart gives an approximation of the darkening or lightening effect on various colours of the most commonly used filters.

the quality of 'mean noon sunlight' — a specific whiteness of light which contains all the colours of the spectrum. When you place a coloured filter over the lens you are, in effect, de-sensitizing the film to certain colours and that means that the overall sensitivity to the film to white light is also reduced. In other words, the effective speed of the film is reduced. To make up for this, you have to give more exposure.

To help you decide exactly how much more exposure to give, every filter is given a filter factor — a number by which you have to increase the exposure you would otherwise have given. This factor is basically for guidance, however, because much depends on the colour sensitivity of the film you are using and also the colour of the light you are working in. Provided you are using Panchromatic material in daylight conditions, you can use the figure quoted.

However, if you are using orthochromatic film or are working in artificial light, then you will have to make special tests unless the filter manufacturer supplies the necessary information (it is worth noting that because of the low sensitivity of orthochromatic material to green light and its total lack of sensitivity to red light, filters of these colours should not be used with this material).

Typical filter factors would be ×2 (for a pale yellow filter) or ×3 (for a deep yellow filter). A factor of ×2 means that, using the filter, you would need to give twice as much exposure as you would without it. In other words, you have to open up one stop or double the exposure time. If the figure is ×3, you have to give three times as much exposure or open up $1\frac{1}{2}$ stops. Remember that each time you open up one stop, you double the exposure; each time you close down one stop, you halve it.

The factors for some filters are given in the table opposite.

One other filter which can come in useful occasionally, is the neutral density filter. This can be thought of as a 'grey' filter and it doesn't alter the colour balance of your film or absorb any one colour. You use it simply to cut down the amount of light passing through the camera lens. This may seem an odd thing to want to do, but there may be times when you have a high-speed film in the camera and you want to use a wide aperture to cut down depth of field (in a portrait, perhaps) or you want to give a long exposure rather than a short one (to introduce blurring).

Neutral density filters come in a variety of densities and their factors are used in exactly the same way as other filter factors. If you use

Filter	Code	Daylight		Tungsten Lighting	
		Filter Factor	*or* Exposure Increase (Stops)	Filter Factor	*or* Increase (Stops)
UV-absorbing		1	0	1	0
Skylight	1A	1	0	1	0
Amber colour-compensating	81A, 81B	$1\frac{1}{4}$,	$\frac{1}{3}$,	$1\frac{1}{4}$,	$\frac{1}{3}$,
	81C, 85	$1\frac{1}{2}$,	$\frac{2}{3}$,	$1\frac{1}{2}$,	$\frac{2}{3}$,
	85B	2	1	$\frac{2}{3}$	
	85C	$1\frac{1}{2}$	$\frac{2}{3}$	$1\frac{1}{4}$	$\frac{1}{3}$
Blue colour-compensating	82A	$1\frac{1}{4}$	$\frac{1}{3}$	$1\frac{1}{4}$	$\frac{1}{3}$
	82B, 82C	$1\frac{1}{2}$,	$\frac{2}{3}$,	$1\frac{1}{2}$,	$\frac{2}{3}$,
	80A	3	$1\frac{2}{3}$	4	2
	80B	3	$1\frac{2}{3}$	3	$1\frac{2}{3}$
	80C	2	1	2	1
	80D	$1\frac{1}{4}$	$\frac{1}{3}$	$1\frac{1}{2}$	$\frac{2}{3}$
All colours*	CC05, CC10, CC20	$1\frac{1}{4}$	$\frac{1}{3}$	$1\frac{1}{4}$	$\frac{1}{3}$
Yellow	CC30Y, CC40Y				
Cyan	CC30C, CC40C				
Magenta	CC30M, CC40M, CC50M				
Yellow	CC50Y	$1\frac{1}{2}$	$\frac{2}{3}$	$1\frac{1}{2}$	$\frac{2}{3}$
Red	CC30R, CC40R				
Green	CC30G, CC40G				
Blue	CC20B, CC30B				
Cyan/Red	CC50C, CC50R				
Green/Blue	CC50G, CC40B	2	1	2	1
Blue	CC50B	$2\frac{1}{2}$	$1\frac{1}{3}$	$2\frac{1}{2}$	$1\frac{1}{3}$
Fluorescent†	FL-D	2	1		
Light yellow	3	$1\frac{1}{4}$	$\frac{1}{3}$	1	0
Light yellow	4, 6 (K1)	$1\frac{1}{2}$	$\frac{2}{3}$	$1\frac{1}{2}$	$\frac{2}{3}$
Yellow	8 (K2) 9 (K3) 12	2	1	$1\frac{1}{2}$	$\frac{2}{3}$
Yellow	15 (G)	$2\frac{1}{2}$	$1\frac{1}{3}$	$1\frac{1}{2}$	$\frac{2}{3}$
Yellow-green	11 (X1)	4	2	4	2
Deep yellow-green	13 (X2)	5	$2\frac{1}{3}$	4	2
Green	58 (B)	6	$2\frac{2}{3}$	6	$2\frac{2}{3}$
Deep green	61 (N)	12	$3\frac{2}{3}$	12	$3\frac{2}{3}$
Blue	47 C5	6	$2\frac{2}{3}$	12	$3\frac{2}{3}$
Blue	47B	8	3	16	4
Deep blue	50	20	$4\frac{1}{3}$	40	$5\frac{1}{3}$
Light red	23A	6	$2\frac{2}{3}$	3	$1\frac{2}{3}$
Red	25 (A)	8	3	5	$2\frac{1}{3}$
Deep red	29 (F)	16	4	8	3

*Except: Yellow CC05Y, no increase, Blue CC20B $1\frac{1}{2}$ × ($\frac{2}{3}$ stops)
†In daylight type fluorescent lighting.

two together, the new factor is the sum of the two individual factors. Never be tempted to make your own neutral density filters from exposed black-and-white negative film – this will play havoc with image definition.

If you have a totally automatic camera in which the meter cell is *not* behind the lens somewhere, you can use neutral density filters to modify the exposures such a camera gives. Use one over the meter window and *more* exposure will be given, use it over the lens and less light will reach the film. The difference in exposure will depend on the filter factor, of course.

Conversion filters

Back at the begining of the book, when we were looking at films, we mentioned that colour films were only designed for use in one kind of light. If you need to use daylight film in artificial light or artificial-light film in daylight, then you have to use a conversion filter over the lens, a bluish coloured one (such as a KODAK 'Wratten' 80B Filter) when you use daylight film in artificial light and an amber coloured one (such as KODAK 'Wratten' 85B Filter) when you use artificial light film in daylight. Conversion filters call for an increase in exposure, though, and, whenever possible, it is better to have the correct film for the light source you intend to use.

Polarising filters

A rather unusual type of filter, which can be used with both black-and-white or colour films is the greyish-brown polarising screen. This will cut down, or even eradicate completely, troublesome reflections from windows, water or very shiny (non-metalic) objects – you control the amount by which the reflection is reduced simply by rotating the filter to the required position. Also in some circumstances, you can darken a blue sky without affecting the reproduction of other colours in the scene. The degree to which this is possible depends on the part of the sky you are photographing. Maximum darkening is achieved in the area of sky which is at 90° to the position of the sun and farthest away from the horizon.

Polarising filters do call for an increase in exposure – they have a

122

Polarized light. A, Light from most sources vibrates randomly: 1, only vibration in one plane is left after it passes through a polarizing filter; 2, a differently oriented filter absorbs this, letting no light through. B, Reflected light is polarized in a plane at right angles to the direction of reflection.

factor of about ×2.5 which means opening the aperture about 1 1/3 stops.

Through-the-lens meters

Most photographers who have through the lens metering cameras forget about filter factors — they simply place the filter over the lens and let the meter do the work. This can be dangerous, however, because exposure meter cells don't always see colours in the same way that the film sees them and, as a result they may cause slight over- or under-exposure. Although in the majority of circumstances this will be so slight as not to matter, it is better practice to work from the published filter factor. Take your meter reading *without* the filter, then put the filter over the lens and adjust the exposure setting according to the filter factor.

Nowadays, you can obtain a whole series of special effects 'filters' which are not really filters at all. They range from the star filter, which causes every specular reflection or point-source of light to flare into a star, through the diffraction gratings, which produce a line spectrum from each light source, to the multi-image attachments which produce semi super-imposed multiple images. These attachments are great fun to experiment with and can be used to good effect in certain types of picture. The important thing is to avoid *over*-using them. Normally, they require no increase in exposure and, in this case, a TTL meter *can* be safely allowed to get on with its job.

Sunsets

Pictures taken at sunrise or, better still, at sunset can be tremendously effective, particularly, of course, if colour film is used. Fortunately, sunsets are not too difficult to record and, provided it is well down on the horizon, you can even include the red globe of the sun itself. For this to be really spectacular, use a very long focal length lens — at least 400 mm — to make the sun appear as large as possible.

Exposure for sunsets is not very easy to assess but nor is it all that critical. Don't forget, you are exposing for the sky itself and not for

the trees, buildings or other land-based objects in your picture. Also, a lot depends on the sort of picture *you* want to produce. The best advice is to experiment, but as a basis for experiment, try taking a reading from the sky itself and then make one exposure at the setting indicated, one at one stop less than this and one at two stops less. Almost certainly, you will find that the first or the second setting will give you the result you want.

Exposure and Instant Pictures

To my mind, the greatest advantage of the instant camera is the fact that within minutes you can see the picture you have just taken and decide whether it is right or not. Then, if it is unsharp you can re-focus, if it has camera shake you can hold the camera more steadily, if it is not perfectly composed you can re-arrange the subject and, if it is not correctly exposed, you can adjust the exposure setting.

The only thing you have to watch is, perhaps, the tendency to become a little bit lazy. It's so easy to shoot a picture quickly, without taking quite as much care as you should, simply because you know full well that if anything *is* wrong you can easily take the picture again in a few minutes. Probably the best deterrent here is cost, because instant pictures are not cheap. The moment of truth comes when you have to dig deep in your pocket to purchase the next pack of film. Before you take a picture then, make a point of checking and double-checking that everything is as correct as it possibly can be. This will not only give you the satisfaction of knowing that every picture you take is a good one, it also saves you cash.

One interesting point is how instant is instant? Certainly with black-and-white materials you only have to wait about 15 seconds between taking the material from the camera and actually seeing the print. However, with the more recent colour picture systems it will take about 5 or 6 minutes for the picture to reach maximum colour and density.

Cameras

At the time of writing, only two manufacturers have entered the field of instant picture materials: one is Polaroid, who have been producing cameras and materials for the last 25 years, the other is Kodak who launched their instant picture system onto the American market in 1976. Both systems are different and therefore incompatible.

The Polaroid cameras range from the basic snapshot model which accepts only black and white film, through a wide variety of

Polaroid SX-70 colour film is exposed and viewed from the front.

cameras, some of which are produced for very specialized work, others intended for both amateur and professional use, to the SX-70, a folding, SLR camera which is quite unique in concept.

The simplest cameras incorporate a fixed-focus lens, built-in flash unit, a single shutter speed (1/200 second) and an exposure meter linked to the aperture — when this is correctly set a 'YES' appears in the viewfinder window. More expensive models have automatic exposure control coupled to an electronic shutter, focusing lenses and a lighten or darken exposure control which allows you to over-ride the meter to some extent. Some cameras will accept two sizes of film, depending on whether you want large or small pictures.

The SX-70 is a single-lens reflex which folds up into a remarkably slim unit. It has an $f8$ lens which focuses down to ten inches and automatic exposure control coupled to an electronic shutter (14 seconds to 1/180 second). It takes only the colour material specially designed for it (Polaroid SX-70 L and Film). This is because its electronic circuitry is powered by a specially-designed battery contained in every pack of film.

The Kodak cameras are totally different in appearance from the Polaroid models, although the most expensive camera in the range, the EK-8, is also a folding design. All have three element $f11$ lenses which focus down to $3\frac{1}{2}$ feet and each has an electronic shutter with a range of speeds variable from $1/20 - 1/300$ second. Each model has automatic exposure control incorporating a silicon cell. In poor lighting, the aperture is automatically set to $f11$ and the shutter speed range used is from $1/20 - 1/80$ second. In brighter conditions, the aperture closes down to $f16$ and the faster shutter speed range is used. All cameras incorporate a low-light warning in the viewfinder and a 'lighten' or 'darken' mechanism which over-rides the metering system by up to one stop in either direction. To achieve their unusual compactness, the EK-4 and the EK-6 use a system of mirrors to reflect the image, transmitted by the lens, onto the film. The EK-2 and Handle are simple versions available in some parts of the world.

Materials

Polaroid materials work on the diffusion transfer principal — that is the first image to be formed is a negative in one layer of the film. From this, a positive image is transferred, chemically, to a receiving

White Light Blue Light Green Light Red Light

Reagent will enter here

Clear plastic layer
Acid polymer layer
Timing layer
Image-receiving layer
Blue-sensitized silver halide layer
Metalized yellow dye developer layer
Spacer
Green-sensitized silver halide layer
Metalized magenta dye developer layer
Spacer
Red-sensitized silver halide layer
Metalized cyan dye developer layer
Negative base

○ Exposed silver halide
⊗ Unexposed silver halide

Clear plastic layer
Acid polymer layer
Timing layer
Positive image in image-receiving layer, visible from above
White pigment component of reagent
Negative image in blue-sensitized layer
Metalized yellow dye developer layer
Spacer
Negative image in green-sensitized layer
Metalized magenta dye developer layer
Spacer
Negative image in red-sensitized layer
Metalized cyan dye developer layer
Negative base

● Developed silver

Kodak Instant Print Film is exposed through the front and viewed through the base.

layer. The actual chemicals, which develop the film, are in the form of a jelly contained in a pod at one edge of the film sheet. As the film emerges from the camera after exposure, it passes between two rollers which break the pod and squeeze the chemicals out through the layers of the film. In some of the colour films available, a white, opaque reflective layer is formed between the negative and positive layers and the film which emerges from the camera is also the finished print. Other colour materials and all the black-and-white films require you to peel apart the negative and positive layers and some require you to coat the print with a special fixing chemical.

Polaroid films are available in a fairly wide range of types and sizes but not all films can be used in all cameras. We have quoted them ASA/BS ratings, though these do not strictly apply to instant picture materials. The most frequently encountered materials (which fit the majority of amateur cameras) are: Type 108, (ASA/BS 80, 20 DIN) which gives you colour prints, Type 107 (ASA/BS 3000, 36 DIN) a high-speed medium contrast black-and-white film and Type 105 (ASA/BS 80, 20 DIN) which produces a black-and-white print plus a **re-usable high-quality negative. There is also Polaroid SX-70 Land** Film, which can only be used in the SX-70 and 2000 cameras. This **is a colour material rates at about ASA/BS 80, 20 DIN. The other** materials can be used in special adapters on 6 × 6 and larger format cameras.

Kodak produce only one material, a colour film, which fits all their cameras; like Polaroid, its processing chemicals are located in a pod at one edge. It is rated at ASA/BS 160, 23 DIN and it works on the reversal system (rather like transparency materials). The film is exposed through the front. When it emerges from the camera, the pod is broken and the processing chemical spreads across the surface of the film under a protective layer. This sets in motion a chain reaction in which dyes are formed in inverse proportion to the amount of exposure received – in other words, the more exposure given, the less dye formed. The finished picture is viewed, right way round, through the *back* of the material.

Exposure problems

Provided you follow the rule book supplied with your instant camera, you are going to produce satisfactory pictures of the majority of sub-

jects you take. Instant cameras are really just another form of automatic camera and, as a result, provided you concentrate on the 'average' subject with no extremes of contrast or brightness, there is no reason why your pictures shouldn't be reasonable.

Remember, you have to be fairly accurate when you are focusing any of these cameras, they take a large-format picture and poor definition can stand out like a sore thumb. One of the problems is that you don't have an aperture control, as such, to control depth of field. All you can say is that with pictures in bright weather, or, when you take flash pictures close up, the aperture is going to be smaller and this will give you an increased field of sharpness.

In most instant cameras the exposure control mechanism is powered by batteries and, if they are not functioning efficiently, your picture will be too dark. Some cameras have a battery test mechanism and it is worth checking occasionally to ensure that everything is in order. Pictures which are too light can sometimes be caused by a finger, or other obstruction, partially covering the meter cell, but excessive lightness or darkness can also be caused by too high or too low a temperature during development. The instruction manual for your camera will tell you the correct temperature range for production of good-quality pictures. Likewise, don't leave your pictures in direct sunlight or on a hot surface while they are developing as this, too, will result in pictures which are too dark. If you cannot avoid the high (or low) temperature, adjust the camera control to compensate.

Controls

Most instant-picture cameras have a lighten or darken control. This does just what it says. It is not primarily intended as a processing temperature compensator, though. It is designed to help you overcome problems of exposure where the meter is fooled by an excessively light or dark area in the background. For example, if the subject is a man in a dark suit standing against a brilliantly lit, white stone wall, the camera will automatically give an exposure which is too short, causing the man to appear too dark. If you move the lighten/darken control to 'lighten' you can, on some cameras, open the aperture by anything up to $1\frac{1}{2}$ stops (depending on how much extra exposure you decide to give). The same goes when you have a

small area of light subject against a large area of dark background, but this time you move the control to 'darken' to close the aperture.

Because instant pictures cost so much, it is worth being on your guard against unusual exposure situations. If you can recognize a typically awkward subject *before* you press the button, you can make the necessary adjustment before you waste a picture — and this means you may save the cost of an exposure. With the help of experience or another, separate, exposure meter (take a reading from the camera position, then go in close and take another reading. The difference is the amount by which you need to increase or decrease the exposure) you can soon learn by how much you will need to increase or decrease exposure for any given situation. It is worth noting, however, that you can only do this if you are working well within the exposure limitations of the camera. If the camera is already giving maximum exposure, moving the control to 'lighten' isn't going to make any difference. This is because the camera lens is already at maximum aperture or the shutter speed is already at its longest exposure setting.

Artificial lighting

All instant cameras are equipped to take flash pictures. Kodak have standardized on the flip-flash — eight AG-3B bulbs each in its own reflector unit. Polaroid offer cameras with either built-in flashguns taking bulbs, flashcube or flashbar sockets or co-axial sockets which let you use your own flash unit.

We will deal with most of the flash systems fairly thoroughly two chapters on, and instant cameras don't call for any significant changes in operation. On many of the cameras, inserting the flash automatically links up the focusing scale with the aperture. This means that provided you stay within the power range of the flashbulb and don't go nearer to the subject than four feet, you will produce well-exposed pictures. The Polaroid SX-70 does more, however. By stopping down to *f*96, this camera allows you to go as close with flash as its minimum focusing distance — 10.4 inches! Using the extremely fast Polaroid black-and-white film should save exposure headaches even in quite low lighting conditions, provided you have a camera which will allow you to make use of its full potential. Of course, all the black and white materials can be used in

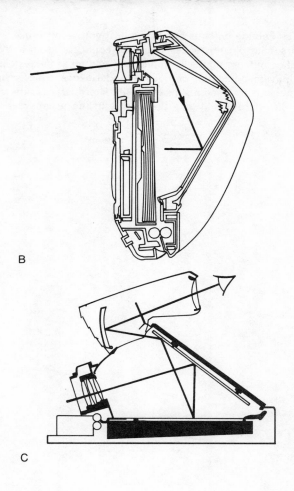

It's all done with mirrors! A, Instant pictures using a Kodak camera are reflected twice. B, In a Polaroid camera (bottom), because of the nature of the process, a single mirror produces the necessary lateral reversal of the image within the camera using SX-70 film).

tungsten lighting without filtration, but if you want to use a colour film in similar circumstances then you could try using a 'Wratten' 80A Filter and turning the lighten/darken control as far as possible to lighten. Even so you may produce an under-exposed picture and the best course is to place a similar density filter ($\times 3$) over the window of the electric eye and take the picture in the usual way.

Exposure in Artificial Light

We don't normally think of it as being so, but most forms of artificial light are very different from daylight. Try switching on your room lighting during the day and you will see what I mean. If you are in the living room it is likely that you will be using tungsten lamps — look how yellow they appear compared with daylight! In your kitchen, you might have fluorescent tubes — they can vary from something very similar to daylight in appearance, to a warm salmon pink or even a greenish blue depending on the type you have.

In fact, it is only when this colour difference is actually pointed out to us that we notice it. Normally we can go straight from daylight into a room lit by tungsten lamps or fluorescent tubes and not give it a thought. There are two reasons for this: one, is that we are so used to artificial lighting that we now accept it as the normal thing; the other is that we unconsciously adapt our vision to the lighting which is available. We *know* that the cover on the dining room table is white, therefore we see it as white even though it is reflecting the yellow lighting of the tunsten lamps.

How do films react?

Just because our vision can adapt easily and quickly to artificial light doesn't mean that films can do the same. A film can only record what is there in front of it, and if the subject is illuminated by artificial light, then the film will see it as being lit by artificial light. If we want it to appear that the light source is daylight, then it is up to us to use a filter to alter the colour of the light passing through the camera lens or to use a film balanced to suit the illumination.

Black-and-white films

Although the colour of the light source is of primary importance where we are taking pictures in colour, we do have to take it into

135

consideration to a certain extent when we are using black-and-white materials. If you have a black-and-white film, take a look at the film speed. You will notice that, in fact, two film speeds are given — one for daylight and one for tungsten light, and the tungsten-light film speed is nearly always slower than the daylight speed. This is because tungsten light sources are always deficient in blue, the very colour to which the majority of black-and-white films are most sensitive. It has almost the effect of a yellow filter over the camera lens.

The yellow filter analogy also applies, of course, to the tone reproduction of the film. If there are red or yellow objects in your picture, they will record as being rather paler than you would expect. On the other hand, blue objects will tend to appear darker. This is why, when you take portraits in tungsten illumination using panchromatic film, freckles become less obvious, lips become quite pale and flesh tones appear fairer. In the '30s and '40s, it was common practice for the serious portrait photographer to use a pale blue or green filter over the camera lens to prevent this deception. Nowadays, few photographers follow this practice.

Colour films

If you use colour and want your results to appear 'natural', you have to use a film which is balanced for the type of illumination you are using. A daylight type film for daylight is straightforward but you will find that some films balanced for artificial light are divided into two further categories — Type A and Type B.

Type A is for use with photolamps (3400 K) — known also as Photofloods. These look like ordinary household bulbs but in fact they burn much more brightly than a conventional bulb. The no. 1 Photoflood (which is the same size as a standard 100 watt lamp) gives out the equivalent of 750 watts. Because they are 'over-run', photolamps don't last as long as ordinary lamps and if you were to leave one running continuously it would burn out after about two or three hours. They also generate a lot of heat, so for the sake of both safety and economy it is wise to have them switched on only when you need them, or better still, use them in conjunction with a dimmer attachment. If you use two, you can wire them to be run in series for setting up, thus each taking only half the normal voltage. Type B film is designed for use with high-powered studio lamps.

Outdoors in bright sun, you can use a short shutter speed and a small aperture to give you overall sharpness. Pictures like this can be taken with the simplest camera – *Kodak*.

Opposite: For interiors, you often need long exposures to make use of the existing light. You must support the camera on a tripod or on solid foundation. You need a small lens aperture to produce the depth of field needed – *Geoff Marion*.

Page 137: A single direct flash source a little way from the camera produces strong modelling, and black shadows – *Colin Ramsey*.

For still life, you can choose whatever speed you need to give the right exposure. With a hand held camera, the only problem is shake — *Geoff Marion.*

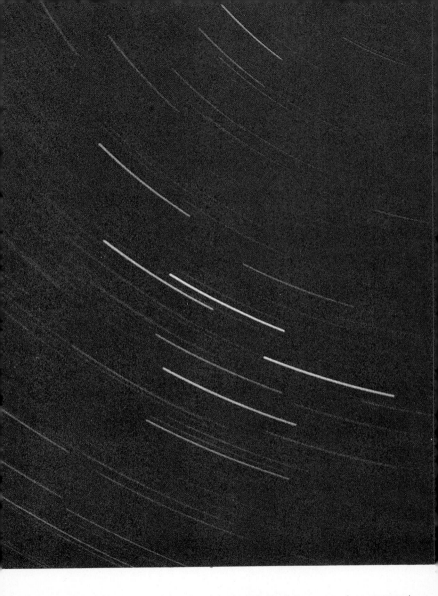

Have your camera pointed to the clear night sky with the shutter open, and you can record trails of the stars as the earth spins — *David Lynch.*

Electronic flash gives very short exposures. Go in close with an automatic flashgun, and you can reveal otherwise unseen details of movement – *David Lynch*.

Page 145 and 146: Strong backlighting can give your pictures a dramatic appeal. If you take a normal reflected-light reading from the whole subject, shadow areas will come out in silhouette – *David Lynch*.

Dancers. With action indoors, you need the fastest available film. Then you can use a combination of aperture and shutter speed to produce sharp pictures. Some grain and loss of shadow detail is inevitable, though — *Geoff Marion*.

Opposite: The exposure for night pictures is difficult to decide. The top picture was given the 16 secs. at *f*11 recommended by the meter. The bottom picture was exposed at 4 seconds at the same aperture.

Double exposure. In the dark, you can combine two or more flash pictures on one negative with the shutter held open on "B". Just keep the lens covered with a black card while you recompose the scene, then, fire the flash manually — *David Lynch.*

Exposure for reflection presents no special problems, but remember that the focus distance is that from the camera to the reflector and back to the subject. Of course, with a range-finder, or screen focus (SLR) camera, you just focus normally.

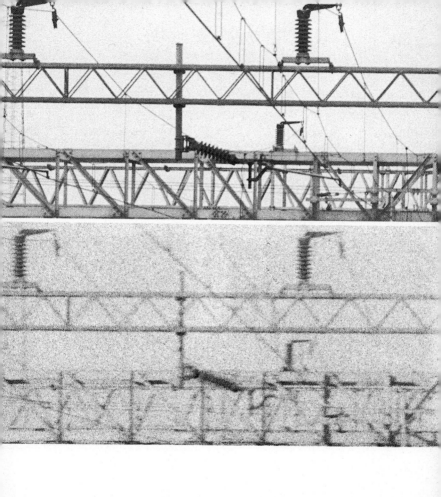

Exposure affects definition quite strikingly. *Opposite* top left and right, one stop under-exposure and correct exposure. Bottom left and right, three and five stops over exposure.

Above: Enlargements from correctly exposed and five stop over-exposed negatives.

When you go in really close, you need extra extension on your camera lens. You have to compensate for that by giving more exposure. Through-the-lens metering cameras compensate automatically, though. With close-up lenses, you need not alter the exposure settings.

These lamps produce a light which is rather more yellowish-red than photolamps. They are not over-run, so while the illumination from them is not so powerful as that from a photoflood, they do last a lot longer and they do run cooler.

Filters

Whichever film you have in your camera, if you want to use it in a light source other than the one for which it is intended, you will get the best results through an appropriate conversion filter. This, of course, will require an increase in exposure. Typical conversion filters, and the increase in exposure when using them, are as follows:

Film	to Type A	to Type B	to daylight
Daylight	80A (+2 stops)	80B (+$1\frac{1}{3}$ stops)	–
Type A	–	82A (+$\frac{1}{3}$ stop)	85 (+$\frac{2}{3}$ stop)
Type B	81A (+$2\frac{1}{3}$ stops)	–	85B (+$\frac{2}{3}$ stop)

Although the idea of two different artificial light films may strike you as being somewhat complicated, in actual fact, you will probably **standardize on one type of illumination.**
To achieve a neutral balance with transparency films, it is essential that you match film and filter. With colour negative films, the prints can be corrected for imbalance. However, you get better prints more easily with a suitable match (or filter).
Never mix light sources with either type of film. If you are using daylight film, never allow any part of the subject to be illuminated by an artificial light source – otherwise you will find a strong yellow cast in that area of the picture. Similarly, if you are using type A or type B film, don't let light from the wrong artificial light source or, worse still, from daylight, to fall on your subject. Daylight will certainly produce the least pleasing effect, causing an objectionable blue cast in those areas of your picture which are lit by it; photolamps will produce a distinct coolness when used with type B film and studio lamps will produce a rather too yellow effect when used with Type A film. A possible exception to this rule is when the odd light source actually appears in the picture. If this happens the

eye tends to accept the unusual colouration more readily, because it can see why it has occurred. Also, light sources in the picture tend to be well over-exposed, thus approaching white.

Using reflectors

It doesn't matter much what artificial light source you are using, for maximum efficiency you should use a reflector with it. A reflector gathers all the light produced by the source and directs it onto the subject, so reducing wastage of light. This, as well as enabling you to keep your exposures to a minimum, also allows you to make your lighting as directional as you wish.

Reflectors are available in a variety of shapes and sizes, ranging from large shallow dishes which give a soft, even flood of light (which is not strongly directional) to small, deep bowls which give a more concentrated beam, similar to that produced by a spotlamp. Lamps are also available with their own, built-in reflectors and while this can be convenient, it does restrict you to one type of light beam. If you are taking portraits for instance, it is nice to suit the lighting to the subject. Women and children, particularly, tend to photograph rather more attractively if the lighting is soft and diffuse and this effect is not easy to achieve with reflector-lamps without wasting a great deal of light.

Inverse square law

If you make proper use of your exposure meter, the inverse square law is not likely to cause you any problems. However, in order to understand how lamp-to-subject distance is going to affect exposure, it is worth knowing about.

It is fairly obvious that as you move a light-source farther away from a particular point, the light falling on that point becomes less. What might not be so obvious is how quickly the power of that light-source does, in fact, diminish. If your light-source is one foot away from a point and you move it until it is two feet away from that point, the intensity of the light is now only a quarter of what it was. That is because it covers an area four times the original size. This is the crux of the inverse square law. It states: 'if a surface is illuminated by a

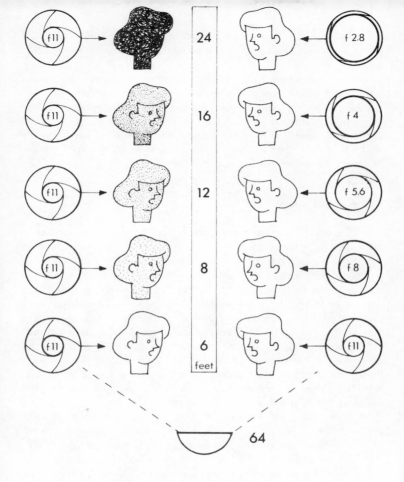

f 11 →	24
f 11 →	16
f 11 →	12
f 11 →	8
f 11 →	6 feet

← f 2.8	
← f 4	
← f 5.6	
← f 8	
← f 11	

64

Inverse square law. When the flash distance is doubled, the illumination falls to one quarter. To maintain subject brightness you have to open the lens up two stops. The background 8ft behind a subject 8ft from the camera receives only one quarter of the illumination on the subject.

point-source of light, the intensity of the illumination at the surface varies in inverse proportion to the square of the lamp-to-surface distance'.

In simpler language: if you decide your light-source is too close to the subject and you double its distance, then you will need to multiply your original exposure by four. For example, with the lamp six feet from the subject you need an exposure of six seconds at f11. With the lamp twelve feet from the subject you need an exposure of 24 seconds at f11. You can check this, quite easily, using a light source, an exposure meter and a tape measure.

Fluorescent lamps

Apart from the fact that some colours may unexpectedly record as rather unusual tones of grey, the only problem you have to face when using black-and-white materials in fluorescent light is that of shutter speed. Because fluorescent lamps pulse at twice the frequency of the electrical supply, you have to use a shutter speed long enough to bridge the gap between the pulses — otherwise you may under-expose the material. In practice, an exposure with a between-lens shutter should be 1/30 second or longer. A focal plane shutter, on the other hand, should only be used at a speed which allows the whole of the frame to be uncovered, i.e. 1/15 second or more with horizontal shutters; 1/60 second or more with the vertical type. A 'banding' effect can occur if a faster shutter speed is used due to the rise and fall in the intensity of the light.

With colour films, you have rather more of a problem. Unfortunately, no colour film is balanced for use with fluorescent lighting and, until you have made one or two trial exposures, you have no way of telling how a film is going to react to your particular light source — it won't record it as *you* see it, you can depend on that. Sometimes you can get away with using daylight type film with no filter. Try it; if the results are too green you may have to use a pale-magenta filter such as a Kodak CC30M, increasing your exposure by about 2/3rds of a stop to compensate. There are, too, special filters for this. However, success with them still depends on the exactcharacteristics of film and tube.

Alternatively, you can make tests using different types of tube (although this could prove a little expensive). They are manufactured

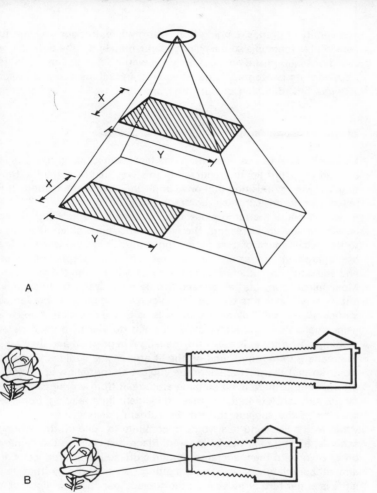

A, How the inverse square law works. A subject 12 feet from the lamp will receive only ¼ of the illumination received by a subject 6 feet away from the same lamp. For correct exposure, an increase of two stops would be required. B, The inverse square law applies to bellows extensions too. Doubling the distance between lens and film requires four times the exposure (or two more stops). Going in close with a short focal length lens avoids the need for excessive bellows extension.

in a variety of grades, ranging from warm white, through daylight to cool white. There is also a daylight colour-matching tube but, before your hopes are raised unnecessarily, be warned that this refers to its *visual* not its photographic qualities. It is, in fact, used primarily for viewing and matching colour transparencies.

More than one lamp

You don't *have* to use more than one lamp when taking pictures in artificial light but limiting yourself in this way can be rather restricting. Unless you position that one lamp very close to the camera, the result will be an extremely contrasty form of lighting.

If you do place the lamp close to the camera, the lighting will be rather flat and uninteresting. The way around this problem is always to use a minimum of two lamps, no matter what subject you are photographing; one as a main, or directional light, to provide shape and solidity, the other close to the camera to lighten the shadows. Most still life subjects can be recorded perfectly well with two lights, but when you come to take portraits you will find three or four lamps particularly useful. However, this leads us to the question, if you are using more than one lamp, at what point do you take your meter reading? The answer is to set the main light in position and then take the reading from a mid-tone on the lit area of the subject. Go fairly close, so that the unlit areas of the subject are not allowed to affect the reading. If there is no suitable area, read from a grey card *right by the subject*. Alternatively, take an incident light reading, from the position of the subject, toward the camera position.

When you have done this, you can continue to build up the lighting scheme, adding next the fill-in lamp. Place this close to the camera on its own, with the main lamp switched off, so that it produces flat, almost completely shadowless lighting. Always ensure that this lamp is either further away from the subject than the main light, or is of lower power, otherwise it will kill the effect of the main light. A ratio of about 2:1 is about right with colour films – that is, one stop difference between the main light and the fill-in lamp. You can check this is so by switching off the main light, taking a reading from the subject illuminated only the fill-in lamp and comparing this reading with the one you took for the main light. For black-and-white films, you can increase this difference to about two stops.

If you are taking head-and-shoulder portraits, no further lighting should be permitted to fall on the face, other than perhaps a rim light, for effect; otherwise you will produce a rather unattractive result in which there will appear to be two main lights (always check your lighting set-up by looking at the nose, for example, to make sure that only one shadow is cast). If you have another lighting unit, it may be useful as a background light.

There is normally no need to take any account of fill-in lights, effect lights or background lights when you compute your exposure. If any of them result in over-exposure, then they are too bright or badly positioned. Not only do they give you the wrong exposure, they give you unsatisfactory lighting. Remember, it is always your main (key) light that lights your subject. The others just add to the overall pictorial effect.

Flash

Flash is the most portable, the most convenient and certainly the most popular of all artificial light sources. At its simplest, all you do is fit a flash unit to the camera and take the picture. At its most complex, you can add a few small calculations to that procedure.

Broadly speaking, there are two types of flash units, bulb and electronic.

Bulb flash. A flashbulb is a small glass envelope, usually blue-coated to give it daylight matching qualities. It is filled with a metal foil (zirconium in the smaller bulbs) which, when ignited, burns in a brilliant flash lasting, perhaps, 1/30 — 1/60 second. Once a flashbulb has been used, all the metal foil is burned and the bulb is useless.

Flashbulbs are obtainable individually, in a range of sizes, from tiny AG-3Bs to the extremely powerful PF100s, which are about the size of a 100 watt household lamp. For most purposes, however, the AG-3B will be found to provide more than enough light. The bulb fits in a flashgun, which goes on the camera. It fires the bulb as the shutter opens.

The biggest and most powerful flashbulbs are still used by professional and news photographers to take record shots outdoors at night. They provide many times the light of a portable electronic flash unit.

Flashbulbs are also available in the more specialized form of the flashcube, the magicube, the flip-flash and the flashbar. Although quite different in appearance these units all work in a similar way. The units are made up of a group of AG-3B type bulbs, (each with its own special reflector). A suitable unit plugs directly into the camera (which must, of course, have the necessary fitting). All are fired electrically except the magicube which is fired mechanically by means of a firing pin in the camera. These units are not interchangeable and, generally speaking, are aimed more at the popular end of the market, where the primary consideration is simplicity rather than versatility.

Electronic flash. Electronic flashguns are all based on the same principle. A spark from a condensor is passed between two electrodes in a special glass tube containing a mixture of gases. The gases

A, Flashcube (or magicube). B, Simple built-in flashgun. C, Bulb flashgun with folding reflector: 1, Bulb holder. 2, Test button. 3, Exposure indicator. 4, Synchro lead. D, Electronic flash unit: 1, Front view. 2, Hot shoe contact. 3, Rear view. 4, Co-axial synchro lead. 5, Mains power adapter.

amplify the spark into a brilliant flash of light approximating very closely to the colour of daylight.

The duration of the flash is extremely short, usually 1/1000 second or less, which makes electronic flash ideal for stopping action. However, there is always a delay (in many cases of five seconds or more) between flashes while the condensors re-charge.

Electronic flashguns range from very tiny, pocket-sized models to large studio lamps powered by the mains and controlled through big consols. However, even a small pocket gun will produce enough light to enable you to take pictures of objects up to about ten feet from the camera. However, that is nowhere near as much light as you get from an AG-3B bulb. Only the largest 'pocket' electronic flashguns can match the smallest bulb. Many small 'professional' guns, too, have around the same output.

One of the nicest things about electronic flashguns is that the flashtube has an extremely long life. This makes it an extremely attractive proposition financially. Although the initial cost can be higher than that of a bulb flashgun, running costs are much lower.

Synchronization

Synchronization is ensuring that when the shutter is released, the flash is fired at precisely the right moment.

With flashcubes, flip-flash etc., you don't have to worry about synchronization, this is taken care of for you simply by the action of inserting the unit into the camera. Bulb flashguns and electronic flashguns, however, need a little more consideration, primarily because of the difference in the duration of the flash.

Let's look at the more straightforward one first. Because it produces a flash of such short duration, electronic flash must not be fired until the shutter is fully open. If your camera has a contact marked with an 'X', this is the one for electronic flash and, provided your camera has a between-lens shutter, you can use any shutter speed. If you have a focal plane shutter, you *must* use it at the flash setting if one is indicated, or, on older cameras, at 1/30 second or more to ensure that the film is fully exposed when the flash is fired. More modern cameras, with vertically-running focal-plane shutters allow you to use faster speeds, up to about 1/125 second.

If you don't know the speed for your camera, you can test it. Open

the back (without a film), connect up the flashgun, cover the lens (or lens-mount if you can remove it) with a piece of paper, and release the shutter. Try it at a range of speeds. The shortest one at which **you see the whole film area is the shortest for electronic flash.**

Flashbulbs are different. Compared with the flash from an electronic flashtube, the light from a bulb lasts a long time, taking anything up to 1/50 second to reach its peak. This means that to make the best use of the flash you must do one of two things: use a slow shutter speed (more than 1/50 second) to ensure that the whole of the flash is effective; or delay the opening of the shutter until the flash has reached peak brilliance.

If you have a diaphragm shutter camera, you can use X-synchronization with flashbulbs provided you use a slow shutter speed — that is, 1/60 second or longer. That gives the bulb time to light up. Alternatively, some cameras have M-synchronization. This **incorporates a delay mechanism, so that the bulb reaches maximum** brilliance before the shutter opens. At this setting, you can take flashbulb pictures at any shutter speed.

Cameras with focal plane shutters may have contacts marked X, M, F or FP. Again, the X is intended for electronic flash but it can also be used for flashbulbs at shutter speeds up to one slower than that quoted for electronic flash. FP synchronization is primarily intended for use with FP bulbs at all shutter speeds. These are a special class of bulb designed for use with focal plane shutters which sustains peak brilliance over a relatively long period. These bulbs are expensive, though, and difficult to find. In general, it is probably best to forget them. In some cameras, FP synchronization will work reasonably well with any flashbulb. In others, you are restricted to slower speeds (usually 1/60 and less). However, it is best to make practical tests or check your camera instruction manual regarding this one. Type M synchronization is intended to match M-sync on a diaphragm shutter. Most cameras so marked can use ordinary flashbulbs at all speeds. F-synchronization is a compromise between FP and M.

Flash exposure

Achieving a perfectly-exposed picture with flash presents only one major difficulty. Because the power of the illumination falls off in ac-

cordance with the inverse-square law, subjects in front of, or behind, the narrow plane of correct exposure will be progressively over- or under- exposed. However, for the majority of flash pictures, this is not a serious problem. Also, to some extent it can be off-set by using bounce flash techniques or even slave lamps.

Finding the correct exposure for objects a specific distance from the camera presents very few problems, however. You need to know the guide number of the flashbulb or electronic unit you are using; it can then be calculated in a second or two. A guide number is simply a **number that relates flash-to-subject distance to the lens aperture** (*f*-stop) needed for correct exposure. It is calculated by the manufacturer taking into account the amount of light provided by the unit and the film speed.

Flashbulbs are likely to have the guide numbers (and, probably, helpful exposure information) printed on their packaging. Electronic flashguns usually indicate their guide number (or the correct exposures for specific distances and film speeds) on the casing of the unit.

To use the guide number, simply measure the distance from the lamp of the object you are photographing and divide this distance into the guide number. The result will be the aperture you need to use. With flash on the camera, you can read the distance from your lens scale if you have rangefinder or screen (SLR) focusing in your camera. Otherwise, you will soon get used to estimating accurately enough. If you want to shoot at a specific aperture, divide that into the guide number and the result will be the distance the *lamp* must be from the subject. Because they relate to distances, guide numbers are different for different units of length — i.e. feet and meters. Of course, you must measure your distances in the right units.

It might be helpful, at this stage, to look at examples of how guide numbers work in practice. Supposing you have Kodachrome 64 loaded in your camera and you wish to take flash pictures using AG-3B flashbulbs.

The guide number quoted by the manufacturer for an AG-3B flashbulb when it is used in a large reflector with a film of 64–80 ASA is 120. This also assumes that it is used with X-type synchronisation in an average-sized room which is not decorated with exceptionally light or dark colours.

You can use the guide number in either of two ways: you can use it

to determine what lens aperture you must use when your subject is a pre-determined distance from the flashgun, or you can use it to calculate what distance the flash must be from the subject when you wish to use a specific aperture.

In the first case, we'll say that you are photographing a small group of people with flash on camera, and to form a reasonable composition, you need to be eight feet from them. To find out what aperture you need to use to produce a well-exposed picture, simply divide 120 by 8 and the result — 15 — is the f-number you need to set. In practice, f16 will be near enough. However, supposing you can't set f16 on your camera — it only goes down to f11 — then divide 120 by 11 and the result will be the distance the lamp must be from the group to ensure the exposure will be correct — almost eleven feet.

Most manufacturers quote their guide numbers in tabular form either in feet or metres. To find the one which is correct for you, you merely cross-reference the film speed you are using against the shutter speed (or type of synchronisation) you are using. You can then read off the guide number for the relevant units employed. Some manufacturers however, dispense with guide numbers altogether and, assuming X-synchronisation, provide a table cross-referencing film speed, flash distance and aperture — you simply read off the relevant factors.

It might cross your mind to wonder how reliable guide numbers can be. Well, in most cases, they have to be something of a compromise. While the manufacturer knows precisely what the output of his flash lamp is, he can only guess at the equipment it will be used with and the circumstances and situations it will be called upon to illuminate. The guide number he puts forward is exactly what it sets out to be — a guide for you to work from. If you could duplicate the manufacturers equipment and test situations, then you could be sure that the guide number would be exactly right for you. But, how accurate is the synchronisation on your camera? How precise are you when you measure the distance of your subject from the light source?

In most cases, particularly if you are a careful worker, guide numbers will produce very accurate exposures. You should certainly have little **cause for complaint if you use a negative-working film which has a** degree of latitude and in which slight correction can be made at the printing stage. However, it pays to be as much of a perfectionist as possible — especially if you use reversal materials, when incorrect ex-

posure, no matter how little it might be, shows. Take note then, of the situations you are working in. Don't forget the guide number was designed with an average-sized room in mind, one of average brightness. If the surroundings differ very much from this specification, alter your guide number – or, following from that, your exposure – accordingly. In a room which is fairly large, or in an average room which is decorated in rather dark colours, open up your aperture by a half or even a whole stop. In a very large, dark room, or outside at night, two stops may be nearer the mark. Conversely, in small, brightly decorated rooms, you will need to close down between a half and one and a half stop.

Guide numbers also depend on the equipment you use. For this reason, it is worthwhile making practical tests to obtain guide-numbers tailor-made to *your* camera and flash equipment. Here's how you set about doing it.

Your own guide number

Load the camera with the film you normally use. Set up a subject, typical of those you normally take by flash, a measured distance away from the flashgun in surroundings typical of those you would normally work in. Using the manufacturers guide number, work out the aperture you should give and take one picture at that setting. Then take four more pictures, one at $\frac{1}{2}$ stop and one at 1 stop *under* and one at $\frac{1}{2}$ stop and one at 1 stop *over* that exposure. Include in each picture a card identifying the aperture used in that shot.

When these pictures are processed, examine them carefully and choose the one which *you* think is the best exposed. It may well be the one taken using the manufacturers guide number and, if it is, then all is well. If it isn't, then multiplying the flash-to-subject distance by the *correct* aperture will give you your own guide number. Two points: if you are using a negative material, check the negatives rather than the prints and, don't forget, if you use a film of a different ASA speed, you will need to make another set of tests (or, as a rough guide, follow this formula: four times the film speed – double the *guide* number).

Once you have determined the guide number, you can depend on it in most circumstances. Of course, if you go outside, or into a very large room with no reflections, you will need a lower number.

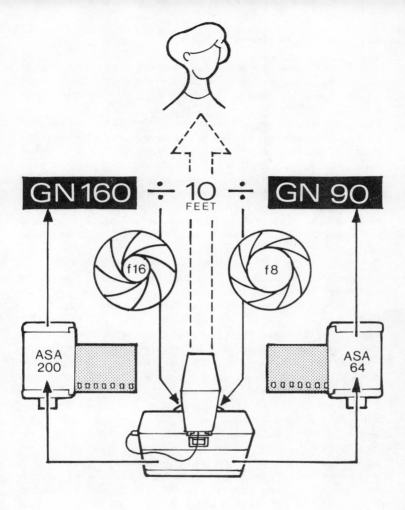

Guide numbers. Every flash unit can be given a guide number for each film speed (and for faster shutter speeds with bulbs). That guide number is the product of flash-to-subject distance and *f*-number to which the lens must be set to give correct exposure. Thus if the guide number is 160 and your subject is 10 ft away, the lens must be set to *f*16. When the calculation does not give an exact *f*-number, set the nearest.

Low output with electronic flash

Even if you have spent a lot of time calculating guide numbers to suit your own particular circumstances, there are still occasions on which an electronic flashgun will make apparent nonsense of your figures.

Part of the problem lies with the re-cycling time. After you have fired an electronic flashgun you need to wait several seconds for the condenser to recharge; most units have a ready-light which glows as soon as the gun is ready to fire. The trouble is, although at this point the unit will operate, it will not operate with anything like full power. In fact you may only get 70% of the light output of which the unit is capable. This is because the ready-light only indicates that the unit is ready to flash, not that the condensers are fully recharged and you will almost certainly have to wait several seconds longer for this to happen.

Recycling time for full light output can vary, depending on the unit, the condition of the condensers and the type and age of the batteries. If you have batteries which are past their prime, you may never achieve maximum light output though the unit will apparently flash perfectly. This is an insidious problem which will only become apparent as the quality of your pictures deteriorates. The moral is to make sure that you keep your batteries in perfect condition, recharging them if they are the re-chargeable kind or replacing them at periodic intervals if they are not. Batteries, unfortunately, deteriorate with lack of use as well as with constant use.

Another reason for loss of light output arises if your unit has been inactive for a while. Unless they work regularly, electronic condensers tend to 'de-form' and it takes an extra-long period of change to reform them completely and bring them back up to full power. This also puts a considerable drain on the batteries.

If you are faced with the problem of having to take pictures as rapidly as possible and you are unable to wait until the unit has reached full power, it is worthwhile opening up by about a half-to-one-stop to ensure that your pictures will receive adequate exposure. The same advice applies if you are not sure of the condition of the batteries or condensers, but in this case you would be better off doubling up — taking one picture based on the correct guide number and one at up to one stop more than the guide number recommends.

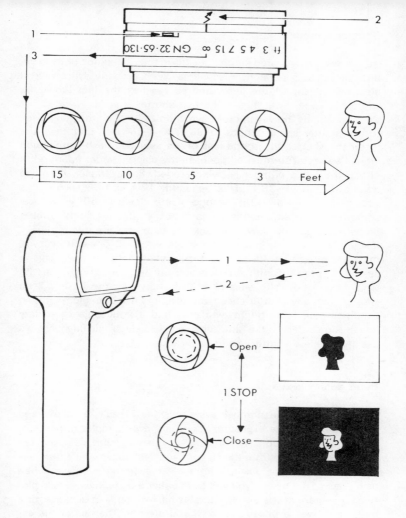

Automatic flash. 1, Guide number indicator. 2, Flash symbol set to focusing index mark. 3, Aperture varies with setting of focusing scale. Self quenching flash has sensor reading light reflected from subject. Adjustments to recommended aperture may be required for unusual subjects.

Shutter speeds

As yet, we have ignored shutter speeds in the calculation of flash exposures. That is perfectly reasonable. With properly synchronised electronic flash, all the light emitted reaches the film while the shutter is open, even at the shortest shutter speeds.

With flashbulbs, however, on M synchronization, you may well wish to use shutter speeds shorter than 1/30 second. In that case, the faster the shutter speed, the less of the available flash illumination which is used. You must compensate by using a wider aperture. In effect, the guide number is being eroded. For example, the guide number for an AG-3B at 1/30 second is 120, at 1/60 second this becomes 85 and at 1/250 second, this is down to 60. With focal plane bulbs, the situation is similar, but the effective guide number drops more quickly. Always check the bulb maker's information.

If you use a relatively long shutter speed, with bulb or electronic, you may record images formed by the existing light as well. This is seldom a problem with bulbs which are relatively bright for the whole exposure. With electronic flash, however, the flash will be shorter than any shutter speed you use, and if the ambient lighting conditions are fairly bright, you may find a noticeable secondary image is recorded on the film. When you use electronic flash, always use the briefest shutter speed you can.

Even easier ways

Although the guide number system is fairly easy to follow and guarantees accurate exposures, there are even simpler if, perhaps, less accurate systems. For instance, with the more basic pocket cameras, the advice from the camera and flashbulb manufacturers is merely that you should keep within 4—9 feet from the subject when using flash. Do this and you will have either a perfectly-exposed pictures if you are at the exactly suitable flash-to-subject distance, or a reasonably-well exposed picture if you are not. The nearer the extremes of this range you are, the less good the picture will be, particularly if you are using transparency materials.

If you wish, you can adapt this system no matter what camera you use. Work out the exposure setting for your equipment for a subject, say, six feet from the camera. Remember this and forget everything

else. You will then be reasonably certain of getting reasonably accurate results provided your subject is fairly close to this distance from the camera. You will learn by experience to open or close the aperture slightly as the subject distance varies or when the subject or surroundings are darker than average or lighter than average.

Some cameras have a special coupling between the focusing scale and the aperture scale for flash. You set the guide number and, as you focus the lens, the aperture automatically adjusts to the correct setting. This has the additional advantage of ensuring that you never take a picture outside the range of possibilities with your camera/flashgun combination.

'Computer' flashguns

However, even this simple system pales into insignificance against the 'automatic' or 'computer' flashguns – those electronic flash units which have their own exposure metering systems.

The flash unit itself has a light-sensitive cell. When the flash is triggered, the light from it hits the subject and is reflected back to the cell(as well as to the camera in the usual way). This calculates when the subject has received the correct exposure and cuts off the flash. When you consider that an electronic flash usually lasts no longer than 1/1000 second, you will realise just how quickly this system works (quick as a flash, one is tempted to say!).

The simplest 'computer' flash units don't allow you any choice of aperture. You check the speed of the film you are using on a table marked on the flashgun and read off the aperture you need to set on your camera and the distance range within which you must work using that film. Using a film speed of ASA 25, the combination is likely to be in the region of 2–12 feet at f2.8.

More sophisticated units allow you to select from a range of apertures. The slightly more powerful compact guns give you the choice of two or three apertures; on the bigger 'professional' models, there may be a choice of five or more stops and in-between settings. You decide which aperture you wish to work with and set it, both on the camera and the flashgun. Provided you stay within the distance range specified, you then can forget about exposure. The distance ranges vary, depending on the power of the flash unit you are using

171

COMMUNICATION LIBRARY, P.C.L.,
8-22, RIDING HOUSE ST., W1P 7PD

and the speed of the film you are working with. However, with an ASA 25 film and an averagely-priced automatic gun, a working range of around 18 inches to 16 feet may be expected.

There are several benefits to be gained from working with computer flash guns, over and above the major one of automatic exposure control. For instance, many computer flash guns have the ability to save and store energy. In a conventional electronic flash unit, all the power discharged by the condensers is used to fire the flash. If this produces more light than you need, you simply stop down. With computer flash, it is only rarely that the full output of the unit is used. More often than not, exposure is completed and the flash cut short well before it has achieved its potential duration. In the original designs, the condenser still had to discharge fully. If after the flash had been fired, there was power over, this was dissipated in a 'quench tube'. Most of the more recent designs make use of special circuitry incorporating a thyristor which retains the excess energy in the condenser for the next flash. The benefits are: faster recycling times, less drain on the batteries and more flashes from each set of batteries.

The fact that the flash is cut off as soon as the exposure is complete means of course, that exposures are frequently shorter than 1/1000 second. In fact, some popular flashguns will operate for a brief a period as 1/50,000 second. This opens the way into a whole new world of high-speed photography for the amateur; but, remember, unless you have special shutter tripping equipment, there are going to be occasions when you will need rather quick reactions.

Most computer guns will also permit manual operation, should you need to work outside the aperture or distance range they offer. Some also allow you to alter the power output of the unit when it is used manually. You can make use of this facility to permit shorter recycling times and reduce the drain on the batteries.

Computer guns have the advantage that they give the correct exposure even if they are fired before they are fully charged. Unfortunately, though, they have no mechanism to tell you when you are out of range. Every gun has a maximum guide number — the one you use when you want to work things out manually. The exposure control works by *reducing* the light from the manual level. Once you go beyond the guide number calculated distance for the aperture you have set, you get under-exposure whether on manual or automatic operation. The calculator discs for most guns make that clear. On a

medium-sized gun, it may be about 16 feet at the largest aperture you can use with particular film.

Individual auto-flash systems

Some cameras have their own individual method of ensuring accurate results with flash. The Olympus OM-2, for example, has a metering system which measure light reflected from the film itself. When the camera is linked up with the Olympus Quick Auto 310 flash unit, the flash intensity is measured by the camera itself and cut off when the correct exposure has been made. The primary advantages of this system are speed and convenience. Instead of camera and flash being separate units which have to be set individually to ensure correct exposure, by this method they link together to become one integral unit making duplication of film speed and aperture setting unnecessary. Once the camera is set, the flash is set. Also, the system works whatever lens aperture you use (within the limitations of the flashgun's maximum power) and whether or not the flash is on the camera. It must, of course be linked to it through the appropriate connecting lead.

Canon also have two automatic flash systems which they say guarantee absolutely reliable flash exposures. One — called the CAT system, works by means of an electrical signal which is fed into the metering system of the camera from the focusing ring. On the basis of this signal (and the charge level of the flash unit) the correct aperture is automatically selected. On the AE1, the speedlight 155A, sets the shutter to 1/60 second, and chooses a suitable lens aperture (on EE) according to the settings of the flashgun. If you release the shutter before the flash is charged, you get no flash, but the camera sets the shutter speed on its dial, and a suitable aperture. On the AT-1, the flashgun sets the shutter speed, but not the aperture.

Flash meters

For anybody who becomes really serious about taking pictures by flash — serious enough to create their own studio set-up that is, — a sound investment is likely to be a flash exposure meter. They are not

cheap, though, and to justify the purchase of one, you would need to take a great many flash pictures.

In essence, flash meters are similar to the familiar incident light meters, they measure the amount of light falling on the subject. To use one, you simply connect it to your master flashgun, place it in or very close to the subject position, and, using a button on the meter, fire the flash. A needle on the meter dial then gives you a reading which you transfer to the calculator portion of the meter to read off the correct aperture. Although they are slower and a lot less simple to use than a computer flashgun, used correctly, flash meters are capable of producing much more accurate results. This is because they are measuring only the light falling on the subject as opposed to light reflected from the subject — and anything else that happens to be in the picture area. They also allow you to balance the lighting set-up to your own personal satisfaction by measuring the amount of light from each individual flash unit.

Flash off the camera

While flash on the camera will give you a result, it certainly won't be a terribly exciting one in terms of quality or imagination. The lighting will be very flat with little modelling, the shadows will be jet black and, if it is a portrait, it is likely to suffer from 'red-eye' — light being reflected back from the retina of the eye.

There are several ways of achieving better and more imaginative lighting with flash. The simplest is to take the flash off the camera and point it at the ceiling (provided there is one and it is low enough to prove useful) or a suitable wall. This is called bounce flash and it provides a very soft, natural-looking illumination. You must be careful, though, for if you are using colour film, a coloured ceiling or wall would effectively provide coloured illumination.

Bounce flash exposures

When you use this technique you are asking the lighting to do a lot more work; it has to travel to the ceiling (where a lot of it will be absorbed) and then down to the subject, so you need a flash and film combination with a fairly high guide number (around 120). The best

174

way to arrive at the correct exposure using this method is to make tests, but of course this is not always possible. A good rule of thumb in a normal-sized room is to divide the guide number by 23 to arrive at a reasonably correct aperture. Alternatively, measure the distance from the flash unit to the subject (via the ceiling, of course), divide this into the guide number to arrive at the aperture and then open up one stop to cover the light lost by absorption etc.

Computer flash guns measure the amount of light reflected back to them. To calculate the correct exposure, the cell should point toward your main subject from the camera position. It can do that either if it is separable, or if you can tilt the gun on the camera without tilting the cell. If not, you are not going to get the correct automatic exposure. In this case, you have to set the gun to manual operation and work out the exposure as you would for any other flash unit.

Units with a separate sensor, which can be mounted on the camera to monitor the light reflected back to the film itself are ideal. The cell can 'see' what the camera is seeing, wherever the flashgun is.

Paraflash

Another, more controlable form of bounced flash is called 'paraflash'. This makes use of a reflector unit which looks just like a large white umbrella on a stand. The flashgun is placed about where the handle would be on a conventional umbrella, pointing into the centre of the brolly. The whole thing is then aimed at the subject to be photographed. The lighting which reaches the subject is soft and slightly directional — similar to the ideal north light of an artists studio. Paraflash units are also available with the reflective area coated in silver or gold foil. Both give more directional lighting than the matt white version, but the gold also gives warmer results which are particularly pleasing for portraits in colour.

Paraflash has many advantages over bounced flash but the most important of these is consistency. Once you have made your own tests using your own flash equipment you will have a guide number which you know is not going to vary according to the height of the ceiling or the distance of the nearest wall. You also know that you are making the most of the flash power you have available — most of it being directed on to the subject and as little as possible lost in travelling to the reflector and back again. Umbrellas do vary in

quality, though, which is why it is important to make your own tests. Some will reflect a very high proportion of the light directed on them, others will absorb and transmit some of the flash. As a guide, you can count on having to open up at least one stop to take account of a brolly.

Multiple flash

Multiple flash offers flexibility of lighting but requires more than one unit. If you were to simply take your flash unit off the camera and raise it up and a little to the side, the quality of the lighting would improve immediately, but you would have some very unpleasant black shadows to worry about. The result is, though, often quite satisfactory in light-coloured surroundings — then, much light is reflected into the shadows. A suitably placed white reflector is also useful for this. However, the best is a low-powered fill-in flash somewhere near the camera position. If you are enthusiastic about flash and want to produce good pictures, the thing to do is invest in some 'slave' units. These are small photocells which sense a flash from another gun, and complete a circuit. Connected to a flashgun (through the usual cord), the photocell fires the flash as soon as it sees the flash from the main unit. Reaction time is extremely fast, so no appreciable delay will be experienced between the firing of the main unit and the slaves.

Slave units are usually, but not always, used to give electronic flashes. When you are buying guns to use with them, try to ensure that they have the same guide number as your main unit — this makes it much simpler to work out the distances they need to be from the subject to give you the lighting balance you require. Always work out your exposure in the normal way, as if you were using your one main unit only. Disregard the slave units — they are only producing secondary illumination either for fill-in or for effect.

One simple way to arrange a fill-in light is to use a computer flashgun on your camera. Set up your main light at a suitable position and distance. Calculate the (manual) aperture it needs. Set that on the camera. Put your computer gun on the camera set to give a full exposure with an aperture two stops larger. Eg: if the main flash needs f8, set the computer gun to work as if the camera were on f4. Now you get a fill-in lighting from the camera position whenever

you move. Of course, once you have made some test exposures, you can modify the ratio of aperture settings on camera and flashgun to give you just the right result.

If you have 'hot shoe' synchronization, this system obviates the need for any trailing cords. The fill-in light can be used to fire the other flashgun(s) through slave controls.

Flash in daylight

Earlier on in this book we talked about using flash in strong sunlight to provide some fill-in illumination. This is a great idea but it can cause some headaches regarding the exposure required and the amount of flash which is needed. Too much flash and the roles become reversed. The flash takes over as main light and the sun becomes the fill-in. Too little flash and the exercise becomes pointless.

The answer to the problem hinges on the exposure needed and this must always be based on the daylight readings you take. Take your reading in the normal way, from a mid-tone which is fully illuminated by the sun. To arrive at a natural looking result you then have to arrange your fill-in flash so that, if it alone were illuminating the subject, it would under-expose by about two stops. Say, for example, the daylight exposure required is 1/60 second at f11; then, to give a suitable degree of fill-in lighting, the flash exposure should require an aperture of f5.6 at that camera-subject distance. Should it require a wider aperture, which is unlikely in this sort of situation where the subject will be fairly close to the camera, there is not much you can do. If it requires a smaller aperture, however, then there are three alternatives open to you. You can cover the flash with a handkerchief, or several layers of tissue to cut down its intensity, you can move the flashgun further away, or you can use a slower shutter speed and close down the lens aperture to compensate. For this type of operation, an automatic flashgun can either be set to the manual mode or alternatively, you can set the gun for auto exposure at two stops wider aperture than you are using. Many of the units which employ energy-saving circuitry will let you select the output of the gun even in the manual mode, in which case all you have to do is select the appropriate output for your purpose. The exposure dial on the flashgun may help you calculate the power you need.

Close-up

When you use flash at very short distances – 2 feet or less – the guide number ceases to be reliable and, if followed, will produce pictures which are under-exposed. There are two reasons for this: first, close-up with flash, the inverse square law breaks down. This is because it specifies a point-source of light and, while a flash can be assumed to be near enough a point source when it is used at distances of 3 feet or more, this assumption will not hold true at shorter distances. Second, guide numbers are calculated on the basis of a medium-sized room with light-coloured walls to reflect the flash. When the flash is very near to the subject, however, the proportion of reflected light to direct light is minute.

To compensate for this effect, at distances of 1–2 feet, open up one stop more than the guide number recommends; at 12 inches or less, open up two stops.

Low Light Exposures

Remember those suntanned blondes on that searing Mediterranian beach? Well, supposing it's about 11 o'clock at night and you're escorting one of them to a night club. The lighting is low (a candle on every table), the mood is quiet and intimate, she is wearing a black **evening dress and looking magnificent. By the merest chance, you** have your camera with you. What do you do?

In this sort of situation, there is one thing that you certainly will *not* do. You will *not* fit a flashgun to your camera and take pictures. If **you do, there are two things you can be sure of: one, you will certainly get a picture; two, it will prove a bitter disappointment, because you will have killed every last bit of atmosphere that might have existed. Instead of the velvety-darkness softened only by the candlelight, you will have a wealth of detail picked out by the bright, hard lighting of the flash. Not much warmth or intimacy about that!** There is only one way to record a picture of this nature and that is by using the light which is actually there at the time — the existing light.

Existing-light photography

When you know in advance that you are going to be taking existing light pictures, it pays to load your camera with reasonably fast film — the word 'reasonably' is there because a lot depends on the lens apertures and shutter speeds you will be using.

In a situation such as the one described above, you will not need great depth of field so you will be able to use the widest aperture your camera has, if necessary. Similarly, there will be very little subject movement while you are actually taking the picture so you will be able to use a fairly slow shutter speed.

You have to use judgment coupled with experience — if your camera has a maximum aperture of *f*5.6 you will certainly need a much faster film than the person with an *f*1.7 lens — unless you plan to use really long exposures with the restrictions of the subject remaining still and the need for a camera support. If you can, use a film which

179

will allow you to keep a little in reserve — don't plan to work to the limits, but bear in mind also that the faster the film you use, the less good the image quality is likely to be. One curiosity, though: in *really* low-light conditions — found only in specific work such as astronomical photography — you *have* to revert to slow films. They have a lower threshold of exposure. In other words, if you wait long enough, they will produce an image when the light is so low that you will never get anything on a fast film. This, fortunately has no bearing on 'normal' low light-work.

Calculating the exposure

Given a situation such as the one above, how do you begin to work out the exposure? The answer is probably 'with great difficulty'; so much depends on the particular circumstances, the equipment you have, experience and, of course, luck. However you work the exposure out, though, you *must* remember to bracket exposures — this is the only way to ensure success. Exposure calculation in low-light situations is a perilous affair and the best insurance is always to hedge your bets. One stop either way is a must and if you *really* want to be certain, then two stops is better. Remember, too, that some sort of picture is always better than none at all and, for available-light pictures. A well-exposed picture here, is often simply 'something on the film'.

Because the lighting is likely to be extremely low, a selenium-cell meter is not always a great deal of use — particularly if you use it in the conventional way, to read from a mid-tone. A better idea is to use it to take a highlight reading, say from a handkerchief, or a piece of white paper near the subject's face and then to open up about $2\frac{1}{2}$ stops. Low-light scenes are usually very contrasty, though, and, if you are pushed and provided you are not too worried about securing detail in the shadows, you will almost certainly get away with an increase of only $1\frac{1}{2}$–2 stops. Slight under-exposure will frequently help to catch the mood, or the atmosphere.

A CdS cell meter, especially one with a 'booster' designed for low-level reading is much more accurate: but it can take several *minutes* to reach the right reading. The more recently introduced SPD and GPD cells are more suitable.

One thing to guard against when taking meter readings from difficult

subjects such as these is including the light source in the area which the meter 'sees'. It's often a great temptation when you see the needle start to flicker, to perhaps subconsciously move the meter towards the light source and thus produce a very wrong exposure. It is particularly easy to fall into this trap, oddly enough, using a TTL meter. You include the light in the bottom corner of the picture when you make your reading, and then lose it as you take the picture. Even if you do plan to include it in the picture, you certainly must not allow it to affect your meter reading.

Out of doors

Much the same sort of advice applies to the typical outdoor low-light situation — illuminations, floodlighting and brightly-lit street scenes at night. By far the best teacher is experience and that is not simply evading the issue, it is fact. Although it is not always easy to make a meter reading in these conditions, there is the compensating factor that exposure is not usually terribly critical. Even using fairly slow transparency materials a stop (or more, perhaps) either way is not likely to raise any eyebrows. The more exposure you give, the more detail you are going to get in the shadows (although this can reach the point where it begins to look as though the picture was taken in daylight). The less exposure you give, the more detail you will record in the highlights, although this will mean that they look less brilliant. Again the major safeguard is to bracket your exposures; one, or even one-and-a-half stops either way can make all the difference.
On the opposite page is a guide to the exposures you may need to give with specific film speeds. Use this as a starting point and you will soon learn what sort of results please you and how you need to react to different low-light situations.
Sometimes, of course, you are really up against it and no amount of metering is going to help you. I'm referring to the limits which may be imposed by your equipment. If your camera has only a very modest aperture and no shutter speeds slower than 1/30 second then you either take a chance and do the best you can, or you forget the whole thing. Some of the simpler cameras do have a 'B' or 'T' setting and, provided you can find some support for the camera or you can brace it against a wall or tree, this can be the answer to the problem.

SUGGESTED EXPOSURES FOR AVAILABLE LIGHT PICTURES

| Subject | Film speed (ASA) | | | |
	64	100	160	200
Candle-lit close-up	1/2s _f_2	1/4s _f_2	1/4s _f_2–2.8	1/8s _f_2
Brightly lit street scenes at night	1/30s _f_2	1/30s _f_2.8	1/30s _f_2.8–4	1/30s _f_4
Neon signs etc.	1/30s _f_4	1/30s _f_5.6	1/30s _f_5.6–8	1/60s _f_5.6
Floodlit buildings	1/2s _f_2	1/4s _f_2	1/4s _f_2–2.8	1/8s _f_2
Fairgrounds	1/15s _f_2	1/30s _f_2	1/30s _f_2–2.8	1/60s _f_2
Fireworks and lightning (shutter open for several bursts)	_f_5.6–8	_f_8–11	_f_11–16	_f_11–16
Theatre performances, ice shows and circuses (brightly lit)	1/60s _f_2.8	1/60s _f_4	1/60s _f_4–5.6	1/60s _f_5.6
Boxing, wrestling	1/60s _f_2	1/60s _f_2.8	1/60s _f_2.8–4	1/60 s_f_4
Star trails (shutter open)	_f_2	_f_2.8	_f_2.8–4	_f_4

Long exposures

At this point, you may be tempted to say 'in for a penny, in for a pound', close down the aperture to obtain maximum depth of field and give a proportionally longer exposure. Before you do, let me just mention — reciprocity law failure! Horrified? Of course you're not. Reciprocity law failure means simply that when exposures start to get abnormally short — around 1/1000 second or less or abnormally long — around one second or more, the amount of exposure the film requires ceases to relate directly to the amount of light it receives. Thus, if your exposure meter recommends 5 seconds at _f_11, it is likely that the film will really need about 10 seconds at _f_11. If you think 1 minute would be fairly accurate, try 3 minutes, too.

This effect, apart from being a minor irritation, isn't really a problem with black-and-white films. With colour, however, where three emulsions are involved, each reacting differently to the reciprocity law, it can cause colour balance problems which cannot be resolved.

Kodacolor II Film, for instance, loses blue and green speed more rapidly than red, producing results with a cyan cast. Astronomical photographers have found that chilling the emulsion during exposure can help, but unless you have some pretty effective portable refrigeration equipment you'll need rather cool weather. They reckon that optimum temperatures are in the region – 20–30°C! In fact, there is no way around this problem, really, although some manufacturers do recommend special filtration when very long or very short exposures are going to be made. If you plan to do a lot of this type of work and you think that failure of the reciprocity law might affect you, then try contacting the film manufacturer for advice. He will, almost certainly, be willing to help you. Unfortunately, though, even he may not be able to be specific. The effect can vary from batch to batch of the same film type.

Fireworks and thunderstorms

Firework displays and electrical storms, although they usually occur under vastly different circumstances, can provide beautiful and very exciting pictures. Ground-based fireworks are fairly straightforward and, provided you can find a support for the camera, relatively easy to take.

For really spectacular pictures, however, the rockets and mortars take a lot of beating, and the trick here is not just to record one starburst, but to include two or three on the same frame. Some cameras allow you to do this quite easily. They have an over-ride on the double-exposure prevention, or even no double-exposure prevention at all. However, if your camera has a double-exposure prevention which cannot be over-ridden then the thing to do is set the shutter to 'B' or 'T', place a dark-coloured card (or a glove, or hat) over the lens and then uncover it as the rocket explodes in the sky. However, for this technique, you really *must* have the camera on a tripod, so that you can concentrate solely on making the exposures. Typical settings for photographing fireworks are given on the table on page 182.

A similar method can be used for photographing lightning after dark during a thunderstorm. Here, you need to be as high as you can (and, preferably, indoors out of the rain of course) so that you can look across the tops of trees and houses. Spend a few moments assess-

ing the direction of the storm, then place the camera on a table, or tripod or window-cill, set the shutter to 'B' or 'T' and cover and uncover it as the lightning flashes. If there are no really light areas, such as street lamps or shop windows in your picture, then an even easier method is to merely uncover the lens, allow two or three flashes to record, and then cover it again. Don't try to record more than three flashes, or the picture will look contrived and a little messy.

Occasionally, taking pictures in this way can produce rather an unusual effect. When part of the emulsion receives a very short exposure to very high intensity illumination and a long exposure to moderate intensity is given, the two don't always add up in simple fashion. In fact, the opposite may be the case, and the result is a reversal of the first image — in other words you get black lightning. This effect is more likely to occur when there is still some daylight about.

Star tracks

The stars at night will provide an unusual and spectacular subject for any camera capable of giving a time exposure — how many photographers do *you* know who have produced pictures of startrails? And don't plead ignorance of astronomy as an excuse for not having a go — that's something you'll learn as you go along. So wait for the first dark, clear moonless night to come along and then out into the garden with your camera!

The first thing you need is a good, solid tripod which really stands firm; without this, your star pictures are limited to placing the camera on it's back, on a wall, pointing straight up (unless you go to a great deal of trouble). The next thing you need is a black card, to start and end your exposures (even a cable release may cause a slight jarring which can ruin the point image of the star or planet). For maximum effect, load up with a colour transparency material of a speed around, say, ASA/BS 160.

To begin with, try photographing a star trail (we all know that it is actually the earth which is moving, but in your pictures, the opposite is going to appear to be the case). Point the camera so that the North Star is centred in your viewfinder, set the lens aperture to about *f*4, then start the exposure. You can now go away and watch

TV, read a book or have a nap for anything from about 15 minutes to several hours. How long you make your exposure for will decide how long the star trails will be. If you're lucky, you might even get a shooting star or a satellite crossing your path. Whatever happens, you will produce a very unusual picture.

There are lots of possibilities in the night sky for pictures. You can photograph the constellations, satellite trails and even the signs of the Zodiac without having any special equipment. What you *must* have, though, for best results, is the darkest, clearest atmosphere you can find.

Processing for extra speed

Although we are not going to enter into any detail here, it is worth pointing out that many films can be persuaded to produce a little more apparent speed if processing is modified. Certainly, for the sort of pictures we have been discussing in this chapter a high ASA speed can often be a life saver. There are some things you should consider, though, before you decide to adopt a higher speed setting for your films.

First, not all films are suitable. Kodachrome films, for example, can only be rated at the manufacturers recommended ASA speed. Slow films are not particularly adaptable, either, but if you are going to process for speed, then it would seem to make sense to use a fast film in the first place. Faster films are usually fairly low in contrast, too, and this is a definite advantage because extended development (which is usually what is meant by modified processing) tends to push up contrast considerably.

Second, quality will almost certainly suffer. Every manufacturer who produces films lays down conditions under which that film should be processed to ensure that it produces optimum results. He is as concerned about emulsion speed as we are, and if he thought that he could rate his material at a higher ASA speed and still maintain optimum quality, he would do so. Almost certainly, any film which is processed to produce a significant increase in speed will show an increase in granularity, contrast and fog and a deterioration in shadow detail, sharpness, colour saturation and, usually, colour correctness.

Third, you have to decide before you start exposing your film what speed you are going to work at. Unless you are happy to start cutting

your film into short lengths, you can't alter your meter setting half-way through a roll of film simply because you have run up against a low-light situation. A modified ASA speed means modified processing, so start as you mean to go on.

As far as the practicalities go, for black-and-white films, choose a reasonably fast material, such as Tri-X or HP4 or 5 and a general-purpose film developer such as D-76 or ID4. Then, as a rule, you can reckon that a 50% increase in development time will compensate for 1–2 stops under-exposure. The softer the contrast of the original scene, the less exposure you can usually make do with and the more you can increase development time, but, before you make any serious exposures DO experiment first.

Colour print films can be push-processed but not usually in the manufacturers recommended chemicals. You may have to do a certain amount of detective work if you want extra film speed here.

Most colour reversal materials which are compatible with Kodak E–4 or E–6 chemicals can be processed for increased speed. Try 33% more time in the first developer for a doubling in ASA speed and 75%–90% more time for four times the speed.

But, and this is a big but, in all cases carry out tests first; and don't expect miracles!

Close-ups

Any photographer worth his salt, at some time or another, takes closeup pictures. A rose in the garden, a bee in a flower, a spiders web glistening with dew — they and a thousand other subjects plead with the photographer to take a few steps closer.

Equipment

Without a doubt the ideal camera for close-up work is the single-lens reflex. In any other camera except an SLR, the lens and view-finder are in different positions, and don't see quite the same thing. Normally this doesn't matter at all — most pictures are taken from a distance which makes this separation unimportant. However, the closer the camera approaches to the subject, the more critical this separation becomes until, from a distance of a few inches, although you may see the subject centred in the viewfinder, the lens may miss most of it. This little problem is called parallax, and the only camera which *cannot* suffer from it is the one which allows you to view the image of your subject through the taking lens: that means, for most, the single lens reflex camera.

If you don't have an SLR, then the way to ensure that the subject is going to be centred in the picture area is to view it through the viewfinder ensuring it is positioned perfectly correctly. Now, without altering the tilt of the camera, move it physically until the lens occupies exactly the same position that the viewfinder did when you were setting up. In other words, if the centre of the viewfinder is exactly $2\frac{1}{2}$ inches above the centre of the lens, then the whole camera must be raised $2\frac{1}{2}$ inches to compensate for parallax after the picture has been composed.

Another benefit of the SLR, of course, is that it does away with tape measures and guesswork. Because you see the image of your subject through the taking lens you can *see* whether it is sharp, and whether the depth of field is right and whether or not those leaves in the foreground are going to intrude in the subject area.

187

Accessories

There is another reason why the SLR reigns supreme in the world of close-ups — it is, in most cases, a system camera. Part of this system will include a bellows unit, extension tubes and even a lens reversing ring to enable you to get the sharpest possible pictures from close up with the standard lens. It is also likely to have through-the-lens metering, and if, like me, you have a mental block when it comes to working with figures, you will learn to love that feature. You'll see why a little farther on. In the meantime, let's look at the simplest way to take close-ups.

Close-up lenses

Whatever camera you own, you can take close-ups with relative ease simply by slipping a close-up lens in front of the camera lens. These little accessories are cheap and will provide reasonable, if not exactly critical, definition — especially if you stop your camera lens down to about f8 or f11. Commonly, they come in three strengths — +1, +2 and +3 — the table below shows you how near to the subject you can go with each one.

Close-up lenses demand no increase in exposure (which could be one of the reasons for their popularity!) They require some fairly skilled work with the tape measure between the film plane and the subject.

Extension tubes and bellows attachments

Extension tubes and bellows attachments can, theoretically, be used with any camera accepting interchangeable lenses. For practical purposes, however, due to the difficulties of seeing what you are going to get on the film and focusing, they are best used only with SLR camera.

Extension tubes and bellows attachments both fulfill the same function — they move the lens further away from the film plane to focus on a closer subject; and so give you a larger image. To achieve a life-size image of an object, you need to move any lens to a distance of twice its focal length from the film plane. In other words, a

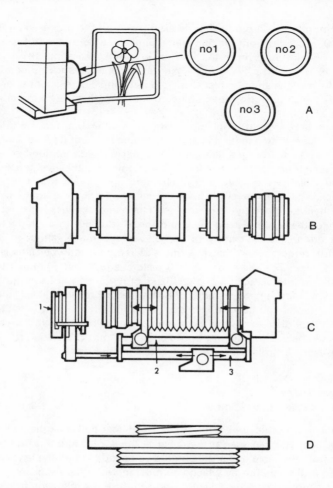

Three ways to go in close. A, Using supplementary lenses (and a wire frame to prevent focusing and parallax problems) needs no extra exposure. B, Using extension tubes moves the lens further away, and needs extra exposure. C, Using bellows, which also needs extra exposure. The unit shown here is set up with a slide-copying attachment: 1, Slide-copier attachment. 2, Bellows. 3, Focusing slide. When going in close a lens reversing ring can often help you produce sharper pictures.

50 mm lens will produce a life-size image on the frame when it is 100 mm away from the film plane. Similarly a 28 mm lens needs to be 56 mm away from the film to do exactly the same thing.

From the point of view of keeping as short a distance as possible between lens and film plane, therefore it can be convenient to use a lens which is of less than standard focal length for extreme close-ups.

There is one slight problem which occurs when you move a lens a significant distance (that is, more than about 1/5 of its focal length) further away from the film plane. The marked aperture numbers can no longer be taken at their face value. Remember the inverse-square law which we quoted a few chapters ago? Well, that law also applies to light travelling from the lens to form an image and the farther you move the lens from the film plane, the less is the intensity of the light reaching the film plane. If you have through the lens metering, this isn't likely to bother you too much (although it is worth remembering that at same-size reproduction your lens is, in fact, two stops the poorer – f2.8 becomes f5.6) but you must take this fact into account if you use flash or if you do not have the TTL facility. Most extension tubes or bellows attachments will tell you by what factor you need to increase your exposures for any given lens to image distance but in case you get stuck, here is a table which should help you. It is only applicable to 35 mm cameras, but it can be used regardless of the focal length of the lens.

Width of field (inches)	12	6	$3\frac{1}{2}$	2	$1\frac{1}{2}$	1	
Open lens by		$\frac{1}{3}$	$\frac{2}{3}$	1	$1\frac{1}{2}$	$1\frac{2}{3}$	$2\frac{1}{2}$
Or, increase exposure time by	1.3	1.6	2	2.8	3.2	5.6	

To use this scale, look through the viewfinder and chek the width of the field you can see (at the subject plane). Measure this and read off from the table either the amount you need to open the lens aperture or the amount by which you must increase the exposure time. For a more accurate calculation, you can use the following formula:

$$\text{Exposure factor (in stops)} = \frac{\text{bellows extension}}{\text{focal length}}$$

for example, belows extension = 150
focal length = 50 mm

$$\text{exposure factor} = \frac{150}{50} \text{ or, 3 stops}$$

Always measure the bellows extension from the focal plane. If you use the standard lens in the reversed position — i.e. — with the rear element facing forward, you will find a slight increase in exposure necessary. This is because, while the rear element normally extends back into the camera, the front element is recessed somewhat in the lens mount. When you reverse the lens, you are increasing the distance between it and the film plane and the effect is though you had interposed an extension tube between the two. Usually an increase of approximately $\frac{1}{2}$ to 1 stop will compensate. With telephoto designs, you get the opposite effect. That is, a reduction in extension if you reverse them. For that reason, such lenses are considered unsuitable for reverse operation.

Remember, when you use the lens in the reversed position, you will in most cases have to operate the diaphragm manually. This may also be necessary when you use some extension tubes or bellows.

Exposure close-up

There is no getting away from the fact that the closer you approach your subject, the less depth of field you have to play with. It is also a fact, that if you use close-up lenses — unless they are of extremely high quality — you will be using lenses which are *not* manufactured to anything like the standards of your camera lens. Add to this the fact that your camera lens has probably not been designed to produce top quality images closer than about 5 feet and you suddenly realize that you may be faced with sharpness problems (or should we say, non-sharpness problems!).

In point of fact, quality need not normally become too disasterous close up, but there is every reason for using a moderately small aperture when you are taking close-up pictures. In spite of the fact that there is an optimum working aperture for every lens, you may well find that an aperture close to the smallest one you have is going to provide you with the best quality close-ups.

Using smaller apertures, however, calls for a consequent increase in the exposure time and, as we found out in the last chapter, that could cause trouble with the reciprocity law. It rarely does, however, because at the distances normally employed in close-up work, one of the problems is cutting down the power of the lighting used rather than increasing it — indoors, at least.

Working out the correct exposure, even with a through the lens meter, can be a hit-and-miss affair because subjects are frequently tiny and backgrounds often jet black or brilliantly bright. The easiest way to take a reading is with our old friend the grey card. If this is interposed between subject and lens (with a built-in meter) or used in the conventional way with a separate meter, then no problems should arise. However, at these close distances it is very easy to include a shadow on the card, without noticing, and this can upset the accuracy of the reading. Remember too, to modify the lens aperture figure if you are increasing the distance between the lens and the film plane. In the excitement of picture taking, it is easy to forget such vital details and lose some wonderful pictures. You will also have to set the lens aperture manually if you have the lens reversed. In this position, the diaphragm cannot operate automatically. You may also have to do this if you are using extension tubes from another manufacturer. Not all permit fully automatic operation.

Pictures through the microscope

Taking pictures through a microscope (or photomicrography, to give it its correct term) is a very specialized technique and we can do little more than touch on it here. If you do decide to try it and then become 'hooked', you will find that most libraries will be able to supply you with authoritative books on the subject.

First of all, any camera and any microscope can be used to take photomicrographs. If your camera has an integral lens which cannot be removed, then focus the microscope in the normal way, set the camera lens to infinity and attach the camera to the eyepiece of the microscope. This should be done so that the front of the camera lens is supported just *above* the eyepiece in the position normally occupied by the eye. This position (the eyepoint) can be found with reasonable accuracy by holding a piece of white paper immediately above the eyepiece and slowly raising it. When the bright circular image on the paper is at its smallest, correct position has been reached. The position of the eye point varies with the eyepiece. If the eyepiece is changed, therefore, the eyepoint may appear in a different position. You need to set maximum aperture because the diaphragm of the camera lens does not work in the conventional manner when used with a microscope. If you stop down, you merely

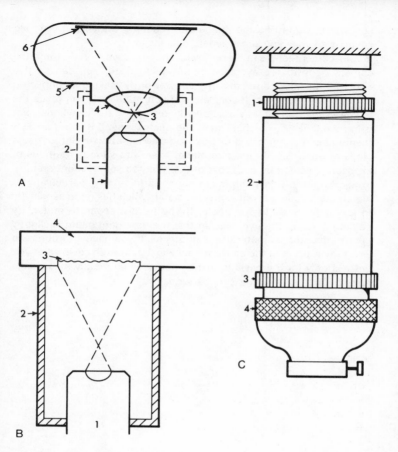

A, For photomicrography, a camera with an integral lens should be positioned so that light emerging from the eyepiece is focused on the front surface of the camera lens: 1, Eyepiece of microscope. 2, Adapter. 3, Eyepoint. 4, Camera lens. 5, Camera. 6, Film. B, The ideal position to take a reading from is at the film plane. When using a separate exposure meter, a tube to prevent extraneous light reaching the meter window will be needed. 1, Eyepiece. 2, Tube. 3, Meter cell window. 4, Exposure meter. C, For interchangeable-lens cameras you can use a specially-constructed microscope adapter. 1, Lens mount adapter. 2, Main tube. 3, Bayonet connector. 4, Microscope draw-tube fitting.

succeed in vignetting the image and reducing the size of the field covered so that you get a small, circular image.

If your camera lens can be removed, then remove it and attach the camera body to the eyepiece of the microscope. You can do this either by means of a microscope adapter or by making a connector, or stand, of your own. If your camera is an SLR, you can focus the image in the normal way, while looking through the viewfinder, but using the focusing mechanism of the microscope. If it is *not* an SLR then you can either buy a microscope viewing attachment, or use a piece of opal glass in the film plane. There are various methods of exposure calculation, but most of them rely to some extent on luck. Image brightness in photomicrography is fairly low, particularly at high magnification, so an exposure meter which has good sensitivity to low light levels is preferable. If you have a separate meter, try holding it above the eyepiece so that the emergent beam is slightly greater than the diameter of the photocell. If you have a through the lens meter, use it in the conventional way but in each case, what you get will only form a basis for experiment and you really *must* make tests before you try any serious work.

Exposing for Special Effects

Photographs are very factual things — no camera can record anything other than what is placed in front of it. That doesn't mean that every shot you take has to be a conventional portrait, view, architectural study, action shot or anything else that you can recognise as soon as you see it, though. There are a million and one pictures you can take simply because the end result will be an extremely beautiful picture — even if it is unrecognisable as anything other than a pattern. For instance, have you ever looked at the rainbow effect produced by a thin skim of oil on a pool of water and thought about it in photographic terms? Or perhaps glanced upwards while walking in a woodland copse and noticed the fisheye appearance of the treetops encircling the sky. Subjects like these form the abstracts of the normally hard, sharp, detailed world of the camera and the appeal of such pictures will lie not in their record value, but in their own intrinsic beauty.

You can go further than simple patterns, too. Take any scene you can think of — a canal, with a barge passing through a lock, your own garden — and imagine the colours of the objects have been transformed. The sky, from a deep blue, becomes a brilliant cyan, the leaves of the trees become rich magenta — the whole world changed from the ordinary to the magical. How about pictures by moonlight — a busy street with bustling people, cars driving along without lights and open shops — all apparently taken by the light of the moon. A weird and unconventional picture you can take with no difficulty. In the next few pages, we will take some of these ideas and see how easy it is to turn them into imaginative and unusual pictures. Like most other photographic exercises, they require some care, a little forethought — and perhaps, slightly more attention to exposure than usual. The results you achieve when taking pictures such as these will depend quite considerably on choice of exposure and, though you will always be reasonably certain of producing *something*, unless it has received the optimum exposure, it will, most likely, not have quite the impact it should. The major problem with most of these ideas, is, unfortunately, assessing the exposure.

195

Filters for effect

One of the simplest ways of producing a dramatic, and often un-usual, effect is to use a filter over the camera lens. You can do this either with black-and-white or colour and, in this case, there are no difficulties with exposure — you simply take a reading in the conven-tional way, then modify it according to the filter factor.

If the weather is good and you have a black and white film in your camera, the obvious choice for spectacular results is a red filter. Place this over the lens and blue skies become darker — sometimes almost black — clouds stand out brilliantly, the sea becomes darker, sand becomes lighter, haze disappears. The whole scene takes on a new appearance of brilliance, contrast and clarity.

Imagine a white-painted windmill in bright sunshine standing on a hill against a blue sky. Taken without a filter, the picture will be in-sipid and lack sparkle with the mill merging into a pale grey sky. Add a red filter (say a No. 25) and suddenly, things begin to happen. The sky darkens dramatically and the mill is pushed forward, brilliantly dominating the picture.

You can intensify this effect further by using an even deeper red filter, such as a No. 29, or by adding a polarising screen to make the sky even blacker.

Things begin to happen to your exposure, too, unfortunately. A No. 25 filter has a factor of $\times 8$, and what may have originally been 1/125 second at $f16$ now becomes 1/125 second at $f5.6$ of 1/60 second at $f8$. Use a No. 19 filter (with a factor of $\times 16$) and you have to open up four stops from your original reading (or adjust the ex-posure time accordingly). With a polarising screen, two more stops are required. Thus, if you use a No. 25 filter and a polarizing screen, five extra stops will be required which makes 1/125 second at $f2.8$. This shouldn't cause any problems, though, and provided the sails aren't going around too quickly, 1/60 second at $f4$ might well stop them and also improve the depth of field situation. Alternatively, do the thing properly and go for maximum effect. Give 1/8 second at $f11$ and let the sails become four while veils fading off into the sky. Don't just stay with red filters, though. Be prepared to experiment. A green filter could be used imaginatively if you were photographing red roses — or even geraniums, poppies or any other red flower against a background of pale foliage or lawn. A No. 58 filter which has a factor of $\times 6$ ($2\frac{2}{3}$ stops) would give you striking black flowers

against a pale grey or white background. Black roses? How unusual. You can often get some idea of the effect you are going to achieve if you look through the filter with your eyes half closed, but the best method of finding out is by doing. Watch exposures. Over-exposure can often undo a lot of the work of the filter. Confusion, too, can easily set in. Filter factors are not the most straightforward things to apply as this author has found to his cost. The following table should help.

Filter factor	1.5	2	3	4	6	8	12	16
Open aperture by (f stops)	$\frac{2}{3}$	1	$1\frac{1}{2}$	2	$2\frac{2}{3}$	3	$3\frac{2}{3}$	4

You can try the same trick with colour film and produce some very spectacular results — here, you can see pretty well what you are going to get simply by looking through the filter. Speaking purely practically, you can produce magnificent sunsets, even at midday, if you choose the right type of subject and take your picture through an orange filter, but try not to be too practical. You are after the un-usual and unconventional, not the everyday. Often, you can give less exposure than the meter suggests, so heightening the colour.

Which leads us, fairly naturally, to pictures taken apparently by moonlight. For best results, pick a bright sunny day (this will not only produce the strongly directional lighting you get on a moonlit night, but it will help your exposure, too), place a medium-blue filter over the camera lens and under-expose to produce the solid unrelieved shadows typical of night-time. How do you calculate the exposure? Well, for a start you could make an exposure reading for the un-filtered subject and give that, ignoring the filter factor completely. If you are using transparency film, though, it is probably best not to give more than two stops under-exposure. Try including the sun in your picture when you use this method of making moonlight shots waiting until it is partly obscured by a light cloud. It can prove remarkably effective.

If you are taking pictures, indoors, with colour film, you can use colour filters over the light sources (or coloured lamps) to produce exciting effects — and the real bonus here is that you can adjust the lighting, or the filtration, to produce exactly the effect you want. For instance, you can use a magenta filter over one lamp, a blue filter over another and a green filter over another — modifying the intensity of the lamps to suit the picture. If you need ideas, pay a visit to your

local discotheque – the effects achieved are sometimes quite remarkable. Assessing the exposure can be difficult, though, because your exposure meter will not necessarily react to coloured light the same way that it does to white light. However, it's suggestions are not likely to be too far out and, provided you bracket your exposures (one stop either way) you will be certain to produce useable results.

Specialized films

There are several films at present available, which were developed for highly specialized purposes. Black and white infra-red film and the colour materials made by Kodak – Ektachrome Infra red film and Photomicrography Colour Film – were all originally produced either for use by the scientist, or by the military and each has been adopted either by the professional or the amateur, to suit his own particular purposes. A few years ago, for instance, the world of haute-couture was startled by a series of high-fashion pictures taken on infra-red colour film. The faces of the models may have been slightly green, but they certainly attracted some attention.

Black-and-white infra-red film is extremely easy to use, either without a special filter, in which case it simply responds as a very fast, highly-red sensitive panchromatic film would, or, with an IR filter over the camera lens, as a true infra-red film (the filter can be used over the light source, if you are using artificial light).

However, we are interested in the infra-red effect and to achieve this you can either use a true infra-red filter (such as a Wratten 88A) which absorbs *all* radiation other than IR or you can use a very deep red filter (such as a Wratten 25) to produce results which are almost as unusual.

And the results *can* be unusual. Used outdoors the most striking effect is on foliage, which turns brilliant white – rather as though there had been a heavy snowfall. The reason for this is that chlorophyll (which all vegetation contains) reflects infra-red radiation very strongly, making trees, grass and any other plant life the lightest parts of the picture. Haze, too, reacts differently – it disappears completely. Water, on the other hand, absorbs IR and becomes black in the picture. People can look rather gruesome. Skin tones appear much the same as they do on conventional materials but blood

vessels near the surface of the skin stand out strongly as dark canal-like markings.

Using infra-red film requires rather more-than-average care. Just because we cannot see infra-red radiation does not mean that it isn't there to fog the film. Ordinary film cassettes, for instance, are not opaque to IR and fogging will result if a special infra-red film cassette is not used. Nor does infra-red radiation focus at exactly the same point as visible radiation. Most modern cameras have a special IR index mark, but, if yours hasn't, focus in the normal way, then rack the lens forward slightly, as though the subject were nearer to you than it actually is. If you can use a fairly small aperture, depth of field will do the rest.

Black-and-white infra-red films are given various ASA speeds for use with and without filters. If you have a through-the-lens metering camera, don't try to use it with an IR filter in place – you won't be able to see anything. Set the camera up (on a support, preferably); focus, take a reading (taking note of the ASA speed for the filter you are using) set the controls and *then* place the filter in position and take the picture.

False-colour films

Infra-red colour films can produce very striking pictures, the interesting thing being that you never know quite what the result will be like until you actually see it. Usually, you can depend on foliage becoming a strong magenta-purple, skies becoming cyan, flesh tones taking on rather a greenish tinge and, from then on, it's anybody's guess; it all depends on whether an object reflects or absorbs infra-red radiation.

Kodak recommend that for scientific purposes, Ektachrome Infra-red Colour Film should be used with a Wratten No. 12 (yellow) filter. That's fine – for scientific purposes. However, for pictorial effects you may well prefer the more strongly-saturated colours produced by an orange filter such as a Wratten 21. The only way to find out is to try both, using first one filter and then the other. It can prove a fascinating pastime, even if you don't produce any masterpieces.

With colour IR film you can ignore the infra-red focusing index on your camera. This is because you are using both visible light *and* infra-red radiation. Instead, focus to the very nearest point on your

subject and then stop down as much as possible to make maximum use of depth of field. Because exposure meters are not calibrated for infra-red radiation, an ordinary film speed rating cannot be applied to this film. If you intend to use it in conjunction with a No. 12 yellow filter, try getting your meter to ASA100 and, initially, bracketing your exposures $\frac{1}{2}$ to 1 stop either way. This way you can find out what the right meter setting is for your equipment. If you have an SLR camera with through the lens metering, make your reading before you place the filter in position. Alternatively, set the meter to ASA200 and read with the filter in position (check the filter factor with your equipment by making one reading without the filter and one with it; the difference should be one stop). Used in very early morning or late afternoon, or in tungsten lighting, which is rich in red, a setting of ASA 150–200 (ASA 300–400, reading through the filter) may be better. However, a great deal depends on test exposures with your own equipment.

There is one other film which will produce highly unconventional results and that is Kodak Photomicrography Color Film 2483. Originally produced for photomicrographers, this film has proved popular with lecturers for making slides of charts and diagrams. It is extremely contrasty and produces very saturated colours, skin tones becoming rather magenta and foliage a strong, emerald green. No filters are recommended specifically, but that certainly doesn't mean you can't use them. Film speed is ASA 16, which is rather slow, but otherwise no special techniques are required when using it.

Abstracts

You can find totally abstract pictures almost anywhere. As much depends on your artistic eye and creative outlook as on your photographic ability. Look for colour and design by observing things in an *unusual* manner rather than the usual. For instance, don't look at the paving stones when you're walking along a wet road at night – look instead at the colours of the street lights reflected in the wet surface (but, for heavens sake, don't trip over). When you're watching the flashing of headlights through a rain-spattered car windscreen (stationery, of course) – don't. Look instead *at* the screen and the patterns formed and at the colours and small reflections in each individual droplet. When you are enviously examining the paint

Kodak Ektachrome Infra-Red Film. The three emulsion layers are sensitive to green, red and infra-red. A yellow filters blue light from the subject. The layers become coloured yellow, magenta and cyan like a normal reversal flm (see p. 49).

work of a brand-new car at a motor show, look again — this time, at the rippling reflections in the glossy, mirrorlike surface — or in the hub cap, perhaps.

Abstracts are everywhere and, often, the difficulty is not in recording them, but in actually finding them. This is why the stress here is laid on looking at things in a different way. Try not to see the obvious, but instead look for the underlying features of a subject. If you notice, everyone of the subjects we have mentioned up to now has included some sort of reflection — and, indeed, reflections are a rich source of material. Think of the reflection of the busy street in the window of a big store — super-imposed over the fashion models in the window. Imagine the shining brass of a trumpet — with the reflection of the rest of the band mirrored in it.

Pictures like these are difficult to spot but easy to take. With reflections, you have to remember that if you want a sharp image, you have to focus as far beyond the reflecting surface as the object is from it. This is fairly obvious if you use an SLR camera but can cause heartaches if you don't. Remember too, when you are making an exposure meter reading that you are exposing for the *reflection*, not the reflecting material or its surroundings. Go in close and, if in doubt, take a second shot opening up one stop. More often than not some light is absorbed by the reflecting material. If your subject is coloured light, you could try underexposing, too. That can enhance the colour.

Of course, reflections are not the only things that provide abstract subjects. Look at patterns of light and shadow — cross-lighting on a white rough-cast wall, take pictures through things — hammered glass (or even old bottles!); look at the rim-lit branches of a tree and see the delicate tracery they produce. Look at as many different subjects as you can, and then think hard whether you can interpret them **differently to produce a pattern of contrasts, colours or textures.**

On the face of it, exposure can often appear an almost insoluble problem but, when you think carefully about it, it is not a great deal more difficult than for most other subjects. Decide exactly what part of the picture you are interested in and take your reading with that in mind. Remember always that whatever part of the picture you take your reading from will be recorded as a mid-tone, so, if you can, find a mid-tone to take your reading from. If all else fails, use a grey card, the back of your hand or even make a highlight reading from a handkerchief. Where you are working using transmitted light — as in

How 'Ektachrome' Infrared film works. The blue light (to which all layers are sensitive) is absorbed by a yellow filter over the camera lens leaving the three dye layers there to cope with the green, red and infra-red. Note, the dye layer sequence is different from that of conventional 'Ektachrome' film (see page 25) so giving rise to the false colour effect.

the case of the sheet of hammered glass or a stained-glass window, take your reading from the surface of that, as though it were simply a normal reflected reading. Be careful, however, that any large areas of darkness or extreme brightness are *not* allowed to affect your readings.

Creative mistakes

Having been a professional photographer, I know only too well that gnawing ache one gets in the pit of the stomach when after having taken a series of once only, never to be taken again pictures, one is about to take them out of the processing solution for a first look. It's awful.

Our pictures are important. If they weren't, then obviously, we wouldn't take them. We want them to come out and sometimes, we hope and pray that they will come out. But, sometimes they don't. Perhaps through no fault of our own we are faced with a blank reel of film, or a set of pictures liberally speckled with chemical stains. This doesn't happen very frequently, though and, more often than not, the fault is ours. Usually we find that it is the odd picture only which is suffering from, perhaps, slight under- or over-exposure, focusing troubles or even a filter left over the lens from the previous picture.

When you find that one of your pictures is not as perfect as it might be, don't simply discard it in disgust. Look at it carefully. Do you remember, in the last chapter, we mentioned looking at things in a different way – from a different point of view, in fact? Well, look at your mistakes from a differnt point of view. Instead of looking at them and thinking 'aren't I an idiot', look at them and ask yourself 'can I turn that mistake to my advantage' in the future. It may sound odd, suggesting that mistakes can be made to work in your favour, but they can. Here's how:

Under- and over-exposure

Probably the most frequent mistake of all concerns exposure. Too much exposure, too little exposure, it doesn't matter which, the

effects are similar — detail is lost in the picture. Often, as we have already said, this can be a disaster. Sometimes, however, it might actually improve the picture if more or less exposure than that indicated by the meter is actually given.

Supposing you are taking a picture of a girl dressed in a long, white, diaphanous gown. She has golden hair swinging around her shoulders and the sunlight is very soft, filtering through a light, morning mist. The setting is a hillside and there are trees in the background. The effect, to the eye, is of lightness and delicacy, with no hard contrasts, no strong, saturated colours and no heavy, shadowy tones. You can shoot now, if you wish and, provided all goes well, you will record an extremely attractive picture. The trouble is, even when we look carefully at things, we tend to be selective and see only what we want to see. The camera never is. It sees exactly what is there in front of it — no more and no less — and *that* may be a lot more than we saw.

In a picture such as the one we described above, everything needs to be kept simple. Intricate detail must be kept to a minimum if you want to retain the fairy-tale dreamlike quality. There are two ways you can do this: you can place a diffusion screen over the camera lens — which will blur and soften *all* detail in the picture and add a light, halo effect (not to be used if you require pin-sharp pictures) or you can deliberately over-expose. This will have the effect of washing out detail in the light areas of the picture and reducing the impact of any really dark areas. If you are using colour material, it will de-saturate even further the colours already muted by the mist producing almost a water-colour effect. A picture produced by this method is a 'high-key' picture. It consists only of light tones with perhaps one or two dark tones to balance.

A high-key picture must be made with some forethought. The subject matter and the background must consist predominantly of pale colours if the shot is to work. There's no point in trying to make a high-key picture if the subject is a brunette dressed in a black catsuit. But, this time, why not make a low-key shot. As you might expect, this will suppress detail at the other end of the scale — the shadow end. If you put the dark-haired girl against a black background, and under-expose slightly, the result will be extremely dramatic and heavy, with only the skin tones and features standing out strongly from the general blackness of the hair, the suit and the background.

High- and low-key pictures can pack quite a punch, provided the subject matter is appropriate to the technique. The problem comes when you try to decide how much more or how much less exposure you need to give to produce just the right effect. If you are using negative materials and normally carry out your own printing, then the answer is easy. Give the correct exposure, produce a perfect negative and carry out the required modifications during printing. This is good insurance against failure because, even if you decide that the technique isn't right for a particular subject, you can still produce a perfect print from the negative.

With transparency materials, it's 'do or die' really, and it makes sound sense to do one conventional shot before you start to experiment. For high-key work, you need to over-expose and for a soft, flatly-lit subject you can probably count on one stop being about right. Things don't always work out as they should, however, and you may find that even two stops may be required. It is always worth while bracketing your exposures because this usually makes it certain that you achieve exactly what you want. Low-key shots require under-exposure and slight under-exposure, as you may recall, has a much greater effect on a film than slight over-exposure. For this reason it is worth trying only a half stop and one stop less than the exposure recommended by the meter. Don't forget, too, to make a picture at what should be the correct exposure.

Be careful when you are taking meter readings from extreme subjects such as these. We said earlier in the book that a meter always assumes that whatever is in front of it is a mid-tone and gives a reading which will reproduce it as such. This still holds good and by far the best way of making accurate reading is to use the grey card technique. Do this and you should find it hard to go wrong.

Double exposures

Double exposure was once the photographer's nightmare and many a gem was lost forever simply because a poor chap forgot to wind on. Nowadays, it is difficult to find a camera that doesn't have in-built double-exposure prevention and the problem lies in trying to achieve it rather than avoid it. But who would want it, I wonder? Can you imagine a picture that only *became* a picture because it was double-exposed?

Well, one answer to that question lies a few chapters back, when we were discussing fireworks and thunderstorms — remember? We said that it was worth trying to record more than one lightning flash or rocket burst on a frame in order to produce a more spectacular effect. However, when you are thinking in terms of double — or even triple exposures, don't limit yourself to these subjects. For instance, you might wish to record a sequence of movements — of a dancer, perhaps, on the one frame. You have probably seen the dual portrait — a profile, three-quarter back lit almost fills the picture area; inside it, in the shadow area, is a smaller, full face portrait of the same person. Even a composite of, say, a single leaf super-imposed on the background of a woodland scene is not too difficult to tackle. All it needs is patience and a little care.

The first problem is: what do you do if you can't over-ride the double exposure prevention on your camera? Well, that makes things slightly more difficult, but by no means impossible. The easiest method is to work at night or in a darkened room (if you are photographing small objects). This enables you to leave the shutter open for short periods without producing any significant exposure on the film — using a slow film will help, too.

What you have to do is set up the camera on a tripod of other rigid support and, using a torch, arrange the subject for the first exposure. Fit a lens cap over the lens and, using the B or T setting, open the lens and keep it open. As soon as you and the subject are ready, take off the lens cap, fire the unsynchronized flash unit and cover the lens again. Now, without moving the camera, arrange the subject in the second position and repeat the process. You can make as many exposures on the one frame as you wish using this method, provided you remember a) each time you make an exposure, you are building up exposure on other objects in the picture and, if the background builds up significantly, it will show through the images of the subject; b) if the flash exposure for the subject is correct (which, one assumes, it will be) any part of an image of the subject which overlaps part of *another* image will be over-exposed; c) too many overlapping images can result in a very confusing picture.

Things become a good deal simpler if you *do* have a double-exposure prevention over-ride on your camera; you can then take pictures in most lighting situations using the conventional combination of aperture and shutter speed to make the exposure.

Exposure

This brings us to a second problem, though – how do you calculate exposures? Well, provided you can decide which part of the picture needs to be correctly exposed, then there are no serious difficulties. The thing to remember is that, in general, all the exposures you give, together, have to add up to the correct exposure for the subject. Thus, if you are making three exposures – perhaps showing a clock, with its pendulum in three different positions – and the correct exposure for a straight picture is 1/30 second at f5.6, then you might give three exposures of 1/125 second at f5.6 or three exposures 1/30 second at f11. (Neither, of course, is exactly right, but both work out as close as you usually can get exposures.)

On the other hand, if you are making a picture of a person in three different positions against a black background (as might be in the flash picture already mentioned) then the person should be correctly exposed each time.

Problem number three concerns what will and what will not record. For best results you should always have a *light* subject against a *dark* background. Supposing you want to make two exposures on the one frame of a black cat against a white background. You make the first exposure. Now, if at this stage you were to process the negative, you would see the cat as clear film against a dense black background. The cat moves into another position and you expose again. This time, if you were to process, you would simply get a dense black negative with no sign of a cat. Unfortunately, a black subject only records on film as an *absence* of exposure. If, as in this case, the cat moves and you make a second exposure, the position it moves to has already been fully exposed by the background, and the position it moves from will, in its turn, be fully exposed by the background. How to make a cat disappear in one – or, is it two – easy lessons!

However, if you do the reverse and use a white cat and a black background, you will be able to record as many cats as you like simply because it is *only* the cat which is actually giving any exposure to the film. The black background has no effect.

If you double expose a brightly-coloured subject and a different brightly-coloured background, on colour film, the colours mix together. For example, a red dress double-exposed with green grass comes out yellow.

The 'wrong' shutter speed

Ask any photographer to take an action shot of a motor-cyclist, a runner, even a weight-lifter and one of the first things he will think of is how fast a shutter speed he will be able to use. Normally our first reaction is to stop movement, either by using a short exposure time or by panning. Try going the other way for a change; consider *not* stopping the action, consider using a *slow* shutter speed and recording a blurred image or series of images on your film.

You'd be surprised just how strong an impression of speed and violent, explosive movement you can get by using a 'lazy' shutter. Try it, and try it in different ways. Try using a slow shutter speed while keeping the camera still. Try using a slow shutter speed and panning at the same time. Try using a slow shutter speed just as something bursts into action (this needs good timing but can work well with children — you get a sharp image with a blurred one peeling away from it.)

Don't confine the lazy shutter to the more usually recognized forms of action, either. A slow shutter speed — perhaps 1/15 second — works miracles with fast flowing water, turning it into an amorphous mass of surging boiling gas. Try a line of washing, waving against a blue sky, a flag fluttering in the breeze, a wheatfield turning into a golden liquid lake as it is caught by the wind, gulls sailing overhead.

Remember, here too, that as ever, light subjects record against dark backgrounds; but you get nothing the other way round. Try to picture a raven as a dark track across the sky: all you will get is a nice clear blue picture.We are talking about shutter speeds in the order of about 1/10–1/30 second here and, obviously, you have to use fairly small apertures to compensate. To make things easier for yourself, use a slow film to take up some of the slack.

Not all cameras have extremely fast shutter speeds, but if you possess an electronic flashgun, you have an exposure setting of about 1/1000 second whether your shutter speed ring says so or not. Try using this to produce completely different effects — water droplets frozen in mid-air as a dog shakes itself after a swim, a child having lots of fun bouncing up and down on his bed. The possibilities are endless. All it takes is imagination!

A Touch of Theory

In this book we have tried to look at exposure from the point of view of the average photographer. To most of us, the prime objective of photography is the production of the best possible pictures with the **least possible difficulty and aggravation.**

In the earlier chapters, we mentioned the relationship between exposure, film and the amount of blackening which takes place when a film is exposed. The scientific study this relationship is sensitometry. If that sounds a little high powered, you're right — it is. But the basics, at least, are not impossibly difficult and a knowledge of them can help us to understand why we actually carry out certain photographic functions. It will also help us when we come to read some of the more technical information relating to materials and processing chemicals. The following chapter deals only with a simple black-and-white emulsion but, when all is said and done, the theory underlying that is applicable to all photographic materials. It is simply the degree of complexity which varies!

A simple plot

A negative which has been exposed to light blackens when it is developed. The degree of blackening which takes place depends on **the intensity of the light falling on the film and the amount of time for which it is allowed to act** — in other words the exposure we give (see p. 213).

This graph doesn't tell us much, though and in order to be able to derive any information from it at all we need to be able to put down figures showing the rate at which exposure and density both increase. At first sight, the figures we are going to use might seem a little odd, and some words of explanation may prove helpful.

Along the 'exposure' axis of the graph, we give units quoting 'log exposure'. Log stands for logarithm and we use logarithms, not to make things more complicated, but to make them easier. You see, if we started with an exposure of one unit (that is the total parcel of light reaching the film) and then give twice as much exposure, we

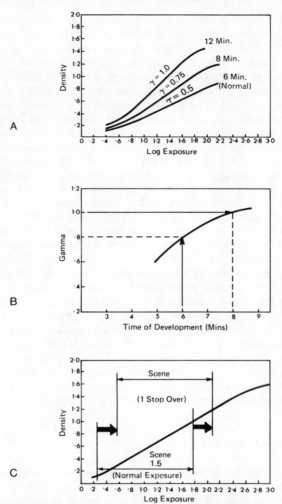

A, As development time is increased, so gamma also tends to increase. B, A typical time-gamma curve; this enables the correct development time to be calculated for the required gamma at a specific temperature. C, For optimum quality the lower portion of the curve should be used. For average subjects, slight over exposure will often produce tolerable results, but under exposure and more severe over exposure will lead to distortion of the tonal range.

211

would have to double our unit — which is simple enough — the result being 2. However, as we keep doubling: 1, 2, 4, 8, 16, 32, 64, 128, 356, 712, 1424: it doesn't take long for our figures to get out of hand and become completely unwieldy. On the other hand, using log exposure units means that we can simply add 0.3 to each previous figure to indicate a doubling of the exposure: 0.3, 0.6, 0.9, 1.2, 1.5. (It's the same principle as the DIN scale on your exposure meter; a film which is 27 DIN is twice as fast as one which is 24 DIN.)

We also use a logarithmic scale to express density. A negative whose density measures 0.8 has twice as much density as one which measures 0.5 (it lets through only half as much light).

To get back to our graphs. If we now write in our logarithmic units for exposure and density, we can get down to business. No film responds as a straight line over the whole curve. If you actually measure the density of a negative (through an instrument called a densitometer) and plot it against exposure, the result will look more S-shaped. This is called a D/log E curve or, if it is produced for a particular material, a characteristic curve.

This curve can be divided into three parts, the toe, straight-line and shoulder. The toe is the region of least exposure and least density. It relates to the extreme shadow areas of the darkest parts of the subject. The straight-line portion is where all the important mid-tones and highlights should fall. That is where the film is responding with equal increase in density to each increase in light. The shoulder, to all intents and purposes, is the region of over-exposure.

Those parts of the image which are recorded on the straight line portion of the characteristic curve will reproduce more correctly than those which record on the toe or shoulder (see p. 213).

Gamma and contrast

Although most characteristic curves are similar some are steeper than others. In general, the steeper the angle of the curve the more contrasty the negative will be. Knowledgeable people often talk about gamma, which can be a bit off-putting if you don't know what it is. Gamma is simply the gradient of the straight-line portion of the characteristic curve. On a steep hill, you may see the gradient marked — perhaps 1 in 8, or 1 in 5. This means that for every so many feet you travel, you rise one foot. Gamma means much the

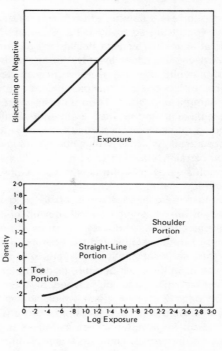

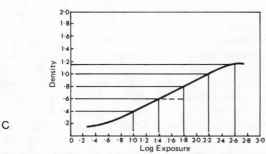

A, A simple graph showing how opacity increases with exposure. B, In practice, when the density of a film is plotted against log exposure, the curve looks more like this. C, Density increases proportionally with log exposure, but only on the straight-line position of the curve. *Gamma* (ɣ) is simply the gradient of the straight-line position, that is, density divided by log exposure.

same thing — for every number of units you travel along the log exposure line you go up so many units of density.

Look again at figure . You can calculate the gamma of that material from the work you have done already. You know that for an exposure increase of 0.4 units of log exposure, there is an increase of 0.2 units of log density; to work out the gamma, simply write this as the equation: gamma = 0.2–0.4. Thus gamma = 0.5.

Gamma *can* be an important measurement if you need to know how a film is going to respond to a particular subject — that is, whether it will produce a result which is of high contrast or low contrast. For instance, you certainly wouldn't want to use a high-contrast material to photograph a very high-contrast subject — you would choose one with a fairly low gamma.

However, most materials are produced to yield a certain gamma only when they are used with a specific developer under certain conditions. These conditions include the time of development, the temperature of the developer and the amount of agitation. Altering any one of these, significantly, will produce a change in gamma. Usually, increasing time, temperature or degree of agitation will increase gamma, while reducing anyone of them will reduce the gamma. On page 211 is a graph which shows how gamma increases with developing time. A gamma of between 0.6 and 0.8 would be typical for a material such as Plus-X or FP-4 (provided it was processed under the manufacturers recommended conditions). Tri-X or HP-4 or 5, on the other hand would be more likely to have a gamma of about 0.45–0.55.

You will sometimes find that instead of referring to gamma, manufacturers and text books will refer to 'average gradient'. This is because gamma is really only a reliable source of information when we are dealing with the straight line portion of the characteristic curve and, nowadays, the tendency is to make greater use of the toe region. In addition, more modern complex emulsions tend to produce a curve which is more of an 'S' shape with a less obvious straight line portion. Average gradient can be defined as the slope of a straight line drawn on the characteristic curve between the two points which represent the derived minimum and maximum densities in a high-quality negative (see p. 211).

Most film or chemical manufacturers publish another type of graph for their products, this is called a time-gamma curve and it shows the relationship between time of development at a specific

temperature and gamma — a typical example is shown on page 211. You can use it to produce exactly the gamma you require (within reason, of course) by drawing a horizontal line from the gamma axis to meet the curve and then from that point dropping a vertical line to the development time axis. In the example shown, for instance, to achieve a gamma of 0.8 you would need to develop for 6 minutes. A time-contrast-index curve is read in exactly the same way as a time-gamma curve.

D-max and D-min

The characteristic curve of a film can also be used to give us further information. At the toe of the curve there is the point labelled D-min. This is the point of minimum density — even a brand new film processed straight from the packaging would show a certain density. This is because a) the film base itself, although apparently quite transparent, has some density and b) when you develop a film — even an unexposed one — a slight fogging occurs.

At the other end of the scale, on the shoulder of the curve, there is a peak point where increasing the exposure produces no further increase in density. This point is called D-max (or maximum density).

Brightness range

We have referred several times in this book to the brightness range of the subject — that is the difference between the lightest and darkest parts of the scene. Some of the subjects you will take will have a brightness range sufficiently long to use the whole of the characteristic curve (a snow scene, perhaps, in brilliant sunshine, with banks of trees in deep shadow, or, a beach scene taken against the sun) but these will be fairly few and far between. Most average subjects will fit comfortably onto a small portion of the curve and, if you are using the film at its rated emulsion speed, this will be the lower portion starting just where the toe starts to rise.

A typical subject might have a brightness of about 30:1, that is, the brightest area is 30 times brighter than the darkest area. In terms of log exposure, this is equal to 1.5 and on page 211 you will see how this fits on to the characteristic curve, assuming the correct exposure

was given. If the exposure was increased by one stop (doubled, in other words) that would mean that the whole scene would shift 0.3 units further along the log exposure scale (remember; doubling the exposure simply means adding 0.3 to the log exposure).

Most black-and-white films will produce acceptable results when they are exposed at 1–2 stops over the normal correct exposure; this is called the exposure latitude of the film. However, although there is reasonable latitude going *up* the scale, you can see that there is very little allowance for under-exposure. Under-exposing by one stop would mean pushing the whole scene *down* the log exposure scale so that those parts of the scene which received less exposure would be forced on to the toe area and would not reproduce properly.

It is obvious, too, why exposure latitude only exists for subjects of average to low brightness. It is only these subjects which are short enough to be moved easily up and down the curve. A subject with a really long brightness range, say 500:1 or over will take up the whole of the curve at the correct exposure and even then the extreme highlights and shadows will be slightly compressed.

Don't stop here

Of necessity, this chapter can only be confined to the barest outline of the theory behind exposure. Whether you need to know more or not depends very much on how seriously you are going to take your photography. If it is simply an enjoyable pastime, well, fine. We hope this book has helped you a little along the way. If you plan to go much deeper, then lots of luck! The further you go the more fascinating this hobby becomes and there's a long way to go from here.

The Focal Press has a wide range of books covering all aspects of photography – including sensitometry – and a stamped addressed envelope will bring you a full list.

Good shooting.

Index